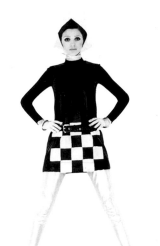

VINTAGE

THE ART OF DRESSING UP

TRACY TOLKIEN

VINTAGE

THE ART OF DRESSING UP

PAVILION

ACKNOWLEDGEMENTS

I'd like to thank everyone at Pavilion and Rizzoli for their
patience and sensitivity, Tom Whyte for teaching me how to
do this, Keith Ryan for activating the passive voice, and
Christine Groom for her efficiency and intelligence.
Thanks too, to Nicholas Tolkien.

I'd like to thank my brother Mark Steinberg for
finding so many wonderful and inspiring clothes.

Most of all I'd like to thank
my father Mark Steinberg who
will always remain the true spirit of
Steinberg and Tolkien.
This book is dedicated to him.

This edition published in Great Britain in 2000 by
PAVILION BOOKS LIMITED,
London House, Great Eastern Wharf,
Parkgate Road, London SW11 4NQ.

Text © Tracy Tolkien 2000
Photography © Michael Harvey 2000
See pages 163–164 for picture credits

The moral right of the author and photographer
has been asserted.

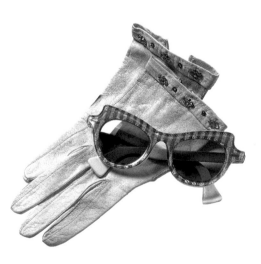

A CIP catalogue record for this book is available
from the British Library.

ISBN 1 86205 305 7

2 4 6 8 10 9 7 5 3 1

This book can be ordered direct from the publisher. Please contact
the Marketing Department, but try your bookshop first.

Colour reproduction by Alliance Graphics

Printed and bound by Tien Wah Press in Singapore

CONTENTS

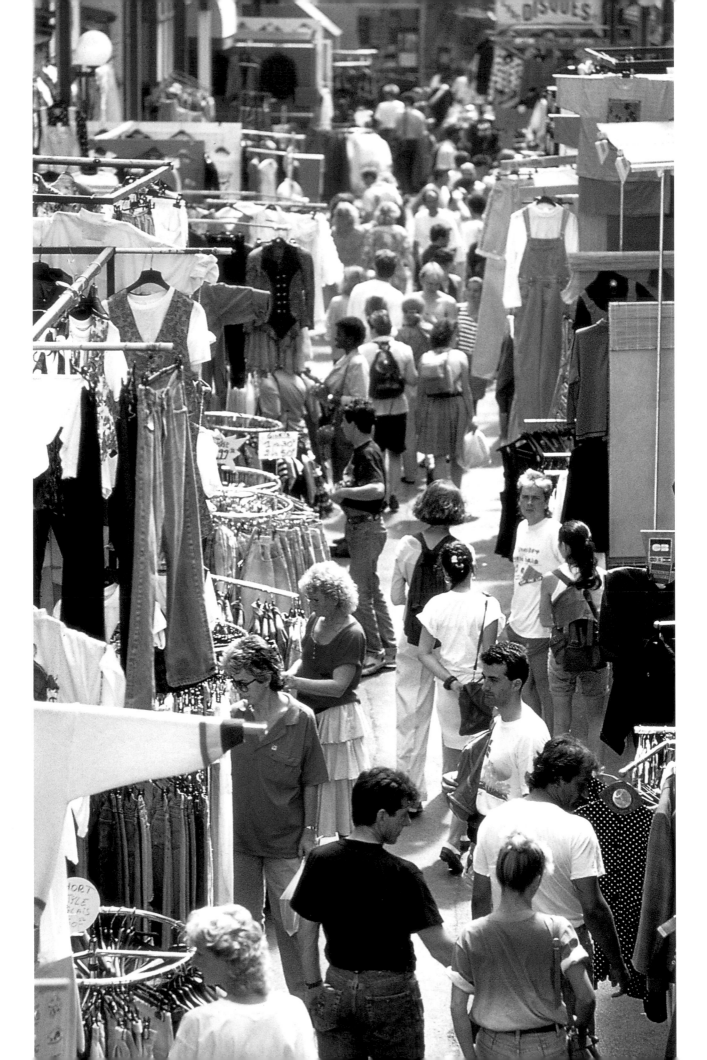

INTRODUCTION

OPPOSITE: Thrift stores and
street markets can throw off
true vintage bargains but
you could easily spend an
entire day searching and
find absolutely nothing.
Basing a collection around
thrift-store bargains is not
only unrealistic, it can take
days, weeks, literally years
of your time

After decades packed away in obscurity and
mothballs the best of twentieth-century fashion is
out on parade again and not just for theme parties or the
odd weekend but regularly and proudly displayed by some
of the world's most glamorous women. Kim Basinger buys
her vintage dresses from Sotheby's, Winona Ryder wore
vintage to the Oscars, and Kate Moss did the Cannes Film
Festival in a vintage white column dress by legendary
couturier Madame Grès. It seems the days of "Second
Hand Rose" are long gone now and women who could
easily afford to buy the kind of new designer clothes that
most of us can only dream about are instead choosing
vintage.

But why, in this brand new century, do the fashion pack insist on turning back the clothing clock? It's partly, of course, a matter of choice. When you buy new clothing you may well feel as if you're a free agent but the truth is that many decisions have already been imposed long before the clothes ever hit the racks. Designers, manufacturers, shop buyers, and magazine editors all get their say when it comes to the way we dress. Modern methods of mass production for low- and mid-priced ranges generate some pretty shoddy garments in some less than appetizing fabrics but even high end products are made in such huge quantities that true individualism becomes difficult, if not impossible.

The exercise of free will in fashion is one of the true attractions of vintage style and in our twenty-first century world of eclectic dressing absolutely anything goes. Thanks to a continuing trend for retro styling we've got decades of incredible clothing, jewelry, handbags, makeup, and hairstyles to play around with, so go ahead: be a "power dresser" for the day, or a "flower child," be a "punk" or hit the clubs in a 1950s crinolined dress. You can re-create the various looks step-by-step, or re-combine and re-invent them into your own personal collage of twenty-first century style. And you don't have to end up looking like an extra from a costume drama to take advantage of all that vintage has to offer. You can chime in with a contemporary trend for slip dresses or ponyskin prints, but put your own unique twist on it by choosing one-off versions from the vintage racks. Our world may be slickly packaged and mass-produced but with vintage you can dress the way *you* want to dress.

1960s embroidered English bag

And to top it all off, the value of vintage clothing can actually increase with each passing season while your pricey new designer number won't bring a tenth of what you paid for it the second you leave the store.

1950s American decorated bag

COLLECTING

Vintage clothes as "collectibles" have always been in a category of their own but some general rules of mainstream collecting do apply. Clothes that were regarded as expensive when they were first made tend to be correspondingly expensive as collectibles today. This is true because pricier items were usually made to higher, selective, less mass produced standards, and with better materials. Fewer were originally produced so there were fewer to survive today. But because rarity and value tend to go hand-in-hand in the collecting world, ephemeral objects cheaply made then promptly thrown away can also be valuable today simply because so few of them survived. Warhol-inspired paper and cardboard pop clothing of the 1960s are good examples of the cheap and cheerful of its day metamorphosing into a vintage treasure.

Condition is another area where vintage clothing parallels mainstream collecting of more traditionally recognized antiques. An original Fortuny gown in perfect condition could sell at auction for $10,000 while an identical dress in tattered condition would be lucky to sell for $100. Condition, though, is a difficult area for vintage collectors because for many the joy of collecting is inextricably tied to the joy of wearing clothes and yet by doing so, condition will deteriorate.

Purists of course would never dream of wearing a Fortuny out on the town (and indeed many of the world's keenest and most serious collectors of fine

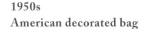

vintage clothes are actually men) but for most vintage enthusiasts, wearing is where the fun is, where the allure comes in. During much of the twentieth century most of us identified ourselves most strongly in fashion terms with a fairly narrow period of time, usually the decade during which we first started choosing and buying our own grown-up clothes. But now that the century has ended all of its decades seem like poignant reminders, souvenirs that everyone can wear regardless of which particular decade felt most like ours.

Today's designers recognize this fact and have been mining the archives for the best of twentieth-century fashion, then re-combing past styles and details in a post-modernist bricolage that feels simultaneously both historical and modern.

Emotionally too there is something very romantic about the idea of these lovely, once treasured clothes coming out of their dark hiding places to live again and become associated with special moments in our own lives, as they once were in the lives of their original wearers. So, if a wearable collection is your goal then that's great, just bear in mind that a little common sense can save a lot of heartbreak.

Don't try to cram yourself into that to-die-for Ossie Clark, bias-cut number if it's just too tight. A vintage piece can be successfully tailored if it's too big but if it's too small, don't bother. You'll just end up hobbling home from a big night out, trying to camouflage your split seams with your frustratingly tiny original 1970s disco bag! Fabrics like chiffon, net, and lace are clearly more fragile than wool, leather, and gabardine so the more delicate materials should only be worn rarely and again only if they fit. Always use padded hangers for fragile fabrics to avoid the dreaded punctured-shoulder syndrome.

A specialist dry cleaner is a vital ally in the fight to keep vintage clothes on their feet. Why not buy a few inexpensive beaded or sequined numbers to test the performance of various firms before you let one loose on your really amazing fleamarket Schiaparelli? It's not, after all, what you paid that counts, it's the fact that you love it so much and it's irreplaceable—but try telling that to an insurance adjuster. Theatrical dry cleaners, though more expensive than mainstream businesses, are used to working with fragile garments plus embroideries and beading. So these usually prove to be money well spent. Such specialists are common in larger cities and can usually be found in the Yellow Pages. If you live in a smaller town, your local theater troupe or the textile department of a local museum will tell you who they trust.

Prices for vintage clothes vary wildly from city to city and from venue to venue. Tastes can be regional, so what goes in Los Angeles might be ignored in New York and vice versa, but there are pieces that are prized the world over and I've tried to cover all of these, at least from the post-war period, in this book. How though can you spot a

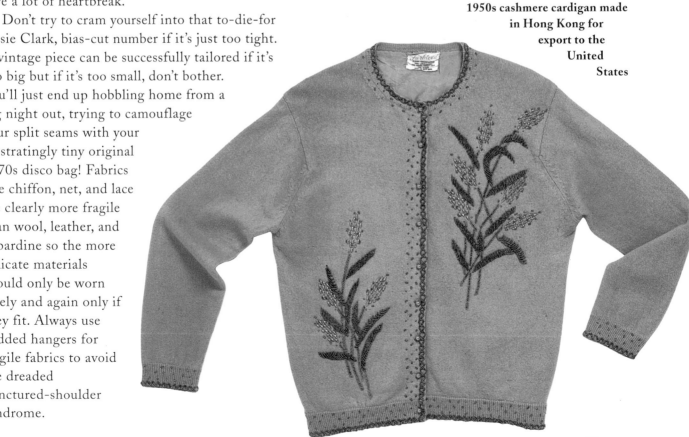

1950s cashmere cardigan made in Hong Kong for export to the United States

1950s American Western shirt

good piece quickly in the mountains of second-hand and vintage clothes that are out there every day in flea markets, yard sales, and vintage stores?

First, you should look for a label in any garment that catches your eye, but bear in mind, a label may mean something or it may mean nothing at all. There are literally thousands of post-war designers whose name adds nothing to the value of a piece today. Conversely, labels such as Dior, Yves St. Laurent, or Vivienne Westwood may mean that a piece is valuable, but if it happens to be an example of one of their cheaper, mass-produced diffusion lines then it's probably not. Mass production and "diffusion" lines are essentially post-war phenomena so unless labels identify designers who ceased production in the pre-war period they cannot be relied upon for quality control. And even then, sadly there are pitfalls. It is not unheard of for an unscrupulous vintage dealer to remove a good label from a boring or damaged piece and re-attach it to a more sellable garment. In fact, labels often go "missing" during auction open houses and probably appear later on clothing originally designed by someone else! The label may not matter to you if you're not a die-hard collector but you should not be paying a top price because a garment is purported to be rare and original when it's not.

So, as with mainstream antiques, never pay a huge price for a couture or designer piece unless you are shopping with a reputable, established vintage dealer or auction company. These experts can spot fakes and will not show them. The best way to protect yourself in the vintage market though or to spot a sleeping treasure in a store full of vintage mediocrities is to train your eye. Learn to recognize good cloth, good sewing, and the basic lines and styles of the various eras. Visit museums, vintage stores, and if you get the chance, the specialist vintage auctions at established showrooms like Christie's, Sotheby's, and Doyle's. Research old magazines and remember to study the various advertisements too. Most local libraries keep full runs of various fashion magazines which they will be happy to let you browse. And don't be afraid to ask lots of questions when you run across an expert. Most vintage dealers are passionate about the clothes and love to talk about them.

There are however four basic categories that can help to assess the art of a vintage piece. The first is "style" or design value. Is the cut pleasing, the color right, the detail suitable? Good design is an elusive, often subjective quality, but a dress by a superstar like Balenciaga will convey interest and beauty even in a black and white photo. Examine fabrics. The sensuous feel of cashmere against your skin may be the point of a garment like a 1950s cardigan rather than its standard cut or neutral color—while a 1960s metal dress by Paco Rabanne *is* its materials. Look carefully at the craftsmanship and the detail of a particular garment and decide if it is appropriate. The hand-beaded Balmain evening dress and the 1960s embroidered hippie jeans both rely on decoration to get their messages across. Finally, think about a garment's historical value as a cultural artifact. How directly does it connect us to the era in which it was made and how fully and eloquently does it express that past? Take, for example, a 1950s American teenager's circle skirt decorated with scenes of Parisienne street life. This piece is full and loose, reminding us of the new fashions that grew up around rock 'n' roll dancing, but it's also wasp-waisted like her mother's corseted Dioresque dresses, with a nod to her father who was stationed in Europe during the war and brought back a whole load of French tourist souvenirs that found their way into the decade's kitschier decorative vocabulary.

The best vintage pieces combine several of these categories. A Balenciaga opera coat in its vibrant fuscia silk gazar is made of the finest quality material. Even its handbeaded crystal buttons are beautiful. The simple architectural design is pleasing but the luxury of its materials and the theatricality of its style recalls the 1950s post-war swoon into an ultra-formal, ultra-feminine opulence.

An important step then in accessing the art of any vintage piece, be it the finest couture or the humblest hippie T-shirt, is to ask yourself, what is it trying to say? What is its point? And how well does it get that point across?

WHERE AND HOW TO BUY

The chances of you spotting a Ming vase or an early Picasso print at a flea market or yard sale are sadly low, but this is not at all the case with vintage clothes. Some of the best, most valuable examples turn up in the unlikeliest places and the possibility of discovering a treasure does exist. This is true because clothes are still the poor relation of mainstream antiques, and when estates are broken up, even quite important ones, the art and antiques go straight to Sotheby's while the clothes usually go to local charities or thrift stores or anyone else who will haul them away.

Yard sales, flea markets, and garage sales can be excellent sources, but true vintage aficionados regularly hit the thrift stores or charities too. Raking through thrift stores takes a lot of time and patience but when you find something there, it is a true bargain. These charity superstores stock an enormous quantity of clothes, mostly of the modern "second-hand" variety, but vintage sleepers do turn up in the racks as well. Again, you've got to learn to train your eye. Seasoned "pickers," as the professionals are called, can walk down a long aisle of thrift store racks and spot the one vintage bargain without even touching a single garment. Large thrift stores rarely have dressing rooms but if you wear a loose skirt and a figure hugging top or leotard you can usually manage (with a bit of fumbling) to try things on in the aisles, without actually getting undressed. It's well worth getting a feel for all the thrift stores in your area (they're

listed in the Yellow Pages) but bear in mind that thrift stores in the better neighborhoods tend to have the nicer stuff. Most larger American cities also have small, upscale thrift boutiques that benefit local symphonies and arts projects and while these tend to focus on newer designer wear, when they do get in vintage, it's usually of fantastic quality. European thrift stores (called charity shops in England) are nowhere near as good as the American variety but they are well worth a look, especially in wealthy neighborhoods. Antique malls and centers often have reasonably priced vintage stands as well, so these are worth checking out, both in your area and whenever you're on holiday. Great vintage bargains can often be turned up in flea markets, yard sales, and private garage sales, so scan your local newspaper or antiques publication for listings and remember to wear your easy access thrift store "uniform" to try on garments because these places won't have dressing rooms either.

1960s Pucci blouse

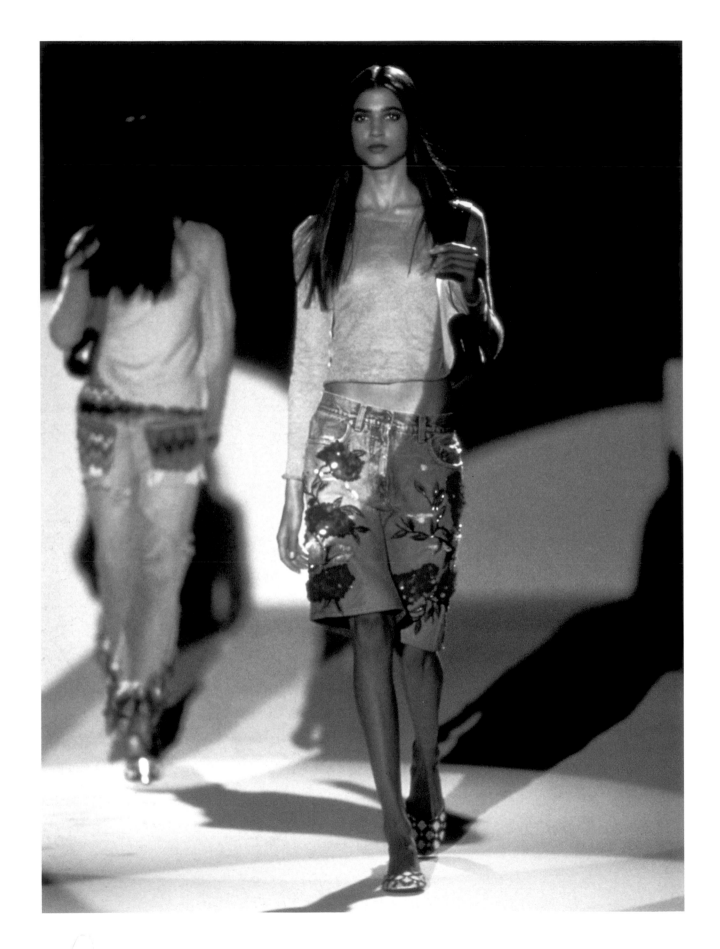

In this busy twenty-first century world, though, where "time is money," working women simply cannot afford to trawl the bargain stores every day of every week of every month like the professional pickers, so the best vintage collections are made up of a combination of thrift store steals, mid-priced flea market finds, and must-have pieces that cost a fortune. Specialist vintage shops and auctions, though higher priced, save time, effort, and disappointment and even the priciest garments from these sources are usually cheaper than the best of today's brand new designer labels.

Many people think that auctions like Sotheby's and Doyle's are for experts only and they feel intimidated by the idea of bidding. With vintage clothes, though, this is emphatically not a problem and, indeed, many private buyers attend these sales. Even if you don't live near enough to buy at vintage auctions it is well worth subscribing to auctioneers' specialist catalogs which are often very informative and give a good overview of which labels and eras are bringing in the best prices. You can buy such subscriptions on the telephone from the costume and textile departments of most major auction houses.

The best ongoing sources for vintage clothes are the specialist shops. There is a comprehensive list of these at the back of this book but keep your eyes peeled because new shops are opening all the time. A regular relationship with your local dealers is your most valuable asset as they will soon learn your tastes and size and look out for things for you.

If you are collecting a specific designer or era, ask your local dealer to telephone you when something new in that category comes in—and remember good loyal customers are usually rewarded with generous discounts on their purchases. Haggling is a big factor on the vintage scene so always ask, "What's your best price?" before you buy. Thrift stores, however, rarely negotiate and don't be insulted if you're turned down in some vintage shops as well. All thrift stores and many vintage shops are staffed by employees who are not

OPPOSITE: **Vintage themes permeate high fashion today and these decorated Gucci jeans owe a lot to the 1960s hippy culture of do-it-yourself style**

Detail from a 1950s cardigan by Helen Bond Carruthers

Detail from a 1970s Missoni dress

authorized to lower prices so time your visits for days when the owner is around. Be very certain before you buy because thrift stores, flea markets, and auctions will not accept returns.

Although they are not obligated by law to give you a refund unless they have misrepresented a piece, some vintage stores will at least allow you to exchange a garment or give you store credit on a return. Most, though, won't even do this because their margins are tight and they've all been burned by the unscrupulous customer who wears their 1970s gear to a theme party and then tries to return it when the party's over, or the insensitive customer who just gets bored with their own wardrobe and wants something new and exciting for free. In both cases this just amounts to a clothing loan for nothing and vintage dealers need to pay their overheads and make a profit to stay in business, so it's far better to spend hours in the shop making a decision than to try to return a garment later.

The internet is an exciting source for vintage fashion accessories but

Fine vintage is getting increasingly scarce so the purchase of a rare, expensive item will surely prove a shrewd investment.

sadly clothes can be a disappointing purchase. Photos are often fuzzy and unprofessional, giving little idea of the appearance of the garment and much less of the condition. There is clearly no way to try things on although most vintage sites do offer a return policy. This can be an incredible hassle though, particularly in light of the stacks and stacks of styles most people have to try on in vintage shops before they find something that fits and flatters. Generally speaking, vintage knitwear, coats, and blouses are your best cyber-clothing buys because they fit over several sizes. And the internet can be great if you collect a particular designer and don't mind whether you can wear the piece or not.

But while the internet usually proves a frustrating and difficult source for wearable clothes, it's absolutely fantastic for vintage fashion accessories. Handbags, shawls, scarves, compacts, hair accessories, and costume jewelry don't need to fit and are often true bargains. A Miriam Haskell rope necklace whose condition is described on the internet as "good"

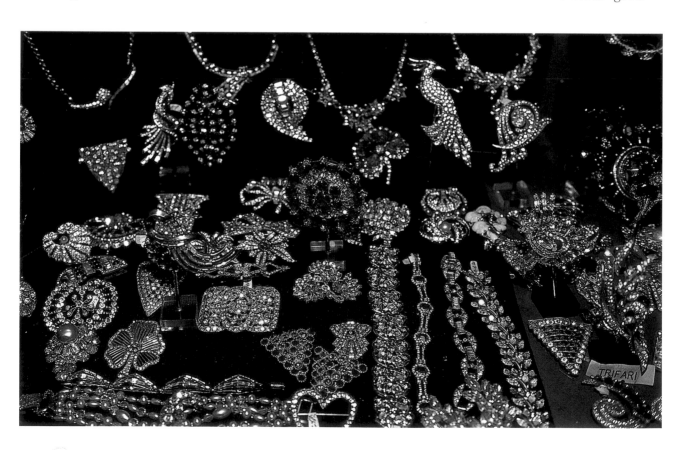

 INTRODUCTION

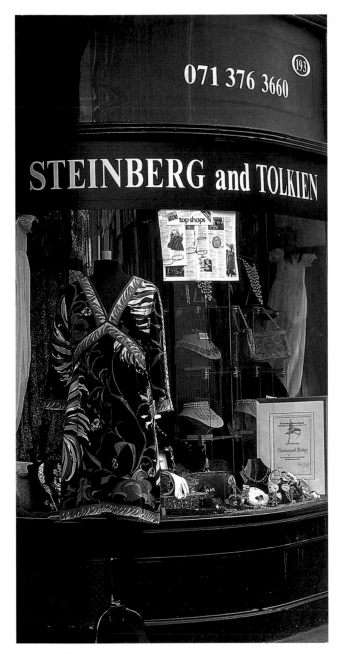

ABOVE: **The façade of Steinberg and Tolkien in London**

OPPOSITE: **Costume jewelry is a great area for vintage collecting**

If you plan to sell or insure your pieces or if you are just curious about what you have, you can use websites, such as Steinberg and Tolkien's internet service (www.vintagevalua-tions.com), which for a fee will tell you what your vintage clothes, costume jewelry, and other collectibles are worth in today's market.

will usually turn out to be just that and if you live in a city like New York or London the Haskell rope that comes to you through the mail from a small town in Oklahoma will probably prove cheaper than the ones you find in your local vintage stores where overheads are far, far higher.

The eBay website runs a fun online auction for vintage costume jewelry, purses, and clothing while the Mining company's specialist costume jewelry site is tempting and highly informative—a definite must for vintage glitter fanatics worldwide.

One of the best, often overlooked, sources though is probably out there in your own backyard, tucked away in the darkest corners of your friends' and relatives' wardrobes. Ask mothers, grandmothers, aunts, cousins—they were there, they lived it, they wore it, and you might be lucky enough to re-discover it now. Fantastic wardrobe boxes may be right under your own nose. A treasure trove not only of fashion history but family history too.

So buy, wear, enjoy, and remember what Mary Quant said:

"Fashion allows you to be what you want. You can dress the part and — my God, it happens!"

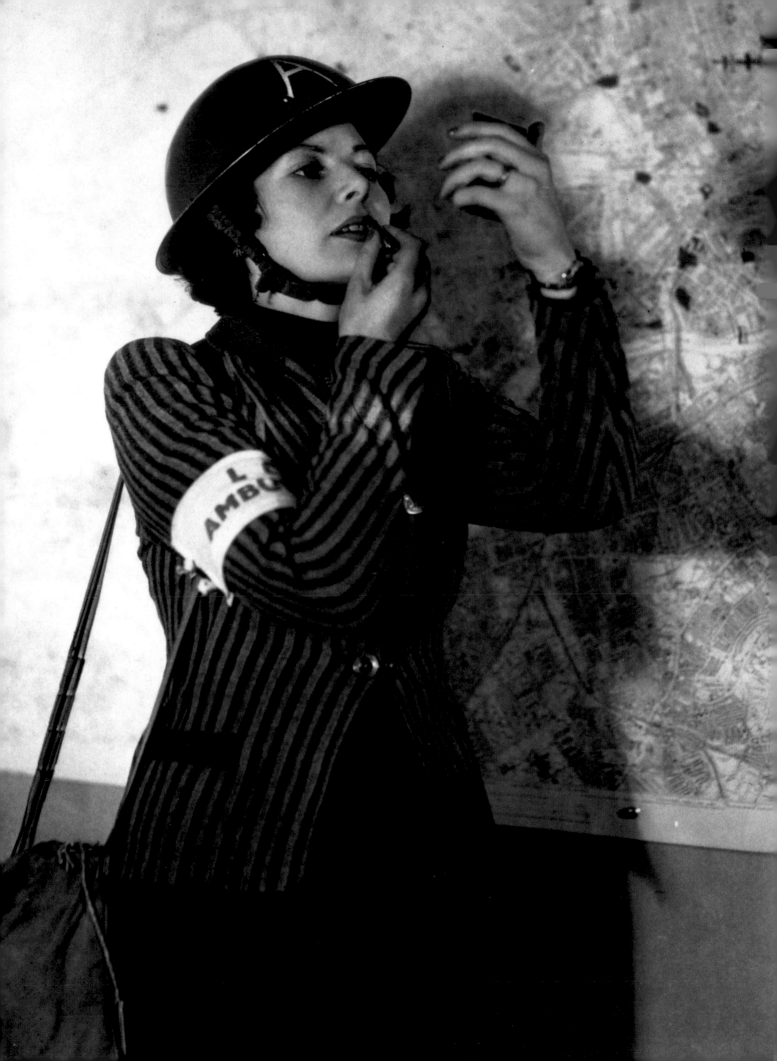

THE 1940s

Wartime Dressing — The Hungry Years

OPPOSITE: The horrific potential of chemical weapons had been demonstrated in World War I so gas masks were issued in the 1940s. Women tried to put a brave face on this threat by carrying their masks in fashionable, over-the-shoulder holders that became prototypes for the post-war shoulder bag still popular today

I t would be difficult to appreciate the true explosion of post-war fashion without a brief look at what was worn during wartime. Wartime clothes on both sides of the Atlantic tended to be static and looked drab compared to the slinky, bias-cut glamour of 1930s Hollywood inspired styles.

World War II was very much a woman's war and in Britain childless women were drafted into factories or other auxiliary jobs while many European women worked in the field at feeding stations or as nurses and ambulance drivers. Many were issued with uniforms while the rest wore practical, utilitarian clothes, especially suits, in austere, militaristic colors like blue, black, or brown. They were cut straight and mannishly, with hemlines just below the knee and no-nonsense shoulder pads that gave off a brisk, confident air, well in keeping with the wartime woman's role as a vital member of the workforce. Wood- and cork-soled platform shoes literally raised her stature, and access to such materials was happily unrestricted.

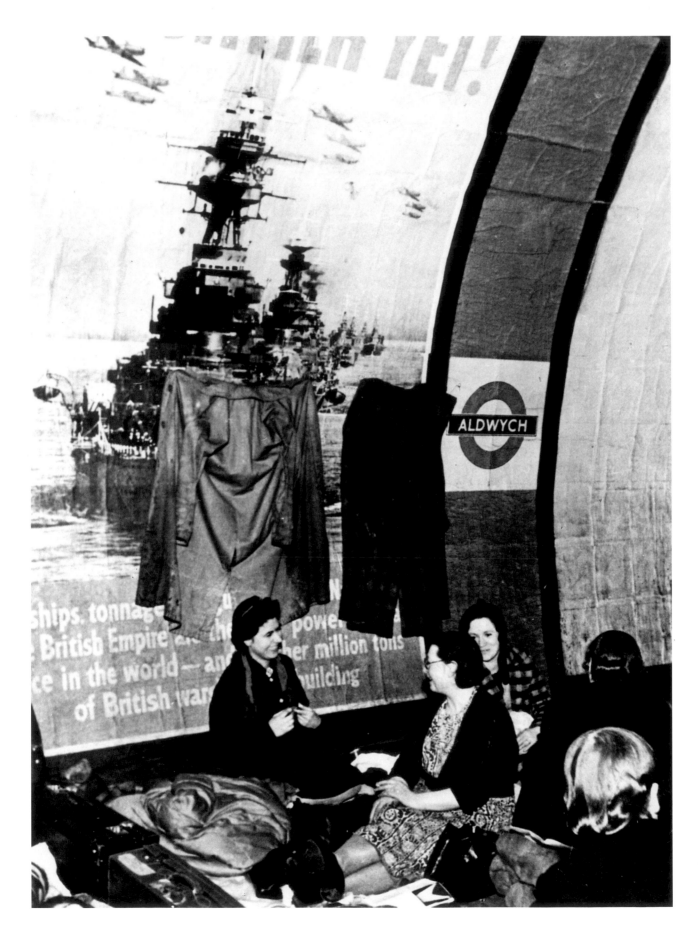

18 THE 1940s

"Many of haute couture's wartime clients would be shot when the war was over." – Christian Dior

Civilian clothing in Britain was controlled by the government's "Utility Scheme" which limited the use of raw materials and operated a rationing system. Each adult was allowed 66 clothing coupons per year and with a casual dress or jacket costing 11 coupons and a suit costing 18, fashion—by necessity—could not afford to change much. The "make do and mend" campaign featured the ever cheerful and resourceful character "Mrs. Sew and Sew," who taught woman how to make clothes out of old dish towels, pillowcases, and draperies. Commercially manufactured clothing had to conform to rigid rules governing color, length, fastenings, and trims. On both sides of the Atlantic the idea was to freeze fashion so nothing would get old before its time and factory space, raw materials, and labor could then be devoted almost totally to the essential business of war.

"I once was lucky enough to purchase an entire wardrobe of haute couture clothing that originally belonged to a member of the French resistance. It was one of my most amazing, humbling moments as a vintage clothes enthusiast when I found a cyanide capsule still tucked discreetly in the folds of one of this woman's beautiful jeweled evening bags. The message was clear and suddenly the past came alive."

Before the war the Paris couture industry was still the *dernier cri* for fashionable women the world over and though Hollywood had started to generate its own style during the 1930s, magical names like Chanel and Schiaparelli still held sway until the occupation of Paris in 1940. The occupation cut off all clothing exports, French *Vogue* ceased production, and many pre-war designers closed their houses and fled. Others stayed, along with the head of the Paris couture association, Lucienne Lelong, and tried to preserve some remnant of this traditional French industry but their only customers were inevitably the wives of collaborators and high ranking Nazi officers. For some designers this new, enforced clientele proved galling but when legendary couturier Madame Grès refused to sell to the Nazis, Goebbels dropped by with a squad of storm troopers and she was eventually closed down.

With Paris in a stranglehold, Americans finally turned to their own home-grown talent. Ready-to-wear designers like Claire McCardell and Tina Leser popularized a casual, distinctly American look using fabrics like calico, gingham, and denim cut in simple utilitarian styles. This pared-down style paved the way for the sportswear tradition that America made its own in the post-war period.

During the war an unprecedented number of women worked and earned their own money, but they were unable to spend much of this on clothing because fashion had been put on hold. Costume jewelry was an obvious indulgence and

Reja silver brooch

livened up the otherwise austere 1940s suit. Unlike most metals, silver was freely available during wartime so a wide variety of top quality figural, floral, and abstract lapel brooches were made in silver and *diamanté*. Look out for 1940s "vermeil" (goldplated) silver pieces signed by manufacturers like Trifari, Peninno, Derosa, and Reja—all collectible and valuable on the vintage scene today.

OPPOSITE: London underground stations were widely used as bomb shelters during the war. Clothes were warm and practical but jumpsuits were particulary popular for the long nights during the Blitz. England's high fashion temple, Harvey Nichols, sold a hooded, all-in-one gas suit specifically designed for women. It came in a range of pretty, feminine colors while the tag reassured the wearer that it could protect them through a full 200 yards of mustard gas

THE 1950s

The New Look — from Elvis to Etiquette

After the years of dark, somber, standard-issue wartime clothing, Dior stunned the world with his opulent, over-the-top, 1947 "New Look" collection. "No more women soldiers built like boxers," he said. "I draw women flowers, soft shoulders, flowing busts, fine waists...." And so was launched the cult of "the living doll," an image of studied and exaggerated ultra-femininity— outwardly cool, distant, and untouchable, but maintained just beneath the surface by a system of cantilevered bras and boned corsetry as fetishistic and erotic as anything to emerge from the wildest imagination of Vivienne Westwood later on.

DIOR'S NEW LOOK AND
THE REBIRTH OF PARIS

Fashionwise, the 1950s really started in the 1940s—on February 12, 1947, to be exact, the day that Christian Dior unleashed his now legendary "New Look" collection on a war-weary world that had forgotten all about luxury and in-your-face glamor. Jaws dropped, to say the least.

Ernestine Carter summarized the look in *Harper's Bazaar*: "Arrogantly swinging their vast skirts, the soft shoulders, the tight bodices, the wasp waists, the tiny hats bound on by veils under the chin, they swirled on contemptuously, bowling over ashtrays like ninepins."

"I was conscious of an electric tension," wrote another observer, Bettina Ballard. "We were witness to a revolution in fashion."

Dior called this first collection "Corolla," a botanical term describing the opening of a flower. Compared to the boxy shouldered, male-tailored silhouette of the 1950s, these clothes were indeed soft, flowerlike, and ultra-feminine. There was an arrogance about them as well, a sense of defiance that made this first Dior collection one of the most hotly debated and controversial debuts in fashion history.

To understand the true shock of Dior's proposal, you must consider the times. Paris lay in ruins. There were still shortages, not only of cloth but also of bread and milk, and yet Dior's models were prancing around in dresses that would have cost the average working Parisienne five month's salary.

While post-war regulations in England still stipulated that no more than three yards of cloth could be used to make a skirt, Dior's "New Look" version required tons—estimates range from 25–50 yards of luxury cloth per skirt! British Minister of Trade Stafford Cripps pronounced it "utterly stupid and irresponsible that time, labor, materials, and money should be wasted on these imbecilities," but

British women did not agree. They tore down their air-raid curtains and made them into "New Look" skirts.

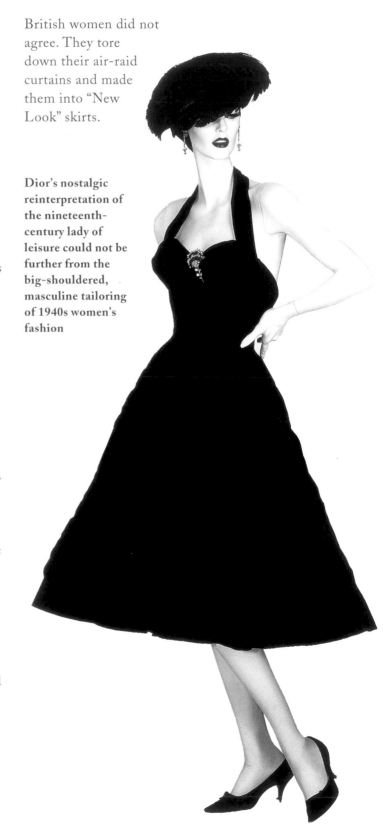

Dior's nostalgic reinterpretation of the nineteenth-century lady of leisure could not be further from the big-shouldered, masculine tailoring of 1940s women's fashion

Dior had been set up in business by Marcel Boussac, a French textile merchant and sometime gambler, who was clearly backing himself when he poured millions of francs into this unknown new designer with a passion for big, cloth-guzzling fashions. Boussac's gamble paid off, as Dior had touched a nerve, capturing a mood, a pent-up yearning for feminine luxury and dressed-up glamor that had, by necessity, gone out of fashion during the war.

While some saw this collection as a triumphant assertion of victory—a sort of phoenix rising from the ashes of war—those still raking around in those ashes were enraged. When Dior tried to stage a fashion shoot in a Montmartre street market, women lining up there for food turned on his models with fury and ripped the clothes right off their backs!

The Americans, with their booming post-war economy and unrestricted access to the materials of mass production, were the first to follow Dior's lead and his influence was felt in both designer and mainstream styles. When Europe got itself up and running again, it too went Dior, and his vision of a stylized, formalized, ladylike femininity went on to define a decade of clothes worldwide.

Dior's "New Look" not only glammed up a war-weary world, it revived the Paris couture industry as well. By the 1950s, Paris was definitely hot again and the excitement centered not only around Dior but his competitors as well. Designers such as Christobal Balenciaga, Jacques Fath, Hubert de Givenchy, and Pierre Balmain basked in the fashion spotlight as Paris regained its pre-war pre-eminence to become the world's fashion arbiter once more.

Balmain was known for his striking "eventful" eveningwear, sometimes encrusted with jewels and embroideries, while Balenciaga eschewed surface decoration in favor of sculptural effects.

Jacques Fath's sexier creations were less stylized or abstract and more body hugging, while Hubert de Givenchy became known for the looser chemise or "sack" dress shape that was popular in the late 1950s.

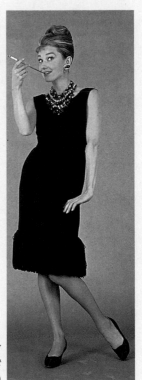

Audrey Hepburn

One of the greatest style icons during the 1950s, Audrey Hepburn changed from a Greenwich Village Beatnik or a boyish gamine into a couture vision of sophistication and refinement with endless ease. Hubert de Givenchy designed much of her wardrobe both on and off the screen, and she remained loyal to him until the end. "It was as though I was born to wear his clothes," she said.

Audrey Hepburn as Holly Golightly in *Breakfast at Tiffany's* (1961)

Balenciaga

Christobal Balenciaga was the only couturier of the 1950s who could do it all: design, cut, fit, and sew an entire garment, a feat helped along by the fact that he was born ambidextrous. His ultra-elegant style celebrated a more severe, less fussy brand of femininity based entirely on the *shape* of his clothing. It is this aspect of his work, his extraordinary ability and vision for dramatic cuts, that is so admired today.

Balenciaga was born the son of a humble Spanish fisherman, but he rose to the very pinnacle of the Paris Couture and his name is still magic for designers, die-hard collectors, or anyone else who just happens to love the best of twentieth-century clothes. Late 1940s and 1950s couture pieces by Balenciaga are sometimes labelled with his mother's name, "EISA."

Name check

Dior, Balenciaga, Balmain, Fath, Givenchy, and Chanel are the most sought-after European designers of the 1950s. American must-haves include Norell (signed Traina-Norell in this period), Claire McCardell, Mainboucher, Pauline Trigère, Galanos, and Charles James.

COUTURE

WHAT IS COUTURE?

After the war, the rich and famous went back to their couturiers and bought some very special, outrageously expensive, limited edition clothing which was then tailored to fit them perfectly. These rare couture pieces are now among the most sought after of all vintage clothing and regularly sell for huge amounts of money at auctions and specialist shops.

The late 1940s through the 1950s is thought of as a real high point for twentieth-century couture, so pieces from this era are especially prized, but how do you spot a couture treasure in a thrift store full of mass produced mediocrities?

Labels are an obvious starting point but they can be remarkably difficult to find on vintage couture pieces. These

This 1950s Jacques Fath couture creation is made entirely of glass beads

labels did not necessarily appear in the inside neck of the garment as most labels tend to today.

If you see a piece that looks good but does not bear an obvious label, turn the garment inside out and examine its side seams, hems, even under the arms. Remember that labels, especially in the 1950s, can be concealed under yards of petticoats and tulle netting, so don't be afraid to root around a bit.

Couture labels usually bear the designer's name and possibly a couture number. Such numbers can either be printed or handwritten in ink, and the customer's handwritten name occasionally appears as well (see photo of a Dior couture label, above).

A piece that is beautifully handsewn, both inside and out, can often indicate something of couture origin, so look for careful, even rows of tiny stitches around button holes, collars, cuffs, and linings.

Vintage pieces with intricate beading and/or embroidery, either couture or otherwise, make a good investment because the sheer detail and artistry of this handiwork would be virtually impossible to reproduce today in anything but the most extravagantly expensive creations. Designer John Galliano has tried to revive the lost art of spectacular decoration in some of his *fin de siècle* couture creations.

Finding couture

Most people imagine that vintage couture clothing can only be found in the finest specialist shops and auction houses in cities like New York or Paris, but this is not strictly true. Fine couture pieces, possibly cast-offs given to maids or cooks, can surface in the most unlikely places—anywhere from jumble sales in Dallas, Texas to street fairs in tiny Provençal villages, so it's always worth keeping an eye out for these vintage gems.

Collecting couture

• Couture can be a joy to wear, especially if you know an expert seamstress who can alter a garment to fit you. Some collectors disapprove of alterations but the choice must be yours. "To wear or not to wear?" That is the question.
• Frustratingly, many women removed designer labels before wearing the clothes.
• Dior's habit of dating his pieces is particularly satisfying for the historically minded. Much of his costume jewelry from the 1940s and 1950s is dated as well.
• The best pieces feature beads and trims that were sewn on individually while cheaper garments were decorated by strips or rows of ready-made, prefabricated embroideries, or beadwork.

Chanel

Accused of sympathizing with the Nazis in occupied Paris, Coco Chanel slunk off to a shadowy exile immediately after the war, but she reappeared in 1954 at the age of 71 and once again made her mark on generations of women.

Rumor has it that blind fury drove Chanel out of her retirement: fury at seeing women once again strangled by constricting corsetry, teetering along on painful spike heels.

She had always defined elegance as simple, comfortable clothing that women could move in easily. Dior's "boned horrors" as she called his dresses and suits, were far from comfortable. Chanel's great contribution to the 1950s was her classic skirt suit made in high quality jersey or tweed, straight cut, knee length, with a gilt chain sewn in the hem of the jacket to give it weight. These suits bear a narrow, lozenge shaped label stamped "Chanel" in black block lettering. The buttons on these suits, most commonly in the form of lions' heads, are often stamped "Chanel" on the reverse and the Chanel company today is very helpful with replacement buttons, even for garments from the 1950s and 1960s.

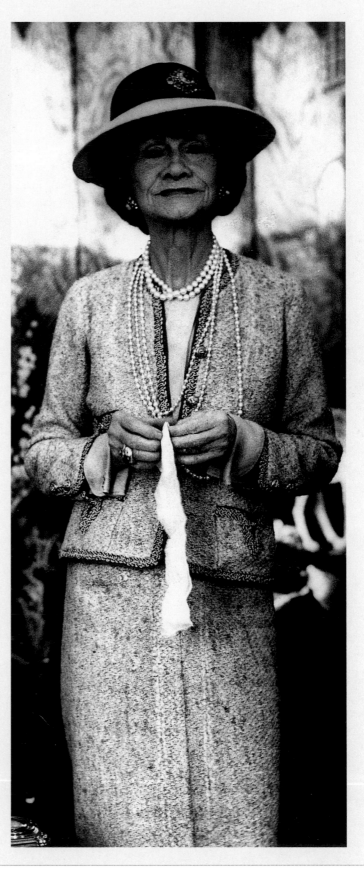

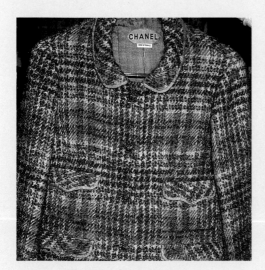

Coco Chanel and one of her suits

THE PARIS LOOK

Couture was only a tiny market even during its heyday in the post-war boom, but the various styles presented by Dior, Balenciaga, Balmain, and Givenchy trickled down from the rarefied atmosphere of their Paris salons to department stores and small town dress shops worldwide. Ordinary middle-class women then reveled in their own, homegrown versions of these rare, handmade originals. By the 1950s, most designers had discovered the joys of licensing, so someone like Dior might sell the exclusive rights to a particular dress to a company such as Saks Fifth Avenue, who would then produce multiples of that garment which they sold as "Dior for Saks." These licensed couture spin-offs can still sell for high prices on the vintage market today if the style and condition are good.

The great bulk of 1950s clothing was mass-produced and this is mainly what we find on our vintage hunts today. The designers of this clothing might be permanent employees with a manufacturer or freelancers working on commission for particular seasons or collections. These mass market spin-offs followed the basic shapes and styles dictated from on high by the Paris superstars and were then popularized by films and fashion magazines.

The post-war economy was booming and facilities once used for the production of bullets and parachutes were turned over to an ever increasing range of retail products. By the 1950s everything from cars to cocktail dresses could be produced with unheard of speed, efficiency and at such low cost that millions could afford to buy into a generous chunk of the good life. Clothes were an obvious expression of this newly emerging middle-class consumer ethos.

LEFT: **A 1950s American hand-painted day dress**

RIGHT: **Opera coats and "dusters" in satin or taffeta are very sought-after today**

With Paris center stage again, it set about dictating styles from on high—and when Paris commanded, most women obeyed! Shop buyers from England and America rushed to Paris season after season to find out what they should be selling in their shops.

Although unprecedented numbers of women had worked during World War II, the average 1950s woman was sold the idea that home, husband, and children were once again her ultimate goal once the war had ended. Perhaps after a short spell in a shop or office, she would settle in to the real business of life as a wife and mother. Women's clothing styles reflected this return to a more stable, traditional role. "Soft," "charming," and "feminine" became advertising buzzwords; themes echoed in the flowery prints, the taffetas, the satins and chiffons, the bows, the flounces, and the frills which are so typical of the 1950s look.

Formality runs through the decade, both for day and eveningwear, and keeping up this ultra groomed, ultra-accessorized, high-maintenance look became a job in itself.

The ongoing developments in wartime technology had a powerful impact on many areas of domestic life during the 1950s. Not only did the general public have to contend with televisions and airplanes, but advances in aniline dyes meant that fabrics could be brighter, as well as colorfast. The decade burst forth in a riot of colors and busy prints. New synthetics like Dacron, Polyester, and Nylon could be laundered at home in washing machines and then drip-dried with ease.

Advances in mass production techniques resulted in standardized garment sizes and, as a consequence, the enormous expansion of the ready-to-wear industry in the 1950s, particularly in America.

The burgeoning middle class of the 1950s migrated to a newly developing suburban landscape where the good life could be enjoyed in spacious, comfortable modern surroundings in this best of all possible worlds. British Prime Minister Harold Macmillan summarized the situation when he said "You've never had it so good."

EVENINGWEAR

The post-war craving for luxurious femininity was nowhere more apparent than in the evening dress of the period. With formality already a firm feature of daytime dressing, something truly over-the-top was needed at night.

Dress shapes were dramatic, in rich sumptuous fabrics set off by long, elbow-length gloves and spectacular costume jewelry.

The mainstream 1950s world was fascinated by the concept of etiquette and the expanding, new middle class looked to these guidelines with relief. This preoccupation with etiquette led to a system of rules that governed all areas of women's dress, especially at night.

Certain fabrics such as satin and brocade were not allowed before 6 p.m and fine distinctions were made between the early evening cocktail dress, the dinner dress, and the more formal theater dress deemed suitable for a nighttime show. The most opulent of all was the full evening dress, centered on the ball gown, which could only be worn after 10 p.m., and only on the most stately occasions.

Deeply cut necklines, along with strapless, backless, and off-the-shoulder styles were popular and worn with fur stoles or satin evening wraps. Loose three-quarter length evening coats in satin or Shantung silk were another option and these are very sought after by today's vintage dressers who stylishly break all the rules and wear them in broad daylight, sometimes even with trousers!

While the 1950s social scene tended to be very structured and formal, dress codes were slightly more relaxed for the "at home" cocktail party, a social phenomenon that really took off with the post-war boom in suburban housing.

Charles James, the Anglo-American couturier, began his career in Paris before establishing himself in New York during the Second World War. His special event ballgowns of heavy silk and satin are a particular favorite and his creations command huge prices at auction today. An expert should value anything you find carrying the Charles James label.

An embroidered and jeweled ball gown by Victor Steibel

COCKTAIL DRESSES

Cocktail dresses were shorter and not nearly as low-cut as dinner or theater dresses, but guests were still expected to wear gloves and hats—although the hostess could get away without them.

Within these basic guidelines, cocktail dresses were made in a variety of shapes and fabrics. Silk, satin, tulle, chiffon, and lace net were favorites of the 1950s. While the "little black dress" established itself at this time as the perennial favorite it remains today, cocktail dresses also came in floral or abstract prints and bright bold colors. Many were jazzed up with bows, beads, and sequins.

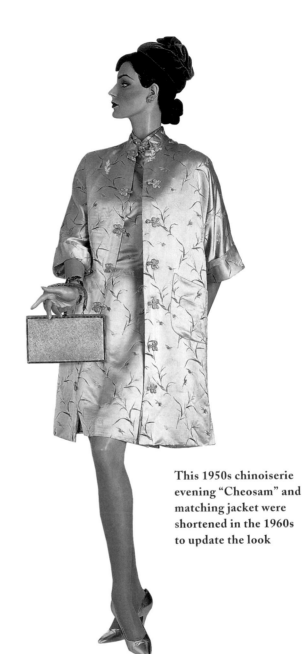

Satin and beaded couture cocktail dress by Jacques Fath

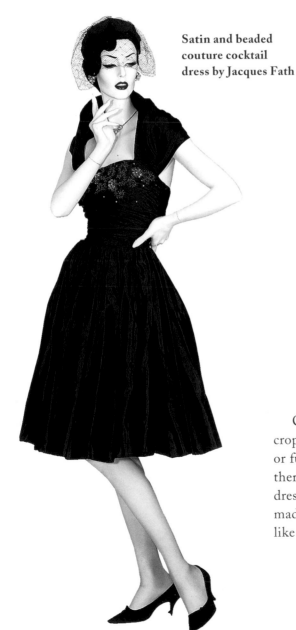

This 1950s chinoiserie evening "Cheosam" and matching jacket were shortened in the 1960s to update the look

Cocktail dresses were often worn with short, cropped bolero-type jackets, little evening cardigans or fur stoles. The Far East look was popular and there was a vogue for satin "Cheosams" Suzy Wong dresses. These tight-fitting dresses were mainly made in Hong Kong and feature chinoiserie motifs like frog closures and oriental embroidery.

THE AGE OF ELEGANCE

The more elegant daytime fashions focused on suits or seriously dressy dresses. Dior was an early enthusiast of "planned obsolescence," the then-radical view that fashion should change very, very rapidly. As a consequence, he introduced completely new dress lines every season. The A-line, the S-line, the H-line, and everything in between appeared and disappeared with bewildering speed. Ready-to-wear manufacturers duplicated these new lines, the copies finding their way into everybody's wardrobe. One season the waist would be featured, then the shoulders and neck, then the legs. This variety of ever-changing shapes and styles suited a consumer culture always hungry for more and more new clothing to buy. Suits were often form-fitting and tailored to draw attention to that vital hourglass shape. Tight-fitting, bodiced dresses with flared crinoline skirts were also a key look in the 1950s, but pencil-slim skirts and waistless sheaths became increasingly popular, dominating the latter part of the decade.

Whatever the line, shape, or silhouette, however, a hat and gloves were required even for daytime dressiness, along with a careful selection of costume jewelry and, of course, an appropriate handbag. This fully accessorized, dressed-up look was deemed necessary for shopping or lunching in town, with the more casual "shirtwaister" dress reserved for cooking and housework.

American handpainted day dress

American raffia and wool day dress by Montaldo's

CASUAL DAYWEAR

These "at home" shirtwaisters can be found in the most wonderful cotton prints with typical 1950s motifs. They're still quite inexpensive in vintage stores so it's well worth snapping them up before they disappear.

In the affluent climate of the 1950s, leisure in the form of holidays, outings, and sports became a bigger priority in most people's lives, requiring new, "resort styles" of clothing. Halterneck sundresses in cheerful cotton prints were popular, along with playsuits or rompers. These usually took the form of a midriff-baring top with matching bloomer shorts or Capri pants. Jeans were strictly reserved for teenagers and non-conformists, but calf-length, form-fitting Capris, as popularized by Italian films, found their way into most women's wardrobes, though they were worn only on the most casual occasions.

American cotton halterneck dress with applied glitter

Early 1950s Pucci blouse and raffia beach skirt, embroidered with real shells

The ideal female of the early 1950s was swathed in fragile taffeta and layers of lace and net, bowed and beribboned like a package ready to be unwrapped.

COLLECTIBLE CARDIGANS
DAY INTO EVENING

The late 1990s witnessed a revival in knitwear based on the pretty, girly cardigan. Cashmere, angora, and plain wool versions appeared on the catwalks and in the high street.

The 1950s were an absolute cornucopia of collectible cardigans and then, as now, these little beauties were incredibly versatile. Dressy daytime styles centered around the lightweight cardigan or twin-set (a cardigan sold with a matching or contrasting and often sleeveless shell to be worn underneath). Both twin-sets and cardigans were usually accessorized with a simple strand of pearls or sometimes a small scattering of sweater pins.

Many cardigans came in solid colors but floral, argyle, and other patterns were made as well. Even the somewhat plain ones often have subtle and attractive details, such as tiny pearl buttons, satin piping, or lovely silk linings.

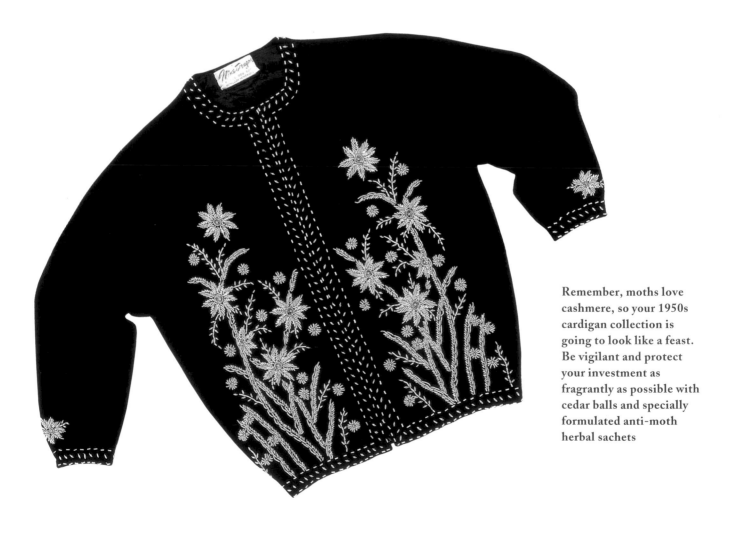

Remember, moths love cashmere, so your 1950s cardigan collection is going to look like a feast. Be vigilant and protect your investment as fragrantly as possible with cedar balls and specially formulated anti-moth herbal sachets

The American couturier and designer Mainboucher is credited with bringing the daytime cardigan into nighttime dressing

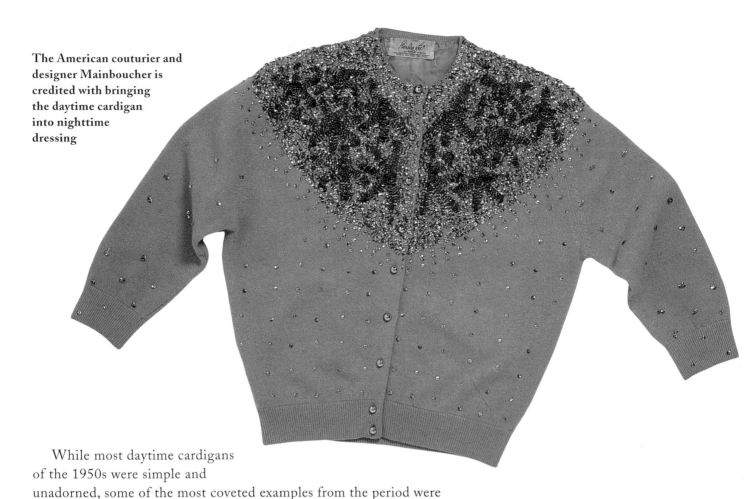

While most daytime cardigans of the 1950s were simple and unadorned, some of the most coveted examples from the period were decorated with applied lace, embroidery, appliqués, rhinestones, beads, or sequins. These were meant to be worn in the evening over a cocktail dress or with a long evening skirt in satin or Shantung silk. Today's vintage dressers wear them very stylishly with everything from jeans to strappy little slip dresses.

The value of a vintage cardigan is not necessarily determined by who made it, but by how attractively and intricately it is decorated. Many fine top price examples bear a label that states only the name of the particular shop or department store where it was sold, so you're on your own when it comes to deciding whether or not a particular vintage cardigan is worth the money. Just remember that detailed decoration like this is virtually impossible today, even in the Third World sweat shops where most modern reproductions are made. Besides, a vintage cardigan makes both a good investment and puts a unique twist on this fashion trend.

Helen Bond Carruthers made some of the most beautiful decorated cardigans of the 1950s. These are usually cropped bolero-style with her label in the waistband. Prices are already sky-high, so it is worth keeping an eye out for this label

CASUAL TEENAGER

Casual separates were the preserve of the 1950s teenager. Many may have based their dressier looks on their mother's grown-up style, but a teenager's day-to-day wardrobe evolved along very different lines.

It is often said that the teenager was "invented" in the 1950s, emerging as a distinct group during this decade. The widespread affluence of the period meant that most working teenagers could keep and spend their own money rather than contributing to the family's upkeep as many had in the past. These young, big spenders were quick to vote with their wallets. A whole new category of "teen fashion" appeared and slowly, over the course of the decade, teenagers learned to choose and buy their own identifying looks.

Rock 'n' roll set the pace for these new teen styles, many of which were worn for dancing. The circle skirt became widely popular, looking particularly good in motion and allowing girls to move easily. The waist of this style of skirt is cut out of a large circle of felt or cotton, then handpainted and decorated with glitter or sequins. They were then worn with lots of crinoline underneath to give them fullness.

Enormous "waspie" style belts emphasized the tiny waists of the 1950s hourglass shape.

The poodle circle skirt and pretty cardigan were staples for teenagers in the 1950s—especially in the United States

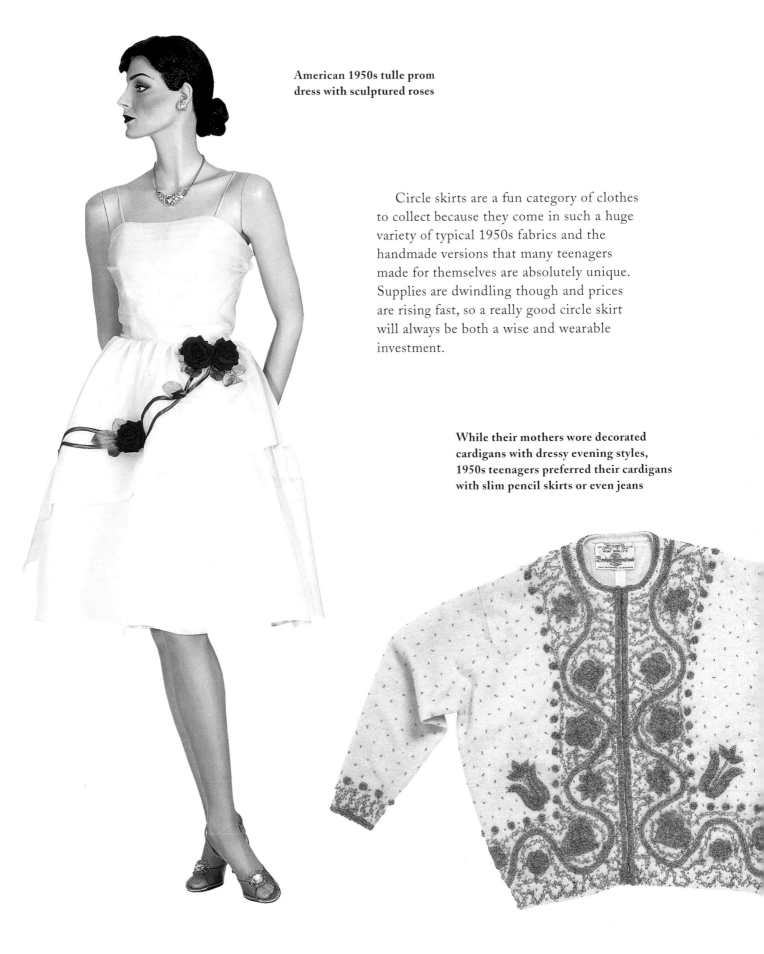

American 1950s tulle prom dress with sculptured roses

Circle skirts are a fun category of clothes to collect because they come in such a huge variety of typical 1950s fabrics and the handmade versions that many teenagers made for themselves are absolutely unique. Supplies are dwindling though and prices are rising fast, so a really good circle skirt will always be both a wise and wearable investment.

While their mothers wore decorated cardigans with dressy evening styles, 1950s teenagers preferred their cardigans with slim pencil skirts or even jeans

COUNTERCULTURE

The world of the 1950s, for all its affluence and optimism, was frightening, a Cold War cocktail of McCarthy witch hunts, atomic bombs, and the stirrings of extreme racial and social tension.

The Beatniks, meanwhile, hung out in coffeehouses on the Left Bank in Paris or Greenwich Village in New York, discussing the situation. Some were "dropping out" ten years before "dropping out" became really trendy. There were rumblings of a rougher, less intellectual sort as well, a general dissatisfaction with the grown-up, middle-class, consumer-oriented society. The rebellious strains of rock 'n' roll became increasingly popular throughout the decade. Films like Marlon Brando's *The Wild Ones* and James Dean's *Rebel Without a Cause* lodged their own form of protest, provoking teenagers worldwide to believe in their age group as a distinct entity, erupting with the "youthquake" of the 1960s.

The various counterculture tribes of the 1950s shared a sense of dissatisfaction with the status quo, as reflected by the working stiff, the man in the grey flannel suit with his 2.5 children and overdressed wife. For all their grumbling about conformist society, however, these rebels inspired strict conformity to their own dress codes. Fashion became the vital badge to distinguish the "square" from the seriously cool.

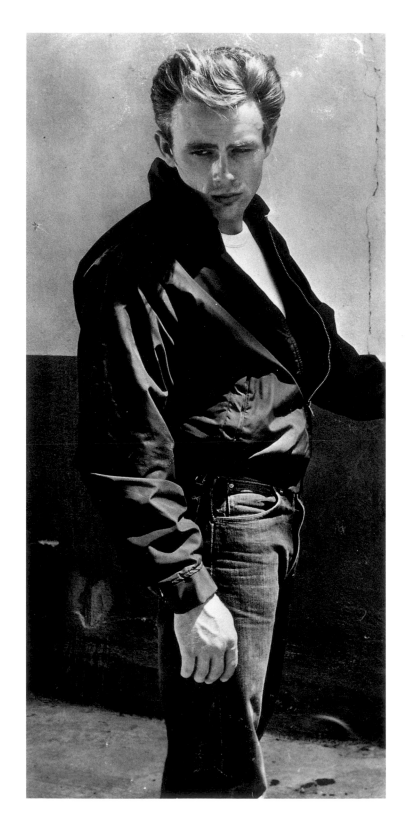

James Dean became an icon of teenage existential angst. Lonely, mixed-up, inarticulate, angry, and, most of all, cool

Beatniks turned their backs on the white, middle-class Establishment and looked to poetry, jazz, and Jean-Paul Sartre instead

The "Big E"

If you see someone enter a thrift store and make a frantic beeline for the denim racks, then you've probably spotted a "Big E" hunter on the trail of vintage Levi's and other vintage jeans. Examples from the 1950s and earlier are worth big money today—hundreds, even thousands of dollars— but you've really got to know your denim. There are many fine distinctions between the worthless, the valuable, and the extremely valuable. There is one shortcut rule, at least with Levi's. If the tag is printed entirely in capital letters then the jeans were made before 1971. If the "e" in Levi's is lowercase, however, then they were made sometime after that year.

Rockers went for jeans, T-shirts, and black leather jackets, while English "teddy boys," with their brothel creeper shoes and Edwardian-style suits, favored a more high-maintenance look. Rock chicks squeezed themselves into tight sweaters and even tighter trousers nipped in by wide, wasp waister elastic belts. The look was completed by messy, teased, "just rolled out of bed" hairstyles and spike-heeled mules.

The Beatnik look was based on black, black, and more black! Figure hugging turtlenecks were popular but oversized "sloppy Joe" sweaters were another option, both worn over close fitting trousers with flat ballet-style shoes. Dressy accessories were strictly for "squares." Beatnik girls banished these from their spare intellectual look and opted instead for a nice dark pair of Italian sunglasses or the ever-popular existentialist Left Bank beret.

UNDERWEAR

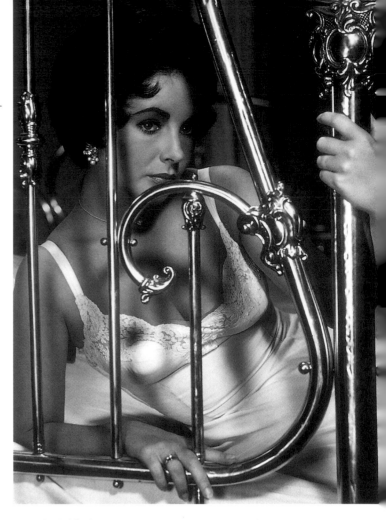

Elizabeth Taylor in *Cat on a Hot Tin Roof*, 1958

UNDERCOVER STORY

As the trend toward "underwear as outerwear" took hold in the 1990s, edgier members of the fashion pack went to great lengths to break down this last vintage taboo. Corsets, bullet bras, camiknickers, and slips from the 1950s moved from the shadowy back rooms of vintage clothing stores and thrift shops into the fashion limelight.

The legendary couturier, Paul Poiret, controversially dismissed the corset in the early part of the twentieth century and the next generation of designers like Chanel and Schiaparelli followed his lead. The corset was well and truly obsolete by the mid-1920s and stayed that way until Dior rediscovered it as a means to achieving that tiny, cinched-in waistline so vital to his New Look.

"Without foundations," Dior said, "there can be no fashion." But luckily, these corsets didn't have to be quite so suffocating, thanks to new post-war materials like nylon and "power net" that promised a two- or three-way stretch.

Foundation garments made of these new materials were not only more elastic than the old canvas types, they did not require whalebone stays to keep their shape. A woman could now pull or roll on a corset up over her own body rather than depend on a relative or maid to lace her from the rear.

Given fanciful names like "Romance," "Pink Champagne," and "Merry Widow," the 1950s corset was designed to be a pretty, all-in-one, long line garment with panels of net lace, a strapless push-up bra, and satin suspenders to hold up a woman's stockings in this last decade before the invention of tights.

Shockingly, Dior designed evening skirts with matched cropped jackets that were to be worn with the upper portion of

Part of the eroticism of the 1950s lay in the knowledge that there were layers of complicated clothing to get through not just on the surface, but underneath as well. Women were like packages to unwrap.

the corset exposed. Most expensive dresses and suits, and certainly most couture pieces from the 1950s, have built-in corsetry complete with a padded bra and old-fashioned boning at the waist and bust.

Along with the nineteenth-century corset, the stiffened petticoat or crinoline returned as well, a bit shorter this time but just as full. Teenagers bought crinolines as separates to wear with circle skirts, while society women sported Dior originals that came with slips and net petticoats permanently sewn in as part of the dress. Many of these fabulous 1950s crinolined creations were so stiff and full that some dresses can actually stand up on their own.

Integral interior architecture such as sewn-in slips or corsetry suggests that a vintage

dress or suit dates from the 1950s and was probably expensive in its day.

Pop singer Madonna, dressed by French designer Jean-Paul Gaultier in the late 1980s and early 1990s, was one of the first to bring underwear as outerwear to the public's attention. She and Gaultier not only revived the corset, they also brought back the 1950s bullet bra.

These circular, stitched, cone bras gave that pointy, insistent look that put a sexy twist on those otherwise demure cardigans and twinsets that were suddenly so popular in the 1950s.

Big breasts were definitely popular in the 1950s and if you weren't born with Jayne Mansfield's eye-popping 42DDs, no problem. This was the era of "lift and separate" and a wide range of new bras were on offer to do just that. The first padded bras appeared at this time, promising to "enhance" and "mold." Eccentric millionaire Howard Hughes figured out a way to lift it all up, for those who already had more than enough. Hughes developed the "cantilevered" bra for his girlfriend, RKO star Jane Russell, based on the same technology used for suspension bridges, and a whole generation of wired push-ups was launched.

Modern copies of 1950s nylon full and half-slips appeared on catwalks all over the world in the later 1990s and these became the cornerstones of a *fin de siècle* outerwear wardrobe. The originals came in a wide variety of solid colors and prints and were often decorated with ribbons, frills, or lace trims. Slips and slip dresses from the 1950s are real retro bargains and appear in thrift shops and yard sales all the time. They are not only cheaper than modern reproductions but totally unique as well.

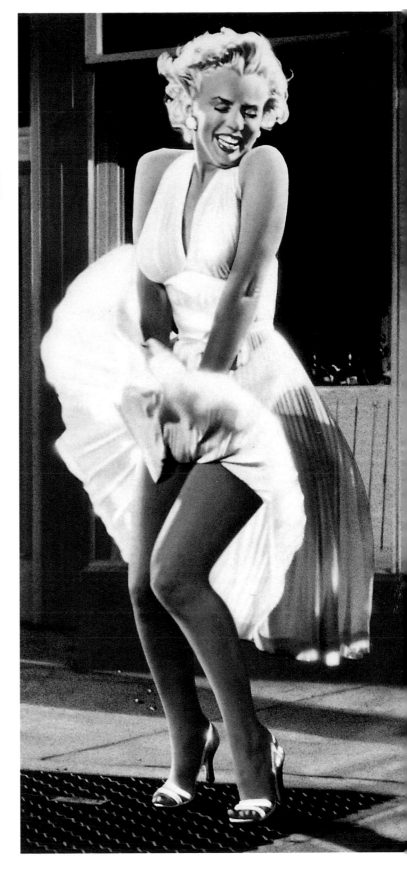

Marilyn Monroe in *The Seven Year Itch*, 1955

ACCESSORIES

The Age of Elegance emphasized attention to detail, so appropriate accessories were essential—even the most casual styles came with loads of "extras." Handbags, costume jewelry, hats, gloves, and shoes provided those perfect finishing touches. In the post-war climate of luxurious, indulgent fashion, accessories flourished. Shops and designers were only too happy to dress women of the 1950s from hat to hem.

The 1950s represented a golden age in handbag design. Styles were many and varied, from the sophisticated sangfroid of the envelope bag through the chunky, clunky Bakelite box to the wildest excesses of 1950s kitsch. There was no such thing as too many handbags and the average woman bought lots. Many brilliant examples survive from the decade and can be snapped up for a pittance at your average flea market—or secured for much, much more in the show-rooms at Christie's and Sotheby's!

Understated leather classics like the Hermès "Kelly bag" and the slightly more glitzy Chanel "2.55" appealed to the conservative post-war woman looking for a little glamor. Alligator, crocodile, or lizard skin bags were also popular, sold in famous jewelry shops like Asprey or Cartier. Black and brown were key shades in reptile skin and these handbags often came with matching high-heeled pumps.

Vintage leather bags and accessories from famous makers already command high prices, so thrifty finds in these categories are always serendipitous!

American 1950s beaded and embroidered day bag

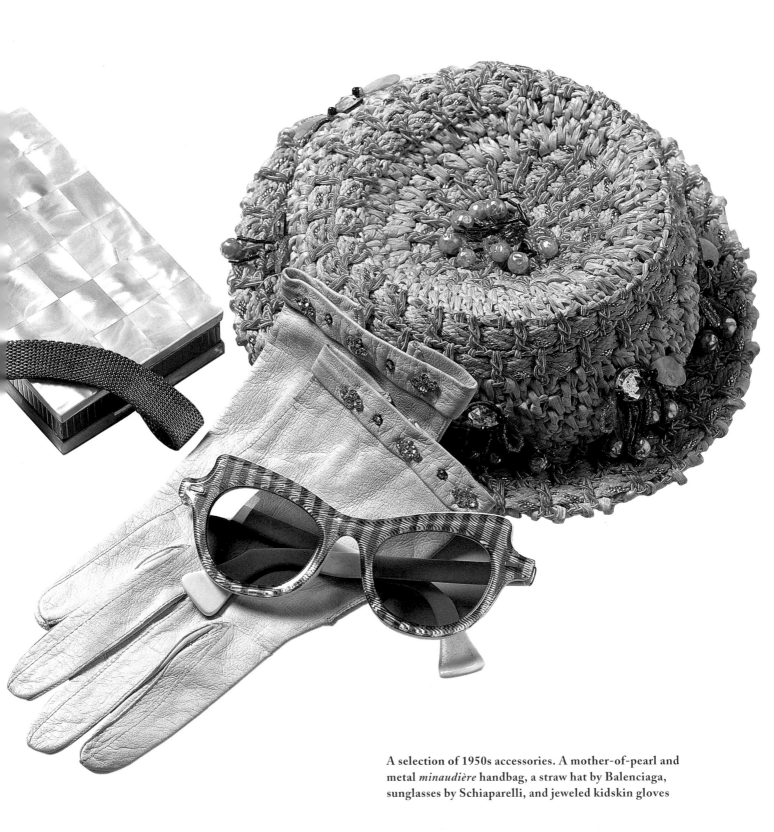

A selection of 1950s accessories. A mother-of-pearl and metal *minaudière* handbag, a straw hat by Balenciaga, sunglasses by Schiaparelli, and jeweled kidskin gloves

HANDBAGS

Informal occasions called for sportier, more casual handbags and the 1950s saw a profusion of lighthearted, highly decorated boxes and baskets in all sorts of unusual materials. Plastic, raffia, carpet brocade, straw, wood, metal, Bakelite, and Perspex were used as bases and then spruced up with anything from beads to faux jewels, handpainted scenes, plastic fruit, shells, ribbons, sequins, and glitter.

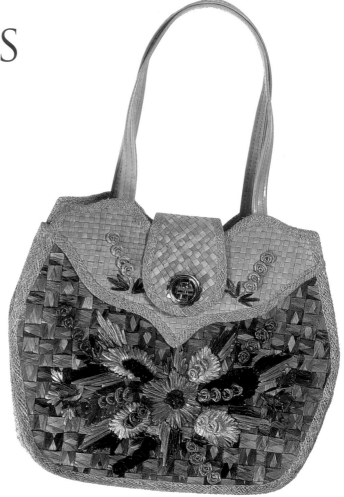

Even trips to the beach were a formal affair in the 1950s

These casual bags often centered on favorite 1950s motifs such as French poodles, Harlequins, Parisienne street life scenes, ballerinas, and sea life.

There was a craze for Bakelite and Lucite box bags made by American manufacturers in New York and Florida. They could cost as much as $50 in their day—a huge sum then—and these are highly sought-after items among collectors of vintage accessories.

American decorated cloth bag

The post-war spirit of technical innovation found expression in quirky handbag gadgetry. Styles appeared with inset detachable watches, matching clip-on umbrellas, and even a battery-operated interior lighting system that enabled a woman to find her way around her bag in the dark!

The amazing individuality and sheer craziness of some of these handbags makes them extremely popular with celebrities, fashion stylists, and vintage lovers worldwide. Numbers are dwindling so it's always worth stretching to buy really good examples from this period.

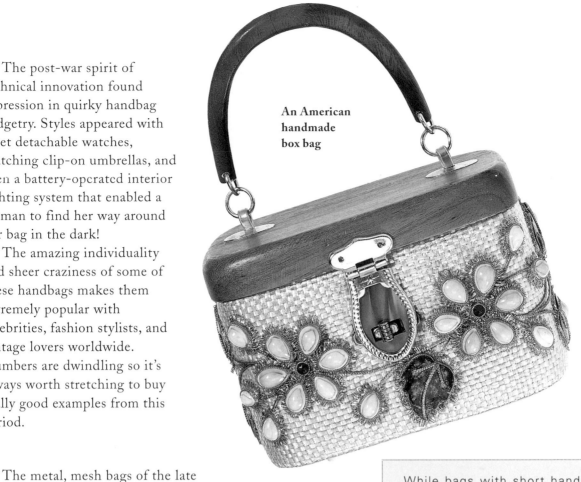

An American handmade box bag

The metal, mesh bags of the late nineteenth and earlier twentieth centuries enjoyed a popular revival in the 1950s. Tiny metal discs create an overall chain mail effect. The American firm Whiting and Davis made the best of these, signing their bags on the clasps.

While bags with short handles ruled the day in the 1950s, evening styles came in the form of envelopes or clutches.

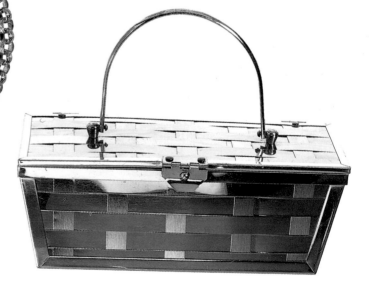

ABOVE: **A 1950s woven metal bag**

LEFT: **A chain mail metallic bag by the American firm Whiting and Davis**

THE "KELLY" BAG

The Hermès "Kelly bag" was a 1950s high-class classic. It was inspired, like the Chanel "2.55," by the equestrian world as a fashionable take on the traditional saddlebag used for riding. The design dated back to the 1930s and was known then as the "sac haut courroies." When Grace Kelly appeared in *Life* magazine in 1956 carrying a large version of the Hermès classic, reportedly to hide her pregnant tummy, the bag was then renamed the "Kelly bag."

Kelly bags enjoyed a huge revival in the 1990s and Hermès operates a six-month waiting list for new orders. Vintage examples command serious prices at auctions, while finding a bargain in a flea market or thrift store is tantamount to hitting the vintage jackpot! These bags, with their handmade, handstitched, super high quality, will always be a sound investment, even when purchased for a high price at a top vintage outlet.

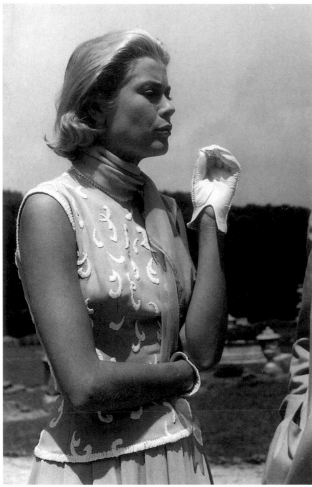

Grace Kelly was a vision of 1950s sophistication

It takes about 13 hours and 2,600 hand stitches to make a Kelly bag today.

A specially commissioned Kelly bag of alligator skin sold for about $30,000 in the late 1990s.

1950s Kelly bags were made mostly of calfskin, but they were also available in ostrich, lizard, and crocodile

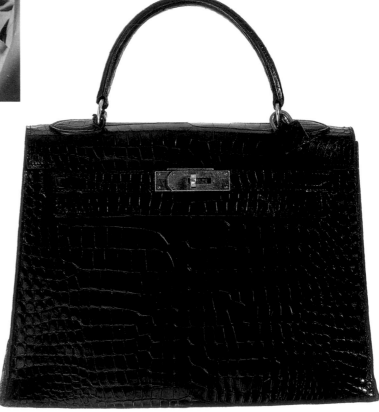

THE CHANEL "2.55" BAG

Love it or loathe it, the Chanel "2.55" handbag has become a twentieth-century fashion icon. It was christened in honor of the date of its conception (February 1955) and became a hallmark of Chanel's post-war resurrection. Quilting was the big feature here, either quilted leather or jersey, handstitched over a padded base in the manner of the "puffa-style" jackets favored both then and now by the horsey set in Britain.

As a former lover of the Duke of Westminster and a self-confessed Anglophile all around, it's not surprising that this most famous of Chanel's designs was heavily influenced by British tradition. It is ironic though, that the "2.55" remained quietly in the background for decades, a symbol of soft-spoken, low-key elegance, until it shot to brash superstardom during the feeding frenzy for designer logos of the 1980s. It then became the ultimate status symbol, so popular in fact that thousands of counterfeit "2.55"s flooded the market during that same decade and well into the 1990s. Watch out for fakes.

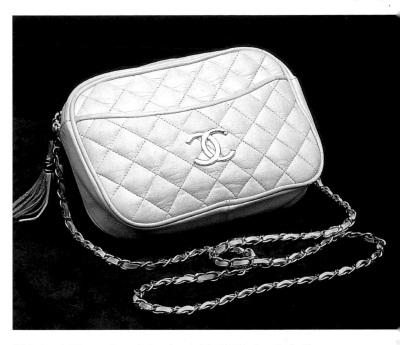

This is a 1980s version of the classic "2.55." Its braided gilt shoulder strap was an anomaly in the 1950s when most bags came in envelope, clutch, or short-handled styles that monopolized the wearer's hand or arm. Freedom of movement, though, was always a golden rule for Chanel style

Bakelite and Lucite bags

The ultramodern feel of Bakelite and Lucite bags appealed to a forward-looking 1950s world obsessed with progress and modernity. Styles might be carved, enlivened by metal strips or jewels, painted, or embedded with glitter. The heavier, chunkier examples tend to be more valuable today and it's especially nice if a bag retains its original adhesive maker's label inside.

Always open a Bakelite bag to smell it before making the purchase. Don't put your money down if the bag exudes a strong, tart, chemical smell. The foul odor indicates the bag has been improperly manufactured or stored and is entering an irreversible process of deterioration. It will shortly end up spiderwebbed with cracks. A bag that smells okay on the day will probably remain that way unless it is exposed to extremes of heat or long bouts of direct sunlight. Remember: the nose knows!

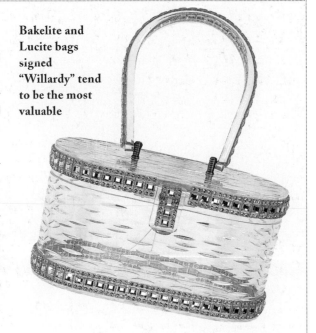

Bakelite and Lucite bags signed "Willardy" tend to be the most valuable

COSTUME JEWELRY

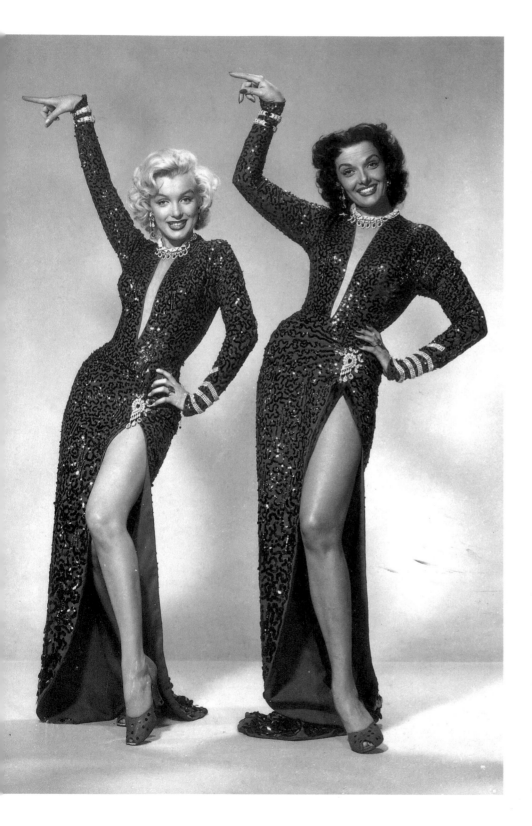

In *Gentlemen Prefer Blondes*, the film hit from the mid-1950s, Marilyn Monroe decided that "diamonds are a girl's best friend," but the rocks in the film—like most of the gems that sparkled their way through post-war fashion —weren't actually the real thing at all.

Once wartime restrictions on base metals and paste stones were finally lifted, the 1950s became an Aladdin's cave of fabulous fake jewelry.

The great opulence of the era was epitomized by its eveningwear, as seen in the showy, theatrical creations of designers and manufacturers like Dior, Schiaparelli, Kramer, Trifari, and Haskell.

Glitz was at such a premium that metalwork was often only used as a vehicle for displaying as many paste stones as could possibly be crammed on to one piece of jewelry and the little black dress was the perfect foil for all this costume drama.

LEFT: **Marilyn Monroe and Jane Russell show off their jewelry in a still for *Gentlemen Prefer Blondes***

OPPOSITE: **A 1950s paste necklace by Christian Dior**

Many jewelry styles were produced as "parures" (a matched set of necklace, bracelet, brooch, and earrings) and it's always exciting to find an original, intact parure at a flea market or auction.

Casual and daytime clothes inspired a range of simpler costume jewelry as well. Plain gilt pieces, pearls and tiny, often figural pins were worn, especially on cardigans. These styles were produced most commonly as separates rather than the more formal parures popular for eveningwear.

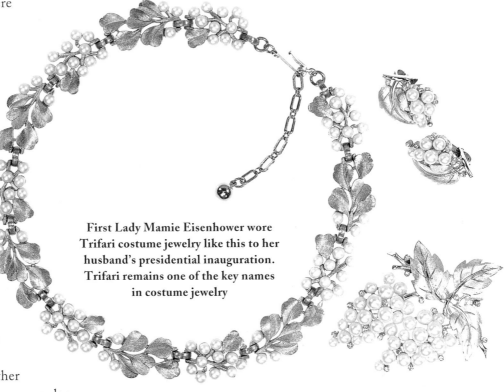

First Lady Mamie Eisenhower wore Trifari costume jewelry like this to her husband's presidential inauguration. Trifari remains one of the key names in costume jewelry

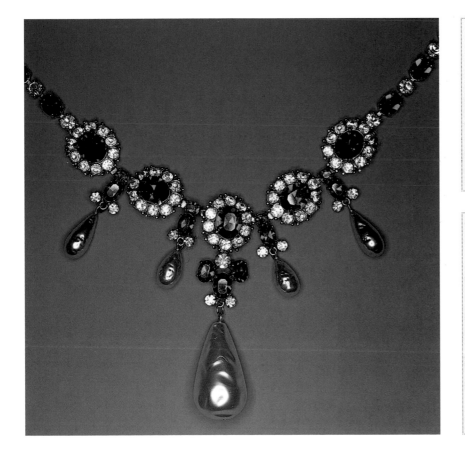

Don't soak your costume jewelry—moisture can loosen stones! Try cleaning the surfaces of your favorite pieces with a bit of window cleaner sprayed on the end of a cotton ball.

The U.S. takes the lead

Thanks to its war-honed mass-production facilities and an influx of super talented refugees from the European fine jewelry trade during the course of the war, the United States led the way in costume jewelry and exported its style all over the world.

Miriam Haskell

American designer Miriam Haskell produced some of the most beautiful and collectible of all twentieth-century costume jewelry. Her distinctive look was based on fragile clusters of tiny faux seed pearls handwired in intricate floral, shell, and leaflike patterns. She rarely used smooth pearls, preferring to copy the more unusual, bumpy, and irregularly shaped ones known as baroque pearls. Haskell metalwork—described as "antique Russian gold"—had a soft, honey-colored, matte finish that made it equally appropriate for both day and eveningwear.

Though Haskell first developed her signature look in the 1930s and 1940s, Haskell jewelry really didn't take off until the 1950s so much of what is unearthed and collected by enthusiasts today actually dates from this post-war period.

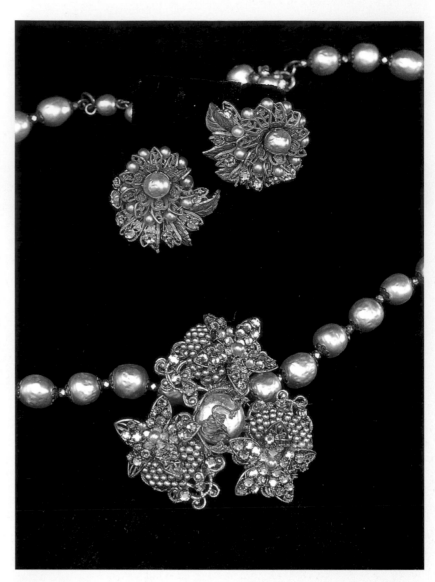

Necklace and earrings by American designer
Miriam Haskell

Costume jewelry marks or "signatures" can appear on an earring or brooch back, on a catch, or more sneakily, on the inside of a catch or clasp. These marks usually take the form of full manufacturers' or designers' names rather than the more cryptic initials and hallmarks that were used to identify precious jewelry

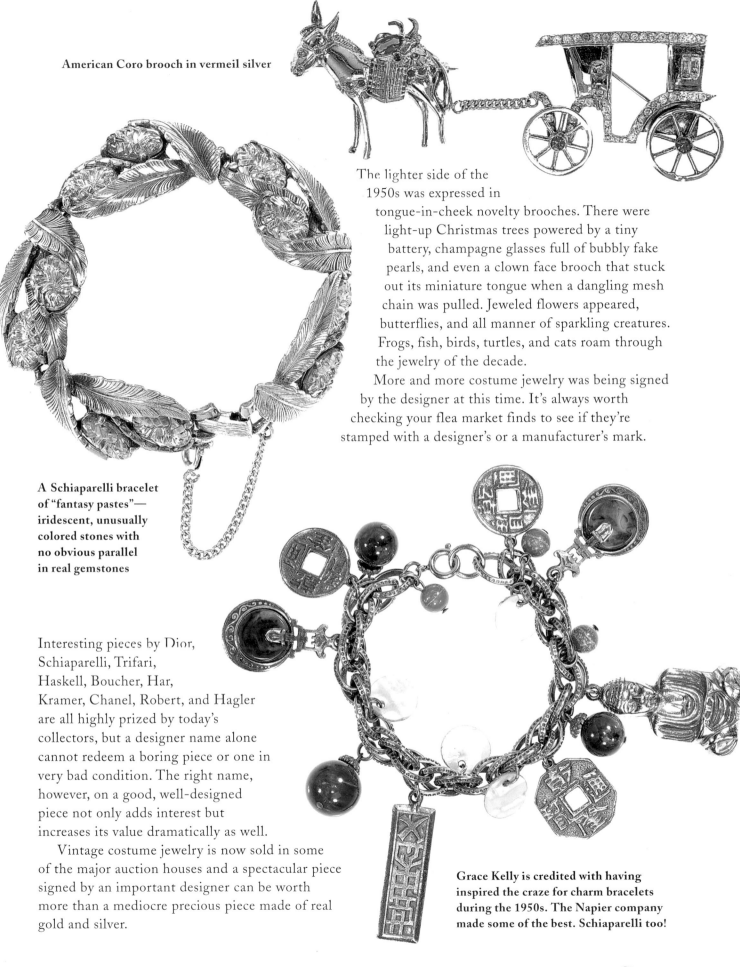

American Coro brooch in vermeil silver

The lighter side of the 1950s was expressed in tongue-in-cheek novelty brooches. There were light-up Christmas trees powered by a tiny battery, champagne glasses full of bubbly fake pearls, and even a clown face brooch that stuck out its miniature tongue when a dangling mesh chain was pulled. Jeweled flowers appeared, butterflies, and all manner of sparkling creatures. Frogs, fish, birds, turtles, and cats roam through the jewelry of the decade.

More and more costume jewelry was being signed by the designer at this time. It's always worth checking your flea market finds to see if they're stamped with a designer's or a manufacturer's mark.

A Schiaparelli bracelet of "fantasy pastes"—iridescent, unusually colored stones with no obvious parallel in real gemstones

Interesting pieces by Dior, Schiaparelli, Trifari, Haskell, Boucher, Har, Kramer, Chanel, Robert, and Hagler are all highly prized by today's collectors, but a designer name alone cannot redeem a boring piece or one in very bad condition. The right name, however, on a good, well-designed piece not only adds interest but increases its value dramatically as well.

Vintage costume jewelry is now sold in some of the major auction houses and a spectacular piece signed by an important designer can be worth more than a mediocre precious piece made of real gold and silver.

Grace Kelly is credited with having inspired the craze for charm bracelets during the 1950s. The Napier company made some of the best. Schiaparelli too!

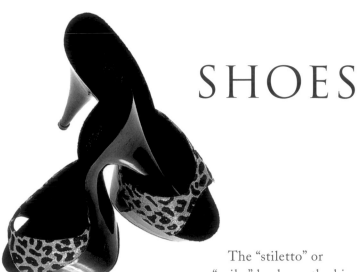

SHOES

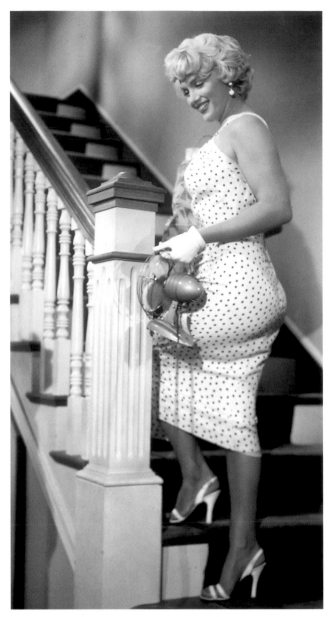

Marilyn Monroe in *The Seven Year Itch*, 1955

The "stiletto" or "spike" heel was the big footwear story of the 1950s, developed simultaneously by legendary shoe designers Salvatore Ferragamo in Italy and Roger Vivier in Paris. The aptly named stiletto was actually a metal spike embedded in plastic. It was tall and incredibly slim but strong enough to support the wearer's weight without breaking.

Though the shoe was strong, the human ankle was not. Doctors complained about a spate of physical injuries caused by these new, dangerous shoes. They wreaked havoc not only on the wearer but on her surroundings as well. Stilettos were summarily banned from airplanes, dance floors, and some public buildings in response to the divots they left in unsuspecting surfaces. Men loved them and women refused to give them up—their highly erotic appeal perhaps fueled by the danger associated with wearing them? Spike heels continued to be wildly popular in the 1950s, with both the fuller style of the earlier New Look and the later, slimmer silhouette of the pencil skirt and push-up bra.

Gold spikes were a favorite for eveningwear, along with leopard skin, Lucite, brocade, and floral print. Matching stiletto and handbag combinations were also popular.

A dress can be altered, a coat or cardigan can fit acceptably over several sizes, but with stilettos, it's sadly a case of "if the shoe fits... ." If it doesn't, you can't. As a consequence, shoes of the finest quality and condition tend to be highly undervalued even in top vintage stores. If you're lucky enough to fit in them or else care to snap up a pair for the sheer fun and interest of owning them, spectacular shoes are among the greatest vintage bargains to be found.

Film star Marilyn Monroe popularized the younger, sexier side of 1950s glamour girl style, with voluptuous curves and an infamous, wiggily walk. She claimed to have achieved her signature step by sawing off a bit of stiletto heel from one of each pair of shoes that she owned.

"I don't know who invented the high heel," she said, "but all women owe him a lot."

OPPOSITE: **Model Jean Marsh illustrates the hazards of the stiletto heel**

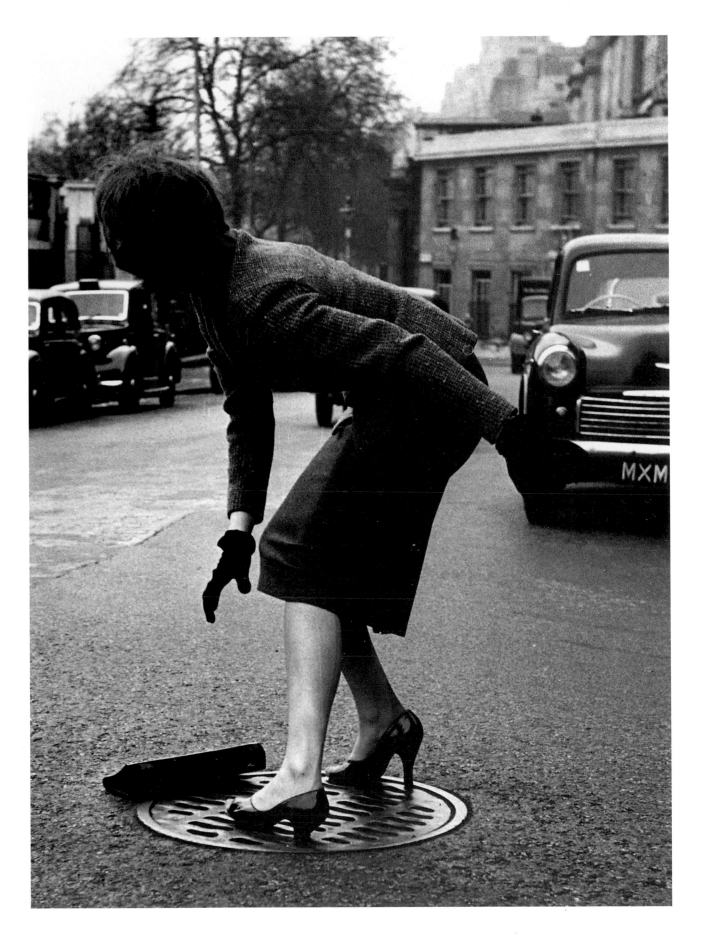

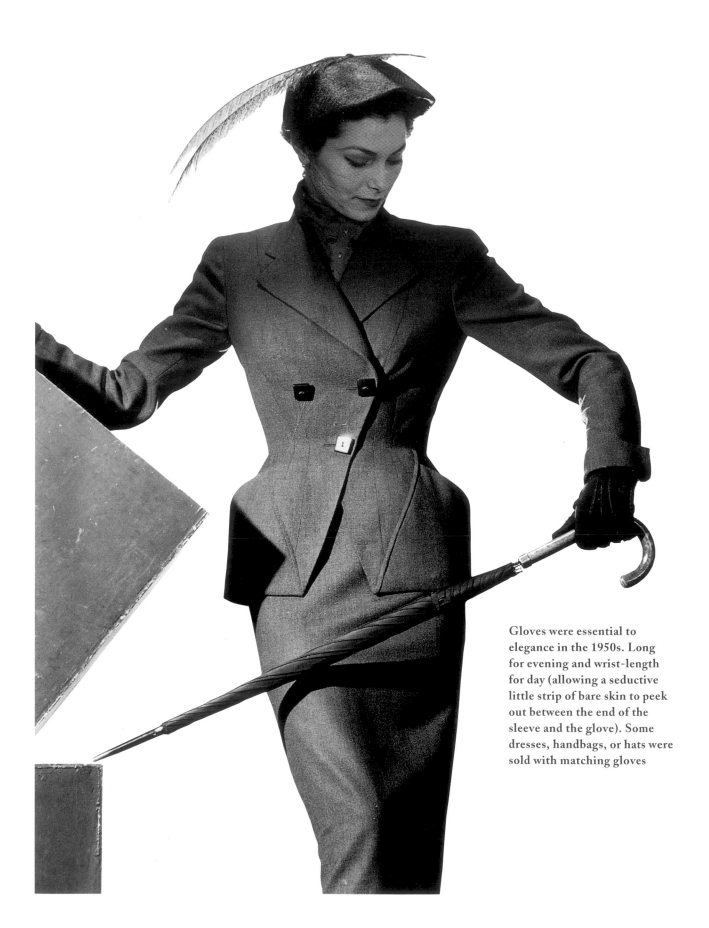

Gloves were essential to
elegance in the 1950s. Long
for evening and wrist-length
for day (allowing a seductive
little strip of bare skin to peek
out between the end of the
sleeve and the glove). Some
dresses, handbags, or hats were
sold with matching gloves

HATS

Interesting hats by famous designers like Dior and Schiaparelli can also be bought very cheaply, even in the swanky showrooms of famous auction houses where they're often sold in large job lots. Hats from the 1950s are difficult to wear today, hence the give-away prices, but they look fantastic grouped on walls or displayed individually on a hat or wig stand.

During the early and mid-1950s, when formality was still the rule, there was a hat for every dress and suit—from the clever little toque to the wide-brimmed picture hat and everything in between. Hats came in straw, cloth, felt, even plastic and were decorated with feathers, flowers, beads, or sequins.

Real hat connoisseurs love the work of Bes Ben of Chicago, a purveyor of some of the most outrageous tongue-in-cheek surrealism in 1950s fashion. They produced a giant black, beaded spider with its legs clamped to the wearer's head, a hat in the shape of a beehive and even a skullcap encrusted with tiny mother-of-pearl clocks.

As bouffant hairstyles took over later in the decade, hats faded away and have not been revived with the same enthusiasm since.

Hair and make-up

Women's hair tended to be worn just above the shoulder and was usually waved or curled. Thanks to the new hair sprays, complicated waves and curls could be kept firmly under control. Longer ponytails were popular with teenage girls while sophisticated grown-ups went for sleek chignons, especially for evening. Home dyeing was big business in the 1950s but the results were often quite harsh.

Makeup in the 1950s was much more obvious and artificial than we're used to today, with dramatic eye shadow and liner, sculptured, heavily tweezed and penciled eyebrows and "pancake" thick foundation.

Key 1950s motifs

French poodles
Masks
Ballet
Paris scenes
Hawaii
Harlequins
Mexico
Fish
Venetian scenes
Shells
Very politically incorrect ethnic stereotypes
Atomic scientific-looking squiggles
Playing cards

These motifs appear on handbags, scarves, jewelry, and fabrics and their appearance suggests that a piece dates from the 1950s. Because these motifs are so quintessentially 1950s, die-hard collectors love them.

"THE DIFFERENT DRUMMER" 24"x36" POSTER
COURTESY HANSON GALLERIES, BEVERLY HILLS
& ACCESS GALLERY, NYC © PETER MAX 1989
SIGNATURE SERIES

THE 1960s

Youthquake — from the Mini to the Maxi and Back Again

"Wow! Explode! The Sixties. It came to life in a pure exaggerated, crazed out, wham, wham, and wow way! The Beatles, Hendrix, Joplin, the Velvet Underground, all exploding so wonderfully."

Betsey Johnson, *Pop Fashion Designer*

From the mini-skirted Chelsea girl to the spaced out California hippie of the Summer of Love, the 1960s was a BIG decade in the world of fashion. For the first time in history, young people found a voice and a platform to develop their own culture and style. Their revolution reversed the age-old fashion flow.

"I love vulgarity. Good taste is death, vulgarity is life."
Mary Quant

"Kill the Couture," shouted young French designer Emanuel Ungaro but he needn't have bothered—couture was already dead, replaced by the young, daring, even outrageous street-style clothes that characterized the decade. With the advent of the pill in 1961, clothes just kept getting sexier—to the absolute horror of the Old Guard.

The earliest phase detonated in London, ushered in by Mary Quant who spoke for a generation when she said, "Adult appearance was very unattractive to us. Alarming and terrifying, stilted, confined and ugly."

Although Quant is often credited with the invention of the mini-skirt, she claims she only copied it from the girls in the street. "There was something in the air," she said. Quant satisfied a pent-up, widespread desire for a distinctly young look and soon Chelsea changed from a Bohemian backwater to the very epicenter of swinging London. British fashion, riding in on the coattails of British pop bands like the Beatles and the Rolling Stones, conquered the world.

Mary Quant and her future husband, the aristocrat Alexander Plunket Green, and their business partner Archie McNair opened their first Bazaar boutique on the King's Road in Chelsea in 1955. Their initial idea was simply to run the shop as a retail outlet, selling ready-made garments purchased from wholesale suppliers, but they couldn't find enough that they really liked. Mary Quant, a former art student, decided to try making the clothes herself.

Quant had no real background in fashion technology so she took some evening classes in pattern cutting and turned her little studio apartment in Chelsea into a makeshift clothes factory where she remembers her cats eating the clothing patterns because the paper was made with some sort of fish derivative. She purchased her first fabrics in small batches from Harrods department store and her business was run on such a shoestring at this point that she could not afford to buy more fabric until the finished clothes actually sold.

Luckily they flew off the racks. Customers soon learned that early evening was the best time to visit Bazaar because Mary would just be coming in then with the day's creations draped over her arm. Thanks to some good publicity in the fashion press, the gospel according to Quant spread and in 1961 she opened another highly successful Bazaar boutique, this time in Knightsbridge.

By 1963 Mary Quant went global with her cheaper, mass-produced Ginger Group wholesale line and her specially commissioned lines for J.C. Penney and Puritan fashions in America.

An early 1960s Mary Quant dress

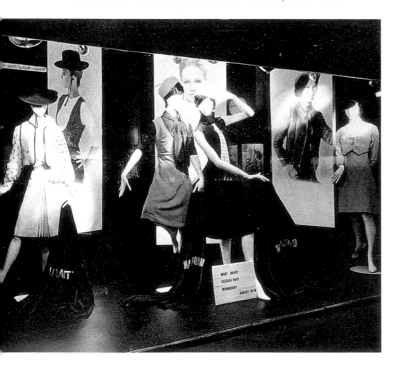

A Mary Quant shop window in the 1960s

While there is no such thing as a quintessential Quant design, she herself did come to personify the Mod look which dominated the early to middle of the decade first in London and then worldwide. The look was based first and foremost on a short skirt either as a mini-dress or as a separate. Dresses were waistless chemises or schoolgirl pinafores. The new skirt length was worn with the new tights and flat-soled shoes or boots. Black and white Op-Art fabrics were considered the height of cool, along with Bridget Riley dots and geometric shapes; vinyl or "wet look" fabrics were also popular, along with Hipster trousers and skinny rib sweaters. Body-wise, breasts were definitely out and erotic focus shifted to the newly displayed legs. It was a childish shape, no calves or muscles, but skinny little girl matchstick limbs—"I think there was slightly a sort of pedophile thing about it," Alexander Plunkett Greene explained, "All pure erotic fantasy, a bit of Nabokov."

Mary Quant's daisy logo was soon recognized the world over and in 1966 she was given an Order of the British Empire by the Queen in recognition of her contribution to British exports and industry.

MARY QUANT GIVES YOU THE BARE ESSENTIALS

The model Lesley Hornby, better known as Twiggy, was a Mod icon, the archetypical "Dolly Bird" with a beanpole figure and huge, heavily made-up eyes. She was photographed most often in the then popular "broken limb" pose of a gawky schoolgirl. This whole Mod look, so radically different from what went before, so unashamedly sexy and modern but also so insistently and distinctly young, absolutely swept away the adult world of 1950s fashion.

Were Twiggy a model today, there would be talk of an eating disorder. But many teenagers in England were very thin in the 1960s as a result of wartime rationing

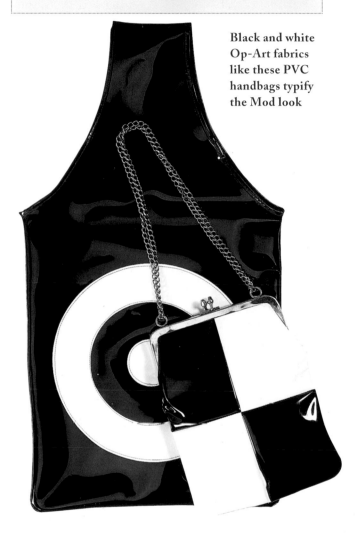

Black and white Op-Art fabrics like these PVC handbags typify the Mod look

A mini-skirt or -dress is a good vintage find, especially if it is strongly Mod in style, because these are the ones that convey most strongly the feeling of those early experimental times. Quant's brightly colored PVC short boots with the daisy logo are very collectible today and anything labeled "BAZAAR" will always be of far higher quality than something which bears the ultra mass-produced Ginger Group label.

BOUTIQUE CULTURE

From the King's Road to Haight Ashbury, from Greenwich Village to Carnaby Street, from Biba to Paraphernalia, so-called "boutique culture" was a retail phenomenon offering a proliferation of inexpensive, exciting, and rapidly changing looks to the working girl and even the teenager with pocket money. It was a fashion democracy of cheap, fun, exciting clothes for ordinary young people—clothes that had nothing at all to do with Paris or couture or serious adult life but that came from the street. Boutiques sold total, top-to-toe clothes, including jewelry and shoes and even makeup was available and snapped up by this generation of baby boomers at an unheard-of rate.

On any given Saturday, the King's Road thronged with hot young trend-setters out to see and be seen. Cars painted in psychedelic Day-Glo colors patrolled the streets while Mick Jagger shopped at the Chelsea drugstore and Hendrix hung out on the shady terrace of a local bistro.

Fashion was very much a part of the scene. Even men were prepared to spend hours and hours engaged in this new shopping extravaganza, perhaps because the clothes and the "birds" looked so sexy. Shop fronts went psychedelic and interiors were either modern aluminum space ships with Day-Glo inflatable furniture or else dark and mysterious, reeking of incense. Pop music blared everywhere. The staff was young, trendy, and decked out in all the gear. For girls shopping without their boyfriends, special "man walls" displayed pin-ups of pop star idols while scantily clad hunks helped the clientele in and out of their mini-dresses.

Retail boutiques, such as the mega-famous Countdown, sold a variety of mass-produced styles while a group of young designer art school graduates opened shops selling their own creations. Many of these started off, like Mary Quant, as cottage industries run on a shoestring until mass-market manufacturers commissioned simpler, cheaper versions of their designs for the French, English, and American markets.

Carnaby Street in 1960s London

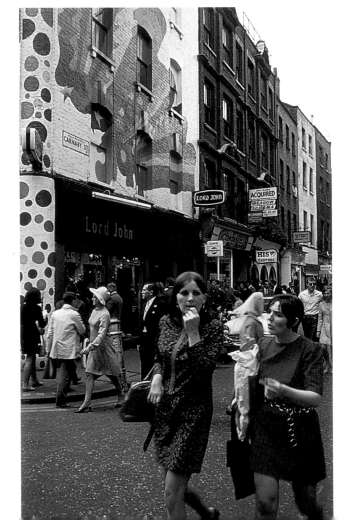

Courrèges "wet look" dress and jacket

Vintage pieces from these boutiques are hotly pursued by edgier enthusiasts. These pieces were often beautifully produced, true artists' creations aimed at celebrities and rich trend-setters with loads of money to spend on the King's Road. Foale and Tuffin's "hipster" pantsuits, popularized by the British actress and 1960s icon Susanna York, are very sought after, as well as Ossie Clark's bias-cut chiffon and crepe dresses.

Other "Cool Britannia" names to look for are Alice Pollack, who ran the famous Quorum boutique with Ossie Clark, Kiki Byrne at Glass and Black, and early pieces by Jean Muir, labeled "Jane and Jane" at that time.

The Mini

"It's like Pop Art in motion," commented one 1960s observer but once the mini was finally here, it was here to stay. Although it went out of mainstream fashion in the 1970s, it was still *de rigueur* for punk girls and then re-appeared on the ladies who lunched in the 1980s. The 1990s incarnation was all about Girl Power. Think slip dresses and Spice Girls and urban, post punk girl warriors.

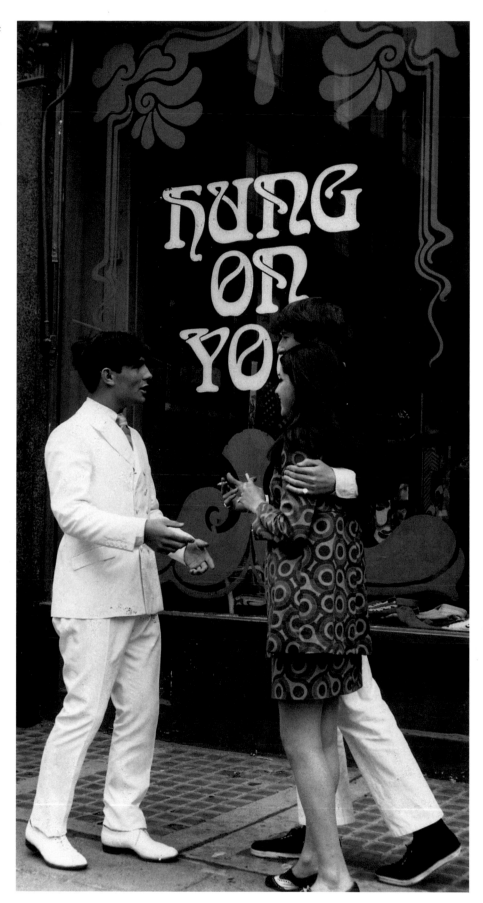

The King's Road in the 1960s

BIBA

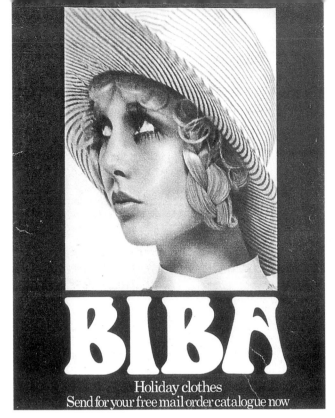

Of the thousands of boutiques that appeared in the 1960s, the best loved and most famous was Barbara Hulanicki's legendary Biba, described as more of a "happening" than a shop. Screen idols such as Julie Christie, pop stars, and European fashion designers on the prowl for new ideas rubbed shoulders with a multitude of ordinary young people shopping for their Saturday night party ensembles.

Like so many British fashion stars of the period, Barbara Hulanicki started small, selling just a handful of simple designs through her mail-order business. One particularly successful pink gingham dress started it all, enabling Barbara and her husband to open the first Biba in 1964. A desire to be different led them to Kensington—in preference to the already highly successful Chelsea. Their succession of larger and larger Biba boutiques stayed in the area, culminating with the 1974 "Big Biba" which colonized an entire department store on Kensington High Street.

The Biba look defined the later 1960s and early 1970s, based on a softer, more romantic "retro" feel than the hard-edged minimalism favored by Mary Quant's "Mods" and Courrèges' Space Age "Moon girls."

The Biba shop was a dreamy, dimly lit Aladdin's Cave where clothes were piled on antique vanity tables or hung from bent wooden hat racks. Feathers bloomed in art nouveau vases and stacks of beads, sequins, and Lurex glittered in shadowy corners.

Biba sold a total look—clothing, hats, handbags, shoes, jewelry, and makeup—all at dirt-cheap prices.

Late 1960s wrap jacket by Biba

The name Biba comes from a shortening of Barbara Hulanicki's sister Biruta's name

"It was a terrible shame to show you were making money," Barbara explained in her autobiography, dedicated to all optimists, fatalists, and dreamers. "We practically gave our things away to the public." The public, in turn, responded. In its heyday, Biba was attracting over 100,000 customers each week and became a tourist shopping Mecca, as a one-stop symbol for all that was meant by the whole "Swinging London" phenomenon.

Although Biba was never expensive in its day or even particularly well made, it is very sought after on the vintage market today.

Many of Biba's most devoted fans in the 1990s were not even born when Barbara closed her doors in 1976. Good examples can command high prices at auctions and are often bought by young devotees who rarely hang out in Christie's or Sotheby's. These young collectors have usually been saving for months to afford some spectacular piece for their collection. The best Biba tends to be the early pieces labeled with her famous Celtic logo, printed on a large brown satin tag. On later, usually less interesting pieces, the label itself is smaller and the logo is embroidered on it with yellow thread.

OPPOSITE: **Interior of the Biba boutique, London, 1960s**

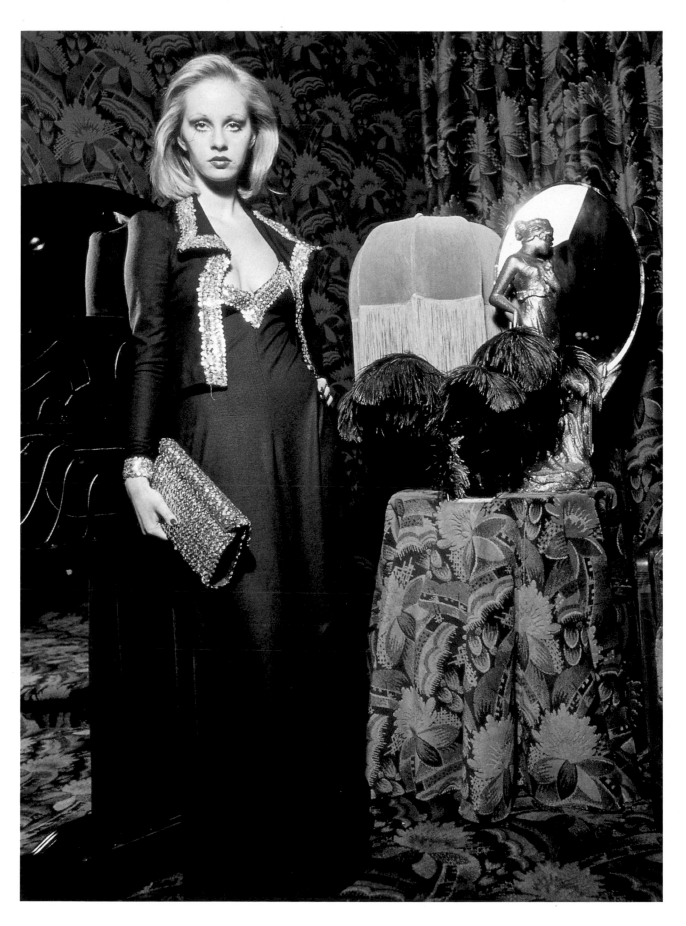

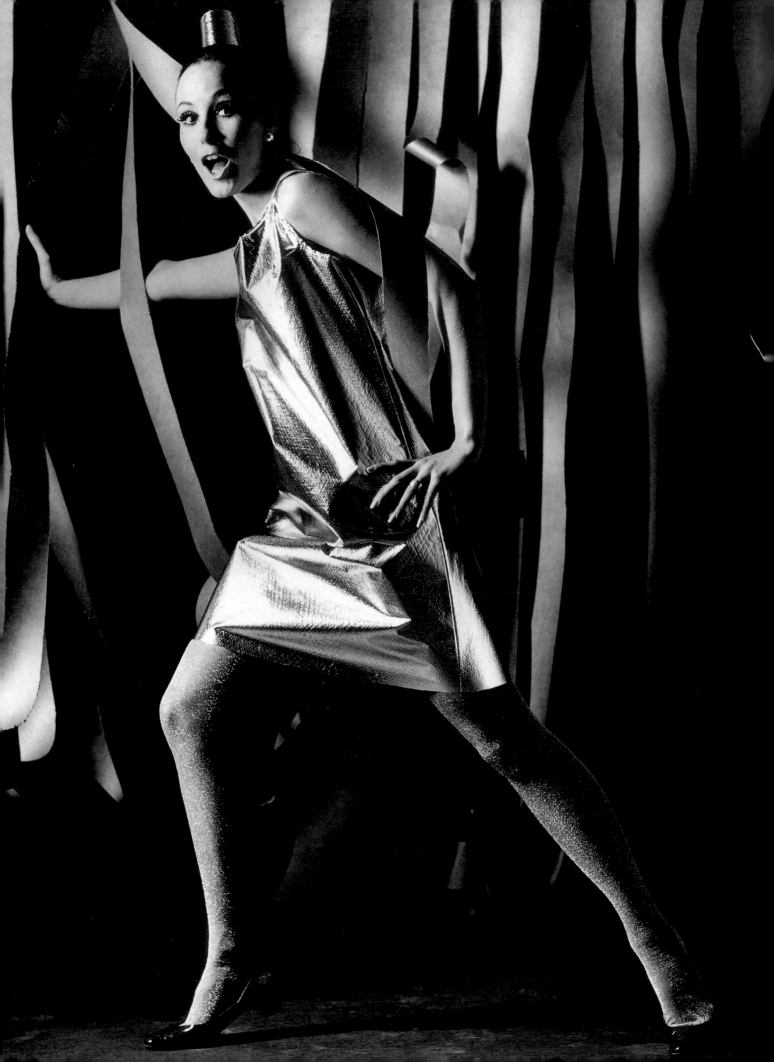

POP GOES NEW YORK

The 1960s fashion revolution may have started in London but it was not long before New York was creating its own Pop version of Mod fashion. Feeding off contemporary art and its stars such as Andy Warhol, fashions grew wilder and more ephemeral as they adopted Pop Art's devotion to the throwaway and the mass-produced. Clear vinyl, plastic, chain mail, aluminum, cellophane, cardboard, even liquids were explored as new material for clothing that was meant to be "famous for fifteen minutes." There was even a "Grow your Own" dress impregnated with seeds that germinated when watered, hopefully just in time for the next big party.

The New York Pop scene was epitomized by Paul Young's boutique, Paraphernalia. Young was instrumental in bringing the British Mod look over to America, first with his work for the J.C. Penney Company and then as the architect of the Puritan company's seminal "Youthquake" promotion.

With Paraphernalia, Young planned to experiment with the wilder possibilities of Mod

Sequin dress by Louis Féraud influenced by 1960s art

OPPOSITE: **Silver Mylar dress from "Paraphernalia"**

fashion in what would become a sort of proving ground for various styles before big money was risked in their mass production.

Young assembled his own team of exciting, talented, freelance American designers like Betsey Johnson, Diana Dew, and Deanna Littell. He sold their work alongside Mod European imports from the likes of Mary Quant, Tuffin and Foale, and Paco Rabanne.

Betsey Johnson shared the 1960s Mod/Pop enthusiasm for unconventional materials. As she explains, "We were into plastic flash synthetics—you'd spray with Windex, rather than dry-clean."

"It was: 'Hey, your dress looks like my shower curtain!' The newer it was, the weirder— the better." Johnson designed cellophane clothes and clear vinyl dresses

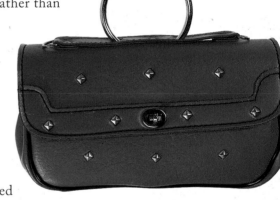

A pink "wet look" American handbag

that came with a packet of adhesive backed foil cut-outs that the wearer could apply to the dress in whatever pattern she chose.

She also used aluminum and silver Mylar originally designed for use in space. All this shiny stuff instantly attracted Andy Warhol, whose own fascination with silver had inspired him to paper the

Despite the name—"Puritan" fashions—this American clothing manufacturer showcased the work of a range of impressive young cutting-edge designers in their 1960s Youthquake promotion.

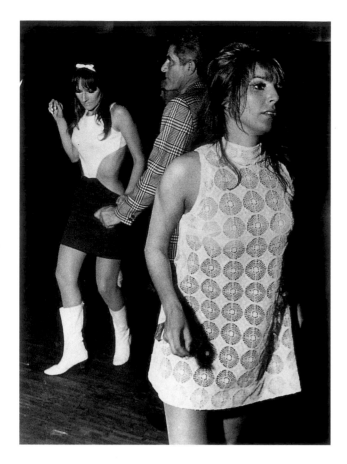

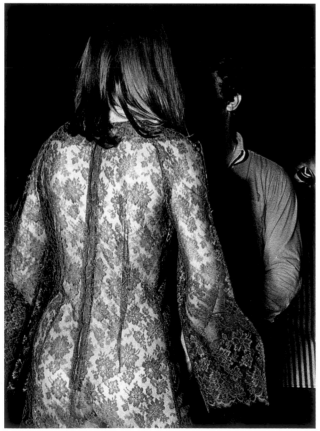

entire interior of his Factory studio with silver foil.

After designing some specially commissioned outfits for members of Warhol's gang, Johnson entered his so-called inner circle and married Velvet Underground member John Cale, while Warhol "superstar" Edie Sedgwick became both a muse and model for her clothes.

The early London "Mods" had done away with rigid distinctions between day and eveningwear, but by the middle of the 1960s, clubs and discos were becoming a big feature of after hours life. Cutting-edge party-goers wanted outrageous clothes extravagant enough to match and even interact with their nighttime surroundings.

Cheetah and The Electric Circus were two of America's most famous night clubs and both ran highly successful in-house boutiques selling all forms of the new fantasy eveningwear. *Life* magazine summed up the atmosphere: "Magnified images of children in a park, a giant armadillo or Lyndon Johnson disport themselves on the white plastic sculptured expanse of the tent-like ceiling. Gigantic light-ameba rove among the images, pulsating and contracting with the relentless beat of a rock band.... A young man with the moon and stars painted on his back soars overhead on a silver trapeze and a ring juggler manipulates colored hoops amid hippies who unconcernedly perform a pagan tribal dance...."

Paraphernalia's Deanna Littell designed evening coats and dresses with glow-in-the-dark trims. Giant light-reflecting sequins called "Pailletes" became a favorite during the 1960s, along with Day-Glo colors and fluorescent fabrics designed to show up under the strobe and black lights used in nightclubs.

ABOVE AND BELOW: **Cheetah Club, Los Angeles**

American boot/tights

The apogee of the new Pop eveningwear were Diana Dew's incandescent dresses and trousers decorated with multicolored strips of light, powered by a miniature battery pack worn on the belt. The lights then blinked and flashed in a pattern that could be adjusted to coordinate with the beat of each song as it was played on the dance floor.

New York Pop fashion rarely turns up on the mainstream vintage market but it is not clear if this scarcity is due to its ephemeral nature or if it has not yet been re-discovered. Many designs were produced in very small quantities but even so an awful lot was sold in what became the Paraphernalia national chain of boutiques, as well as in the scores of spin-off boutiques that Paraphernalia inspired. Keep your eyes open!

American designer, boutique owner, and club hostess Tiger Morse was particularly well-known for her handpainted vinyl dresses, but also claimed, "I'm making light dresses, I'm making dresses that make noise, I'm making dresses that whisper, dresses that smell."

Another Paraphernalia designer, Joel Schumacher, turned Robert Indiana's iconic Pop Art paintings into clothing. A typical example was his "L-O-V-E" dress where the "O" was cut out to reveal the belly button.

Rudi Gernreich

Rudi Gernreich presided over the West Coast version of New York Pop, designing first for the seminal Jax boutique in Los Angeles and later in conjunction with Harmon Knitwear. He also designed under his own label. Although many of his dresses were simple, functional, and relatively conservative, he shot to superstardom—and in some circles, super-infamy—with his mid-1960s experiments in varying degrees of undress. His topless bathing suit of 1967 scandalized those who had not yet taken the 1960s on board; his mini-dresses, inset with body revealing strips of clear vinyl, continued the theme. Today, however, vintage Gernreich is proudly sold in top auction houses where it brings serious prices.

Paraphernalia

The store itself was as wild as the clothes, with live models decked out in all the gear dancing like go-go girls on raised pedestals in the window displays as well as inside. The lighting was dark and theatrical, and as the store became more and more minimal in feeling, the clothes themselves all but disappeared. Clothes were finally offered as images projected on giant video screens which the customers operated by remote control.

"Paraphernalia sometimes stayed open till two in the morning. You'd go in and try on things and 'Get off My Cloud' would be playing—and you'd be buying the clothes in the same atmosphere you'd probably be wearing them in."

Andy Warhol, in *Popism in the Sixties*

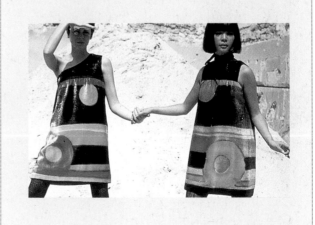

ANDY WARHOL

During this era, Pop artist Andy Warhol worked in a big industrial loft called the Factory, which became a sort of kaleidoscope for all that was new and trendy in mid- to late-1960s New York. His parties or "Happenings" attracted socialites, celebrities, and weird and wonderful unknowns, who danced, drank, took drugs, and dreamed up the Next Big Thing. Lou Reed and the Velvet Underground provided the music and, combined with Andy's video images and light shows, became the multimedia performance art extravaganza called the "Exploding Plastic Inevitable."

Fashion was very much a part of the scene and Warhol silkscreened some of his own most famous images on to paper dresses, sometimes while they were actually being worn by Nico, one of Warhol's favorite "superstars."

Thanks to Warhol's fame, both as an artist and a cultural icon, vintage clothes associated with him and his Factory years bring unimaginably high prices at auction today. Paper dresses printed with archetypal Pop iconography from his artwork, things like Campbell's soup cans, S & H Greenstamps, and Brillo Pads are displayed now in the costume departments of major museums and only very rarely turn up on the vintage market. But they are out there, so keep looking!

While Warhol's experiments with paper dresses were isolated and fleeting, Paraphernalia's Elisa Stone worked almost exclusively in paper or else in plastics as flimsy as paper. She often assembled her dresses in layers of fluttering strips or else attached streamers to them so they moved like Pop Art mobiles.

"I loved the idea that my clothes were not going to last. I thought of them as toys." Sadly for vintage dressers most of these fragile fashion treasures did not survive a single "Happening."

Mass-produced paper dresses and clothing, however, does turn up with more frequency on the vintage scene and sometimes at very modest prices.

Although these pieces are not particularly flattering or wearable today—looking more like hospital garb or oversized lobster bibs than trendy clothes—they make great souvenirs of the throwaway society of New York Pop.

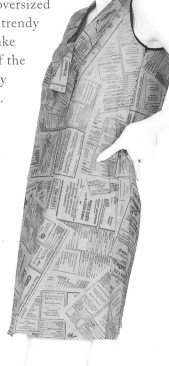

Paper dresses come most commonly in plain colors or floral prints. This particularly Pop Art American version was based on a straight reproduction of the Yellow Pages

OPPOSITE: **Warhol and the gang in New York**

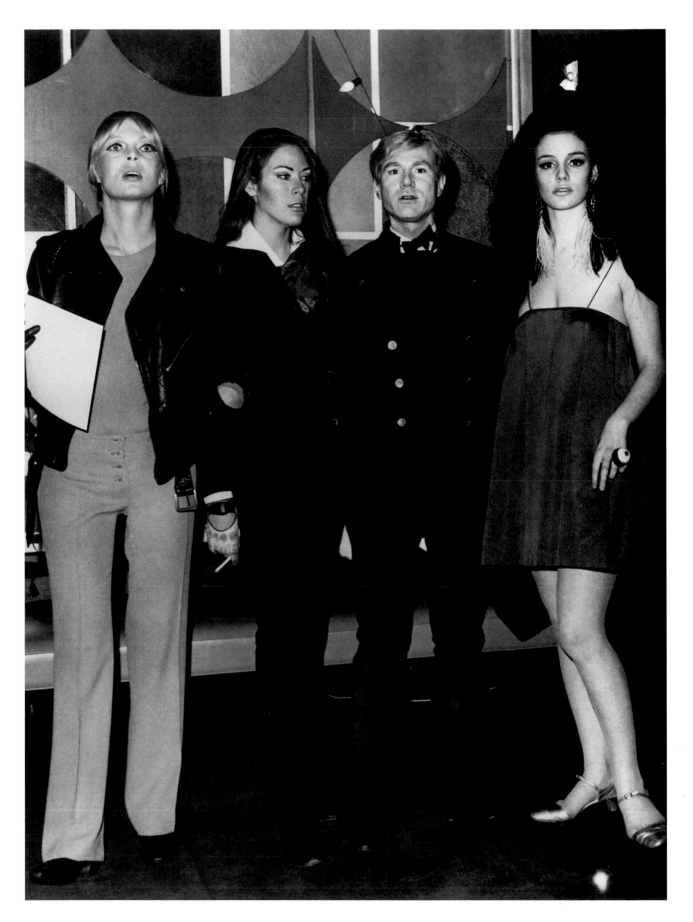

THE SPACE RACE

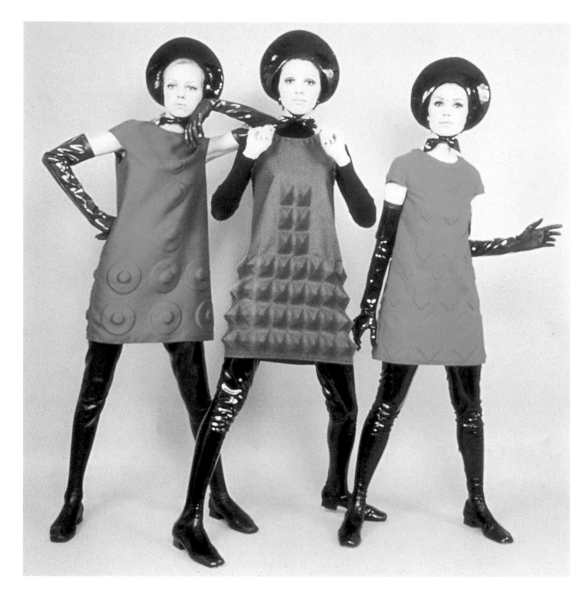

"You are going to see some slightly strange boys and girls," Pierre Cardin warned just before the opening of his 1966 couture show. And then out they came, in their unisex Space Age gear, complete with Cosmonaut Helmets

The flow of fashion influence reversed in the 1960s and teenage styles now filtered up to the highest echelons of French Couture. By 1968, Dior's successor, Yves St. Laurent, was sketching students at the Paris barricades and cruising the Chelsea boutiques for ideas and inspiration while his competitors were looking even further afield for the Next Big Thing.

Neil Armstrong made that first "giant leap" by walking on the moon in 1969, but space travel had been a major theme right through the decade and quickly found its way into fashion, especially in France. The idea of an ultra-modern, genderless space uniform was a look that was explored over and over again, both in the Couture and ready-to-wear designs of Pierre Cardin and André Courrèges. Both favored modular wardrobes of mix-and-match pieces and used lots of silver and black and white fabrics in Op Art combinations.

After thirteen years with Balenciaga, Courrèges opened his own house in 1961 and brought all his classical training into the new swinging era. The Courrèges look was based on mini-dresses, catsuits, and pantsuits in stiff, wrinkle-free fabrics. He also used see-through fabrics and cut-out areas to give a sexier twist to his generally stark futuristic designs. Space Age style vintage Courrèges, especially couture, brings huge prices at auction today and is probably a rock solid investment for anyone who loves the 1960s.

Pierre Cardin's Space Age designs are also hotly pursued by today's vintage dressers, but Cardin was a ruthless "licensor," who attached his name to a whole range of cheaply made mass-produced products and clothing, so remember the Cardin label alone is not enough.

Both Courrèges and Cardin Space Age clothes look very sturdy and wearable but be warned that the "wet look" PVC they often used for their appliquéd logos, decorations, and trims—and sometimes for entire garments—is actually quite fragile and can crack and peel if worn or dry-cleaned too often.

Space Age accessories

Courrèges designed boots, sunglasses, hand-bags—even an instamatic camera printed with his logo—and these little extras are well worth picking up. Helmet hats by Courrèges and Cardin also appear occasionally on the vin-tage market and though they are quite hard to wear today, they are a definite must-have for collectors of the Space Age look.

American silver handbag

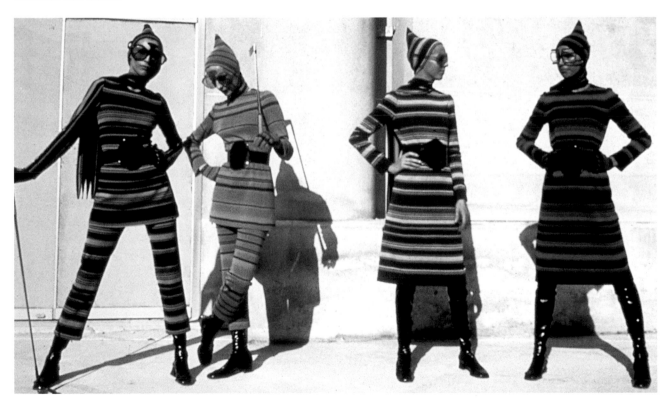

French fashion goes into orbit with the Space Age creations of Courrèges and Cardin, who turned the staid world of Paris couture on its ear with their futuristic Star Trek looks

PACO RABANNE

Like many fashion designers, Paco Rabanne started off as a student of architecture but found that the world of fashion was infinitely more interesting. His 1966 debut collection featured clothes made entirely of plastic discs held together by tiny metal rings instead of thread. This revolutionary use of new materials grabbed the headlines and he went on to design amazing dresses made entirely of metal discs and chain mail in a surreal style, combining medieval and futuristic Space Age influences.

Paco Rabanne's clothing, jewelry, and handbag designs of the 1960s are very collectible and dresses bearing his original label command many thousands of dollars at auction today. He did, however, inspire a whole host of imitators, so anyone longing to try out the 1960s feel of heavy metal against their skin is far more likely to find one of these less expensive anonymous spin-offs. A signed original is probably too valuable to wear unless you've got nerves of steel and money to burn.

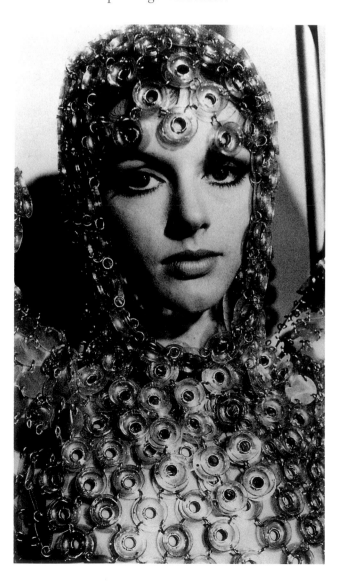

After a long period out of the spotlight, Paco Rabanne came back in the late 1990s. As a self-styled mystic and visionary, his theories about millennium disasters grabbed the headlines, along with his *fin de siècle* revival of his own unique brand of stylish body armor

YVES ST. LAURENT

After a brief stint as head of Dior, Yves St. Laurent opened his own couture house in 1961 and a chain of ready-to-wear boutiques called Rive Gauche in 1966. He was instantly successful and quickly became the couturier of choice for a whole band of wealthy trend-setters. While his ideas were never as wild as many that emerged in the 1960s, he kept his finger very much on the pulse, successfully marrying the raw excitement of this cultural period with the more refined French tradition of beautifully made, high quality clothing. This formula obviously appealed because Yves St. Laurent went from strength to strength in the 1970s and 1980s.

This dress, from St. Laurent's 1965 collection, is based on a painting by Piet Mondrian. It has become one of the Holy Grails for vintage collectors

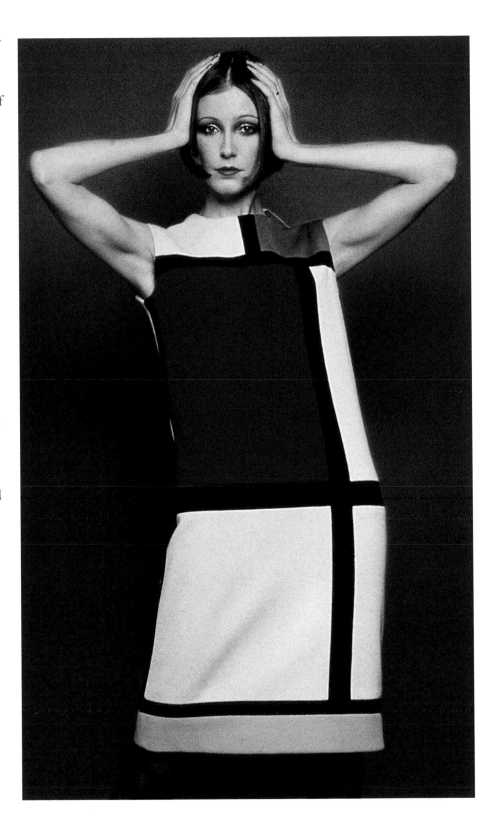

PSYCHEDELICS FOR GROWN-UPS

The wealthy, more sophisticated woman of the 1960s decked herself out in Emilio Pucci's psychedelic creations, prized above all for the artistry and energy of their swirling, colorful prints that seemed to achieve the impossible: a sort of free-form geometry. Elizabeth Taylor, Ingrid Bergman, Grace Kelly, even the feminist Gloria Steinem were all photographed in their favorite Puccis and before long the stampede was on. Pucci has been revived again and again, up to the present day when supermodels like Kate Moss appear in vintage versions that keep the Pucci magic alive.

The creator of these mind-bogglingly complex prints and the simple, eloquent clothing canvasses that he used to show them off would surely have been voted least likely to become a high fashion clothing designer.

Emilio Pucci—also known as "the Marchese di Barsento"—was born into an old aristocratic Florentine family related, on his father's side, to Peter the Great, Czar of Russia.

Pucci started life as a ski bum for Italy's national team but quickly distinguished himself as a fighter pilot and hero in the Second World War. His family, like many European nobles, was impoverished by the war so Emilio went to study and seek his fortune in America, first at the University of Georgia and then at Reed College in Portland, Oregan. It was in America that his mind turned seriously to fashion. His first break came when a buyer for New York's Lord and Taylor spotted some ski suits which Emilio had designed quite informally for the Reed College ski team. With this first small commercial order, the Pucci phenomenon was launched and has snowballed ever since.

His earliest designs, dating from the 1950s, were sold in a boutique which Pucci opened on the island of Capri in Italy just after his return from the United States. These early pieces tend to come in solid colors or simple figural prints based on typical 1950s motifs like Chianti bottles, Harlequins, and Italian village scenes.

As time went on, Pucci prints became more and more complicated, culminating in the wild kaleidoscopes of abstract color which came to be the hallmark of his look. These "abstracts" were initially based on medieval heraldic banners but his imagination soon took over and they evolved with seemingly infinite variety.

The typical Pucci is made of silk or silk jersey but many designs of the 1960s and 1970s were made in "Emilioform"—a special fabric which Pucci developed, based on a blend of Jersey and the synthetic "Helauca"—which made for a stretchy, clingy fit that held its shape. He also used some cotton, velvet, and toweling material, but these pieces are less common. His most common design was the T-shirt or chemise dress with a narrow string belt, sometimes decorated with crystal tassels. He also created a variety of blouses, pants and tunic sets called "Palazzo Pyjamas," long evening gowns, sarong dresses, bell bottoms, bathing suits, and a line of lingerie and underwear which he designed for the American manufacturer, Formfit Rogers of Chicago.

As his look became more and more iconic, all sorts of unexpected objects got the Pucci print treatment. He designed ties, towels, carpets, scarves, lingerie, handbags, shoes, costume jewelry, sunglasses, tights, and even a line of porcelain for the Rosenthal Company and all these Pucci extras are pursued as hotly as the clothes by today's vintage fans. We are, in fact, right in the middle of yet another Pucci revival, so prices are high and customers are fighting over dresses in the vintage shops. This will cool off eventually, but vintage Pucci will always be a wise purchase and even a bargain if you're lucky enough to spot some in between the inevitable "revivals" which these days have been measured in months rather than years.

OPPOSITE: **Pucci became wildly successful and his jet-set lifestyle, combined with his aristocratic breeding, was great publicity for the high fashion, élite status of his clothes. He showed his collections in the sumptuous atmosphere of a huge baroque ballroom in his own Palazzo in Florence, where he lived with his beautiful wife and muse, the Baronessa Christina Mannini**

Genuine Puccis are signed like paintings, with the script signature "Emilio" incorporated into the design of the fabric, but you must look very carefully to make sure that the signature is correct. Pucci had a host of low-cost imitators who incorporated their own hastily scrawled names into their spin-off fabrics and these copies are worth nowhere near as much as the real thing. The copies do, however, make a super low-cost alternative for the vintage enthusiast who craves the look but who doesn't really care about the label. Puccis labeled for Formfit Rogers were originally underwear or lingerie, although most of these are worn as "outerwear" today. They should not be as expensive as a proper Pucci dress or shirt because these mass-produced little garments have nowhere near the same quality.

THE BEAUTIFUL PEOPLE

While the new looks had a major effect on the fashion face of the decade, many preferred to opt out of its wilder sartorial exploits and adopt the youthful but ladylike style of the young American first lady, Jacqueline Kennedy. Her iconic look was based on loose, waistless shifts and sheaths, usually sleeveless and some-times worn with a matching coat. Prints were eschewed in preference to pale pastel colors or whites and creams.

Extras were kept to a minimum so a simple strand of pearls, an envelope bag, and perhaps just some gloves and Jackie's signature pill-box hat were all that was needed to pull the look together. This 1960s conservative style was elegant but also seemed a more youthful and modern way to dress than the 1950s insistence on elaborate accessories and breathtaking corsetry. Her signature shift and overblouse dresses were created (exclusively for her) by the American designer Oleg Cassini, but the look filtered down to department and speciality shops all over America. Many fine examples are inexpensive and can still be snapped up today at flea markets and yard sales.

The beautiful people may have played it simple by day, but at night the look was totally dramatic. Jewel-encrusted silk gazar formals and feather-trimmed, wide-legged palazzo jumpsuits went on parade for glitzy occasions, along with false eyelashes, heavy makeup and elaborately teased bouffant hairdos and hairpieces rivaling anything Marie Antoinette had had to offer. Costume jewelry designers, like Kenneth Jay Lane in America and Coppola and Toppo in Italy, created huge, over-the-top bib necklaces and chandelier earrings to get the message across.

ABOVE: **Jacqueline Kennedy**
TOP LEFT: **Shantung and Paillete sequins by Oleg Cassini**

This more grown-up version of the 1960s "Youthquake" (for both day and evening) is often easier to find in today's vintage market because its workmanship and materials were usually superior to the hastily thrown off, super-cheap teenage clothing that has come to characterize the decade and so it has survived. The most collectible evening pieces are the heavily decorated ones encrusted with sequins, Mylar strips, or jewels.

Designers like Geoffrey Beene, Scassi, Valentino, Yves St. Laurent, Givenchy, and Norman Norell all dressed the beautiful people in the 1960s and good examples— especially couture from this period— command big prices at auction.

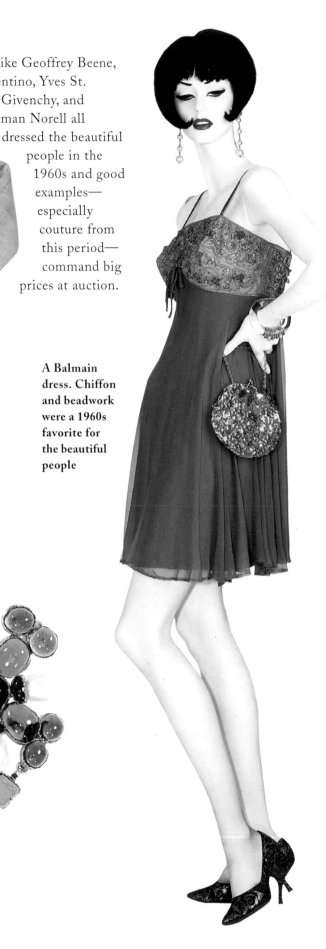

A Balmain dress. Chiffon and beadwork were a 1960s favorite for the beautiful people

The Chanel look was a must-have for the 1960s conservative. Suits and day dresses like this one are highly collectible…

…while Chanel's "poured glass" costume jewelry of the 1960s, like this brooch, can sell for thousands of dollars

THE HIPPIES

For the seriously cool, once the 1960s really got going, it became a decade of restless experimentation and a relentless pursuit of the Next Big Thing. During the late 1960s, the quest for self-expression combined with a backlash against the consumer feeding frenzy of the earlier years, turned the public's attention away from the hard-edged minimalism of the Mods, the all-white futurism of the Space Age look and the ephemeral frivolity of Pop. A sort of fashion anarchy took over.

"Anything goes now, as long as it is some sort of look," commented one observer. "Today nothing is out because everything is in."

The Mods, following on from the Beatniks, had opened a door on a brave new world of previously unimaginable personal freedom, not just for an avant-garde few but for the masses. Now that the battles had been fought and the old guard—sometimes grudgingly, sometimes enthusiastically—came around to the multi-talented "Youthquake" generation, the hippies took over and tried to underpin it all with their anti-Establishment, anti-materialistic culture of love.

Suddenly, fashion no longer felt like harmless fun as it had at the dawn of Mary Quant but was characterized instead as "a system that society imposes on all of us, restricting our freedom," turning us into money grabbing consumers.

The cultural and fashion focus then shifted from Chelsea and swinging London to the hippies' groovy new spiritual home in the Haight Ashbury area of San Francisco.

Archetypal flower children at Woodstock

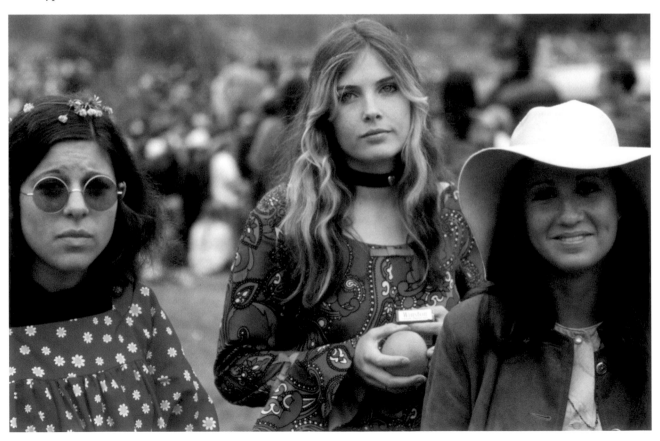

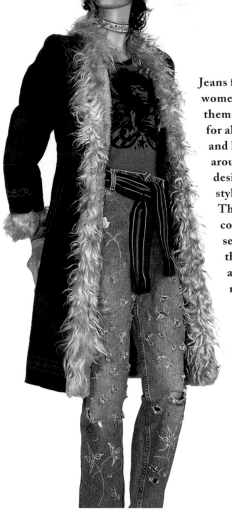

Jeans for men and women established themselves once and for all in the 1960s and have been played around with by designers and street stylists ever since. This 1960s Afghan coat though spent several decades in the shadows until a recent late 1990s revival

must-have, the Afghan coat. This embroidered suede number was lined with long, curly lamb and became famous as much for its hippie look as its distinctive "wet dog" smell, activated whenever it rained. It has been reported (by those who were there) that a liberal dowsing of Patchouli oil was the only reliable way to keep these aromatic coats in line!

All these various ethnic originals are not usually too pricey on the vintage market today and therefore make fun and affordable forays into late 1960s dressing.

In this philosophical climate, the "ethnic" look became wildly popular and clothes from pre-industrial cultures like Asia and South America seemed more individual, more friendly, and most of all more "authentic" than the gear that was being mass-produced in a society that was starting to look a little too mechanized and shamelessly capitalistic.

Legions set off on the "Hippie Trail" to India or Morocco in search of cheap drugs, alternative lifestyles, and spiritual enlightenment. Presumably only a handful returned in a truly enlightened state but most came back with knapsacks full of beads, bells, sandals, exotic caftans, embroidered peasant blouses, shawls, and that absolutely 1960s

In the "do your own thing" spirit of the times, stay-at-home hippies got heavily into handicrafts and created some spectacular do-it-yourself fashions. Handknitted and crochet tops and dresses were popular, along with tie-dyed cottons and handpainted denim. Even embroidery, that old-fashioned pastime of cultured, well-behaved ladies, was rediscovered by hippie chicks, who decorated their own jeans with rows and rows of "flower power" daisies, peace signs, rainbows, and smiley faces. If you're lucky enough to find a pair of vintage jeans with a lot of custom-made decorative detail, by all means grab them because, now that Gucci has revived the look in 1999, prices for originals are bound to skyrocket.

All the Mod/Pop excitement over new, synthetic materials went right out the window during the hippie phase. Who wanted to wear a plastic Cardin dress now that the phrase "plastic people" had come to mean the ultimate in non-groovy?

American handcrocheted skirt and top

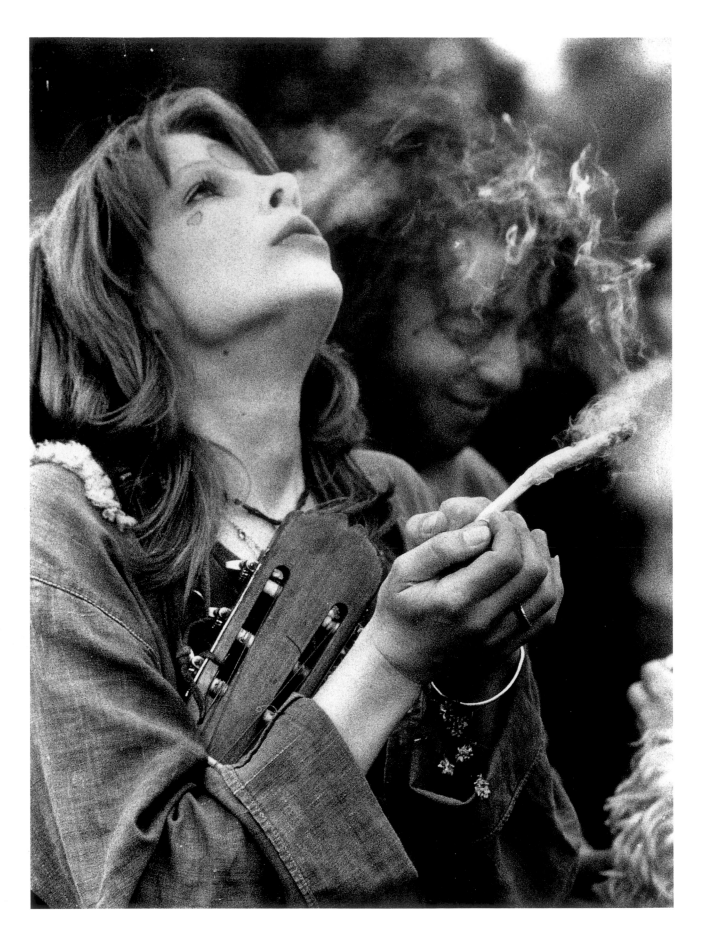

While the Mods were fueled by alcohol, amphetamines, and the heady exhilaration of the Sexual Revolution, Timothy Leary's "Turn on, tune in, and drop out" philosophy informed the later decade. Marijuana, LSD, and other hallucinogens were the substances of choice and under their influence, wild color, intricate wavy patterns, and soft, sensual "feel good" materials inspired hours of rapt meditation. By now, the Beatles had put away their matching Mod suits and, in 1967, they opened a hippie boutique called "Apple," where a group of Dutch designers called "The Fool" came together briefly and supplied clothes for this short-lived retail adventure.

After Beatlemania swept the world in the early 1960s, pop music quickly became the medium of the new world order and musicians like the Rolling Stones, The Who, Joan Baez, and Grace Slick not only spoke for a generation but taught it how to dress. Rock stars and their lovers were widely copied and television music shows and rock festivals were as much platforms for new fashion as they were for new music. Janis Joplin was an icon for the hippie look and many of her costumes were made by the Los Angeles designer Linda Gravenities.

OPPOSITE AND BELOW: **The 1969 Woodstock rock festival was ironically both a high point and a swansong for the hippie world of the later decade**

The hippie aesthetic was a busy, scribbly, colorful, "more is more" mentality. They painted their walls, cars, clothing, and even their faces and bodies with childish exuberance

The late 1960s emphasis on individuality found expression in a craze for vintage clothes. Everything from Edwardian lace petticoats to 1930s bias-cut satin evening gowns went on parade during the summer of 1967 and these retro influences carried on well into the early 1970s. Skirt lengths no longer mattered and micro-minis, midis, and maxis all appeared happily together in a climate captured perfectly by *Vogue* magazine: "Now beauty is free, liberated from hangups over form and function, unencumbered by tradition or design, kite-high, moon-pure, groovy, powerful, and weird!"

By the late 1960s, however, it was clear that utopia was not exactly around the corner. John F. Kennedy and Dr. Martin Luther King Jr. were dead, the civil rights movement had come up against violent opposition and responded in kind. Violent protests, like the Watts race riots of 1965, hit the headlines. The Cuban missile crisis and the rise of Mao in China fueled Communist paranoia while young people in America grew up under the specter of the Vietnam War. Graphic images from the frontlines were piped into homes on a daily basis while the excitement and idealism of the culture of love gradually drained away.

"All the people of the earth are forced to come together now and this expresses itself even in fashion. Our ideas come from every country, India, China, Russia, Turkey—from the sixteenth to the twenty-first century."
"We want to turn them on. Our ideas are based on love"
 The Fool

Collecting the 1960s

Although this is a relatively new area for serious collectors, the 1960s are becoming more sought after, thanks to some recent, high profile street style auctions. So much in this era was inexpensively and anonymously mass-produced by huge clothing manufacturers or tiny, often ethnic, cottage industries—and as a consequence, style may be the sole criterion to determine the value of a 1960s piece. Before buying, ask yourself: does this piece evoke strong and clear feelings of some particular stylistic niche of the 1960s, or is it watered down and vague?

Although so much was produced and sold during the 1960s, quintessential pieces are not as common as you might imagine. In this first true era of cheap, throwaway fashion, much of it was quite literally thrown away or else it was so poorly made that garments fell apart after several wearings. Other pieces were discarded because trends changed so rapidly that the new "Youthquake" clothes got old long before their time.

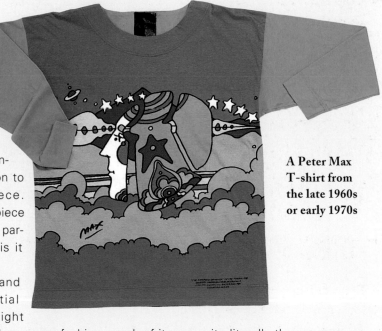

A Peter Max T-shirt from the late 1960s or early 1970s

HAIR AND MAKEUP

Eyes grew really big in the 1960s and false eyelashes were worn by many fashionable women. At first, these were applied painstakingly, lash by lash, but soon ready-made fringes of mink, sable, or even human hair came on to the market. Mary Quant produced a popular line of cosmetics featuring frosted eye shadows and lipsticks with fun, quirky names like Skitso and Jeepers Peepers, while the dark, sultry tones of Biba's makeup line colored a generation of retro-looking 1930s style vamps.

Colors became stronger, wilder, and more adventurous as the decade progressed, culminating in a late 1960s craze for face and body painting.

Hairwise, Londoner Vidal Sassoon dominated the period. His neat, geometric, early 1960s bob, popularized by Mary Quant, came to define the authentic "Mod" look and Sassoon shops soon colonized all of the known fashion world.

Long, straight hair was equally popular though and came to be associated with the earthier, more natural look favored by the hippie generation. In tune with the general trend toward unisex dressing, men's hair grew longer, provoking the sort of outrage portrayed in the seminal film *Easy Rider* (1969), where the characters are teased, taunted, and finally beaten because their hair was judged to be too long. Beaded, leather, and fringed headbands became a popular hippie accessory, while wigs and hairpieces were worn by dressier types.

OPPOSITE: This hard-edged "Mod" look gave way to the shaggier hippie style by the end of the decade

BELOW LEFT: Mary Quant with a Vidal Sassoon cut

BELOW: Glastonbury Festival, 1971

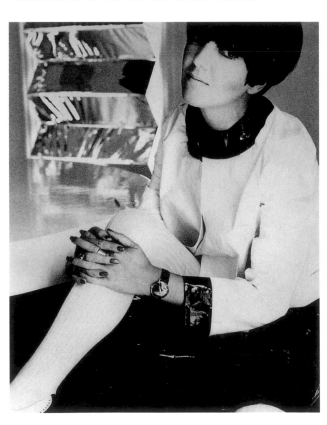

ACCESSORIES

In keeping with the 1960s distaste for anything old and parental, there was a falling away from the fussy complicated accessories that defined the 1950s look. Even though accessories were no longer the big story, there are some fun 1960s extras that are well worth having.

Like everything else, costume jewelry got wilder and bolder. Stanley Hagler made huge chandelier earrings in crazy artificial colors. Rhinestones came in "flower power" designs and Pierre Cardin made fabulous lucite and plastic jewelry in Space Age designs.

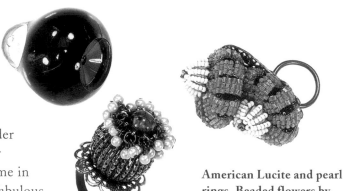

American Lucite and pearl rings. Beaded flowers by Stanley Hagler

As in the 1950s, there was an enormous variety of handbags, something to suit everyone from Janis Joplin to Jackie–O. The mini-skirt spawned a decade of boots, from ankle length to thigh high versions, and spike heels were sawn off in favor of flat or low heeled styles. Breasts were out and the braless look was in, so underwear wasn't much of a factor in the 1960s, but tights were invented then—an absolute necessity for the leggy, mini-skirted look. Unused 1960s tights in their original packaging often turn up at flea markets and vintage stores and can bring a really authentic touch to your swinging 1960s outfits.

Pierre Cardin Lucite watch

Pierre Cardin silver toned pendant. Space Age pieces like these are highly collectible

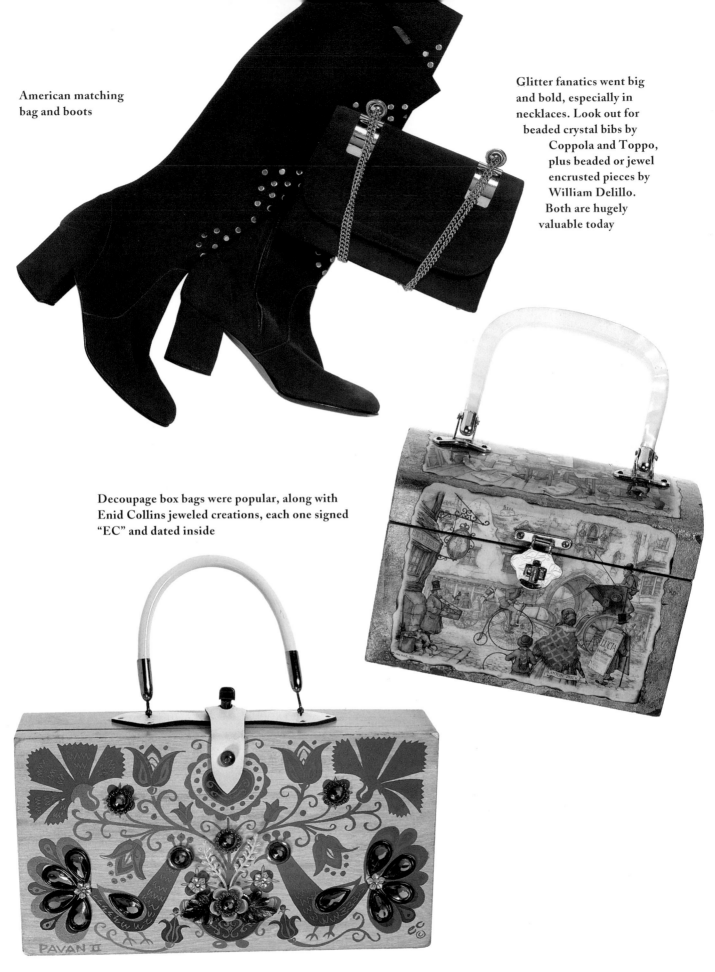

American matching
bag and boots

Glitter fanatics went big
and bold, especially in
necklaces. Look out for
beaded crystal bibs by
Coppola and Toppo,
plus beaded or jewel
encrusted pieces by
William Delillo.
Both are hugely
valuable today

Decoupage box bags were popular, along with
Enid Collins jeweled creations, each one signed
"EC" and dated inside

PAVAN II

THE 1970s

The Decade That Taste Forgot

LEFT: **Detail of Missoni knitwear**

Tom Wolfe characterized the 1970s as "The Me decade," a "sexed-up, doped-up, hedonistic heaven," as the radicalism of the 1960s and its liberal policies seeped into the mainstream: "If the hippies had one irrevocable effect on culture, including fashion, it was to destroy every rule except the injunction to please oneself."

Fashionwise, the situation was confused. "For the longest time everyone kept saying that the 1970s hadn't started yet. There was no distinctive style for the decade, no flair, no slogans" and instead it became a fashion free-for-all of hippie leftovers, recession-conscious work-a-day separates, and flamboyant, music inspired excess.

OSSIE CLARK

Late 1960s "antique" dressing continued and retro fantasies ran through the designs of the decade, from the Victorian "granny gown" look of American labels like Gunne Sax and Sweet Baby Jane, to the drop dead glamour of the 1930s Hollywood vamp—a style that not only inspired Biba's later incarnation, but also the legendary British designer Ossie Clark.

Although Clark started in the 1960s boutique culture of swinging London, his aesthetic was really more in tune with the "retro" feel of the early 1970s.

Clark was a genius at cutting and the slinky 1930s bias-cut silhouette was the perfect vehicle for his virtuosity. His crepe and chiffon dresses in this style are highly sought after by vintage dressers, who find them far more sturdy and wearable than 1930s originals, not to mention sexier and more flattering than the often poorly-cut modern knock-offs.

The earliest Ossies were handmade, sometimes unique pieces which he designed, cut, and stitched together during marathon all-night bursts of creative inspiration. They were then sold in Alice Pollack's Quorum boutique on Radnor Walk in Chelsea. Ossie's wife, textile designer Celia Birtwell, made the fabric for many of these works and together, this imaginative team produced some of the best and most wearable clothes of the century.

Clark's fame quickly spread and by the middle of the decade, his client list read like a Who's Who of cool in the 1960s and early 1970s.

An Ossie Clark dress in fabric designed by Celia Birtwell

Other sought-after labels from the late 1960s to the mid-1970s Brit Pack are Bill Gibb, Thea Porter, Jean Muir, Zandra Rhodes, Gina Fratini, and pieces by Rae Spencer-Cullen, which were labeled "Miss Mouse." Jean Varon also made some quintessential mass-produced pieces during this era and prices for this label are still low, so there's scope for investment.

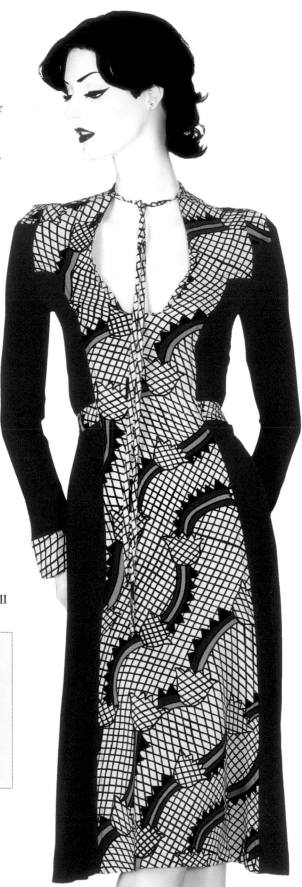

Julie Christie,
Twiggy, Bianca Jagger,
Liz Taylor, Faye
Dunaway, Veruschka—
they all called into
Quorum for the Ossie
Clark treatment and
became not only loyal
customers but personal
friends as well.

Most of Clark's best
designs come with a
tiny secret pocket
inside, said to be only
big enough for a key
and a $10 bill.

These early handmade Ossies are highly sought
after on today's vintage market, but you must be
careful. As is always the case, especially with post-
war designer clothes, there are Ossies and then
there are OSSIES!

Anything labeled "Ossie Clark for Radley" dates
from the years 1968–77, when Clark designed for
this manufacturer, who mass-produced garments
with some inevitable loss of quality and cut. On the
other hand, the Ossie Clark designs for Radley
labeled "Celia Birtwell textile design" are usually
beautiful and a dream to wear. These are
understandably very sought after, although often
not as valuable as the custom-made designs.

While chiffon and especially crepe were favorite
fabrics, genuine snakeskin pieces do occasionally
turn up and send Ossie Clark collectors into
raptures. These were made from a bolt of unused
1950s python skin that Clark found in a London
warehouse. It has been reported that singer
Marianne Faithfull and Anita Pallenberg (Keith
Richard's ex) still share custody of one such Ossie
Clark snakeskin suit to this day.

Clark designs labeled with gold
or silver metallic thread on a
black background are later,
mass-produced pieces and not
worth much.

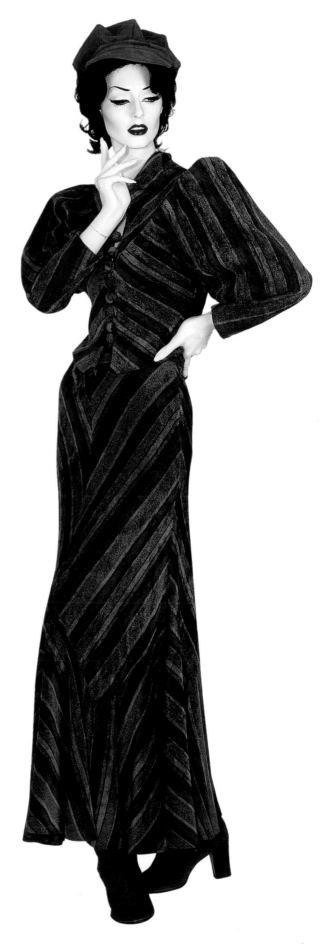

British retro-inspired Maxi suit labeled "Miss Mouse"

ETHNIC STYLES

Running alongside the nostalgia of the 1970s for earlier eras was a passion for exotic lands. Ethnic styles persisted and offered many designers a helping hand through the confusing maze of post-1960s dressing. Yves St. Laurent sent gypsies down the Paris catwalk, while Zandra Rhodes and Thea Porter in London sent a parade of eastern princesses down the King's Road in brightly colored robes and caftans decorated with embroidery, beads, mirrors, and tinkling bells.

The ethnic look in America was more Wild West than Far East. Loads of fringed and beaded suedes by anonymous makers turn up on the vintage market today at very reasonable prices.

For the higher end of American ethnic, look out for pieces by Giorgio di Sant'Angelo, an Italian who worked in America and enjoyed the patronage of *Vogue* magazine's Diana Vreeland. His American Indian-inspired suede outfits with their fringes, feathers, and thong lacings are highly collectible today and have been given a huge push by the eye-popping little vintage Sant' Angelo number that actress Nicole Kidman wore to the première of *Eyes Wide Shut* (1999).

First Paris couture and then Hollywood dictated style during the first half of the twentieth century, but by the late 1960s pop music had taken its place as a force in fashion. By the 1970s, clothing and music had become so intertwined that a group's fashion packaging and image were just as important as the songs that they sang. The various music styles launched or else popularized distinct looks.

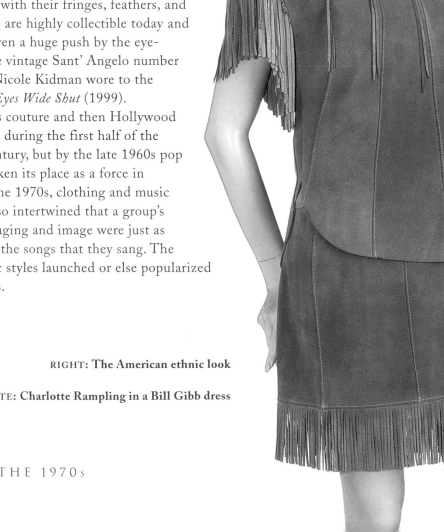

RIGHT: **The American ethnic look**

OPPOSITE: **Charlotte Rampling in a Bill Gibb dress**

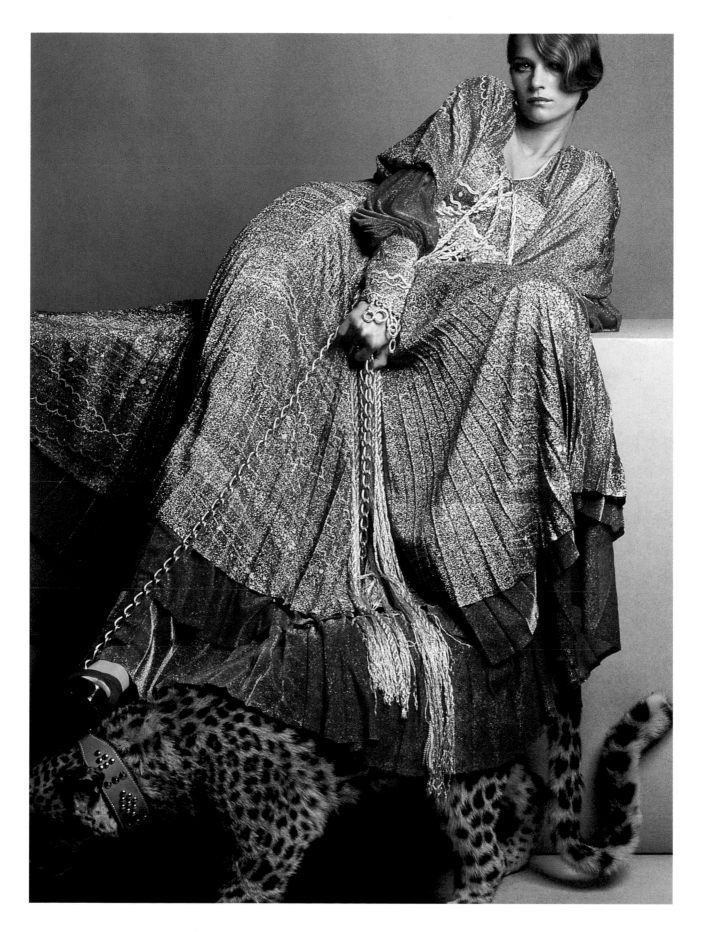

BLAXPLOITATION

Funk music and "Blaxploitation" films like *Shaft* (1971) and *Superfly* (1972) created a fad for the Afro-American look. This started life as a menswear trend but key elements quickly found their way into women's styles.

Pantsuits for women became enormously popular in the 1970s and funk versions sport wide, exaggerated lapels and hugely flared trousers decorated sometimes with metal studs or inserts of patchwork leather. These were worn by both men and women with slim-fitting, slinky, brightly colored polyester shirts. Many fine examples from mass manufacturers like "Monzini" survive from the period and make a wonderful wearable area for collectors on a budget. Leather, crushed velvet, and fur-trimmed maxi coats, plus big, chunky platform shoes were essential to the funky look and hats of all descriptions—everything from the enormous flat "pancake" to gangster type fedoras—were *de rigueur*.

With Afrocentric style so much at the cultural forefront, black fashion designers like Stephen Burrows stepped into the limelight. Burrows was in-house designer for New York's Henri Bendel, where his work was featured in a special boutique called "Stephen Burrows' World."

Early, funkier pieces feature patchworks of suede, leather, and jersey decorated with colorful topstitching and an armory of metal zips, snaps, or studs. Later pieces became simpler and more minimalist. A jersey or chiffon dress with an asymmetrical cut and Burrows' signature "lettuce leaf" fluted hem would be a quintessential find from this later phase.

OPPOSITE: **Marsha Hunt, one of the stars of *Hair***

RIGHT: **Pantsuit decorated with metal studs by Steven Burrows**

GLAM

The dressed-up androgyny of glam rockers like David Bowie and T. Rex's Marc Bolan took the *Superfly* model of man as sartorial peacock in an entirely different direction, inadvertently influencing the way female fans dressed.

For glam rockers, boys will be boys and boys will be girls, so for the first time this century the unisex concept in fashion started to swing both ways. Both Bowie and Bolan launched a full frontal assault on society's definition of masculinity and camped it up on stage in everything from feather boas and sequins to out-and-out dresses. The fans loved it and glam rock clones of both sexes sprouted up all over the world.

Glam belt by London's Mr Freedom

The key to this look is in the name. "Glam" meant glamor and that's what it was—an over-the-top, in your face, high maintenance, flash trash sensibility that left its mark all over the decade, with skintight, fluorescent satins, gold and silver lamé, sequined top hats, feathers, and the tallest, kookiest platform shoes and boots. Face painting came back, along with elaborate glitter makeup, while hair went alarming artificial shades of fuchsia, green, orange, or even a little bit of each.

David Bowie in one of his many gender-bending stage personas, this time as Ziggy Stardust

London's Zandra Rhodes, designer to Marc Bolan, fits in perfectly with the new sensibility and, at the age of sixty, still sports a sort of "bird of paradise" glam rock look today.

Rhodes, along with her countryman Bill Gibb, mark a 1970s return to exotic, decorative clothes on a grand scale that presages the 1980s love of "big" clothes for "big" occasions.

A perfect Zandra Rhodes gown might have huge bat sleeves, pearls, beads, and appliqués all in the floatiest, feel-good, chiffon.

As a former textile designer, Rhodes' fabrics are always interesting. Prints are usually bursting with graffiti, abstract squiggles, lipsticks, cacti, flowers, and stars. Hems can be flouncy and scalloped while pearls, ribbons, and pompoms finish off the look. Zandra Rhodes' 1970s designs already appear in auctions but prices are very uneven and there are still plenty of bargains out there.

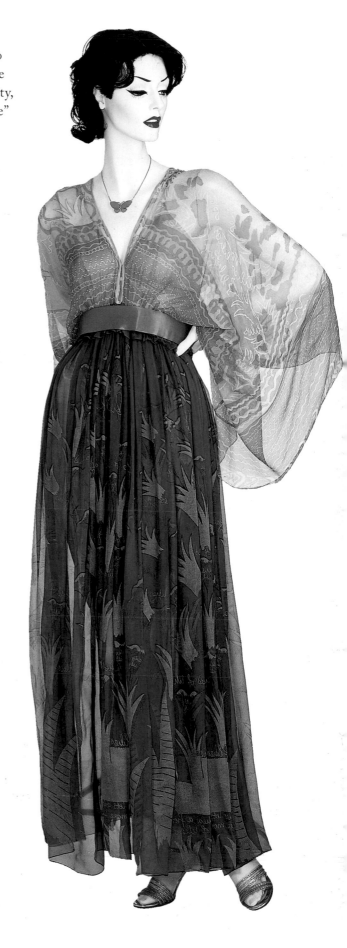

A metallic maxi by Missoni

A Zandra Rhodes' dress, especially a sheer one like this, might bear a label only on its sash so be sure to hang on to all the "extras" or your piece might go from the "labeled" to the "attributed to" category

DISCO

London designer Bill Gibb also did some wonderful glam/disco pieces—complete with rainbow appliqués and rhinestone trims—but he soon moved toward an even more lavish Renaissance-inspired look based on lashings of rich fabric, ribbons, and decoration. He also had an interesting collaboration with the Italian knitwear manufacturers, Missoni. Gibb/Missoni co-ordinating skirt, top, cardigan, and cape outfits are not only very fashionable and trendy today but already change hands at "street style" auctions.

These special "street style" sales, pioneered by Christie's auctioneers in London, focus on the edgier, more recent names in the history of fashion. The 1970s are still wide open because the period is relatively recent so prices can be low but the enormous excitement and publicity generated by these auctions mean that bigger prices are just around the corner—so stockpile your super 1970s stuff before it's too late!

The disco phenomenon, from New York's notorious Studio 54 to its numerous small town spin-offs, turned women into "dancing queens" and underpinned a huge chunk of 1970s fashion. The disco style was all about dressing up to see and be seen and its theatricality follows on from Glam Rock's camp self-consciousness.

Like John Travolta's Tony Manero in *Saturday Night Fever* (1977), the disco dancer threw off the boring nine-to-five world and stepped into a fantasy. Flashing strobe lights, the smoke of dry ice, the pulsating beat, and the glitzy, sexy clothes created a perfect atmosphere for 1970s decadence.

Cocaine and amyl nitrate were the drugs of choice and casual pick-ups and one-night stands became social currency in this post-1960s world of personal and sexual freedom.

Dancers wore satin hot pants and tube tops or sheer figure-hugging disco dresses, which were usually short and made in light, reflective synthetic fabrics like polyester, spandex, lurex, or lamé. Some of the best disco dresses were made by Halston and Norma Kamali.

The American disco queen, from top to toe

British designer Bill Gibb's knitwear using Missoni fabric

OPPOSITE: **John Travolta as Tony Manero in *Saturday Night Fever***

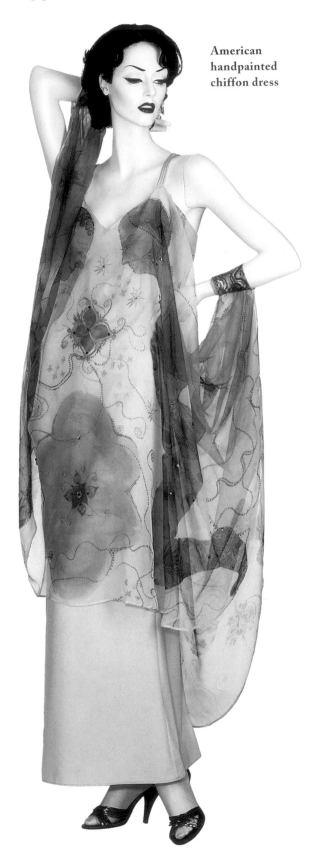

American handpainted chiffon dress

Spaghetti straps and deep décolletage put lots of skin on display, while glitter makeup and lip-gloss got the message across.

The most notorious of all the disco pleasure palaces was New York City's Studio 54, opened in 1977 in a cavernous empty television studio. Door policy was as ultra strict as it was arbitrary. Dozens of famous people were inexplicably turned away by the doorman or the club's owner Steve Rubell, while outrageously attired nobodies could breeze right in. Plenty of celebrities did make the grade, however, and in the thirty-three months that the club operated, Elizabeth Taylor, Andy Warhol, Liza Minelli, Truman Capote, Rudolph Nureyev, and Jackie Onassis joined European aristos and downtown artists for one long non-stop party.

Energetic revelers boogied on the main dance floor, while the danced-out rested and watched from the balconies above. Sex and drugs were on tap in the basement for those in the know and celebrities chilled out in the heavily guarded VIP lounge. Topless male waiters in skintight satin shorts served the drinks while a gigantic effigy of the man in the moon (the club's logo) turned overhead—only at Studio 54 the man in the moon came complete with a coke spoon up his nose!

In this over-the-top atmosphere of anything goes pure hedonism, a plethora of styles vied for the fashion spotlight. Some people didn't bother to wear clothes at all but instead simply painted their bodies silver or gold. Drag queens posing as Marilyn Monroe danced with captains of industry wearing conservative three-piece suits while S&M leather types cavorted with the Beautiful People decked out in Halston couture.

Bianca Jagger and Liza Minnelli at Studio 54 in New York. For her birthday celebrations Bianca rode through the club on a white horse led by a black man. She wore Halston and he wore nothing but a light dusting of gold glitter

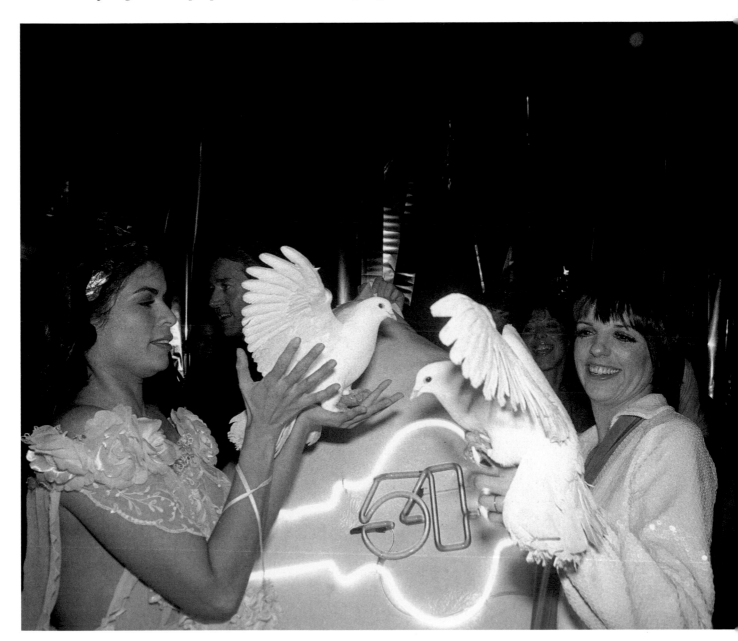

THE DECADE THAT TASTE FORGOT

Fashion designer Betsey Johnson says that, by the 1970s, "everyone wanted to trash the 1960s" and the search for something new but equally exciting culminated in some of the most toe-curling kitsch of the century. The hugely popular strapless "tube top" (or "boob tube") was made from a tube of elastic fabric. These glittered with metallic thread for night-time wear while demure cotton print and lace versions came out by day.

Today, both tube tops and that other 1970s favorite, the slinky polyester halter top, show up at flea markets and boot sales for next to nothing. These both came in an enormous variety of colors and prints, so they are a cheap and cheerful area for super 1970s collecting.

If you can't afford the already pricier designer versions of 1970s fashion souvenirs, anything ultra-kitsch is always worth snapping up because it's so typical of the decade. Lurid colors, skintight satin, bomber-style jackets, big lapels, wide bell bottoms, and that proud label of the 1970s—"100% polyester"—are well worth looking out for. Some wonderful mass-produced trouser suits, capes, and maxi-coats emerged from the period. Anything with a kitschy print, studs, leather inserts, or wild appliqué work would be worth collecting as prices are still rock bottom. As interest in the period grows, however, prices will rise. Fiorucci in Italy and Mr. Freedom in London made some wonderful kitsch clothes; keep your eyes peeled for these labels.

An American lace and appliqué pantsuit worn with a funky denim

This British Maxi coat is a typical funk/glam synthesis of velvet, faux fur, and diamanté

AMERICAN CLASSICS

In response to the tackier polyester excesses of 1970s fashion, there was a move toward a new classicism, a call for "real clothes for real people." This was an American-led movement based on natural materials like cashmere, linen, tweed, and suede in a range of tailored separates that answered the needs of the 1970s working woman.

Calvin Klein—dubbed the "King of Unclutter"—and Ralph Lauren opened the door on this sort of sensible dressing, much of it based on classic menswear looks which were easily absorbed into the gender bending unisex world of 1970s fashion.

In fact, Lauren dressed Diane Keaton for the 1977 film *Annie Hall*, which put legions of trendy young women in men's ties, vests, and blazers.

The new 1970s minimalism was perhaps best epitomized by Halston. He started his high fashion life as a milliner and introduced Jackie-O to her famous pill-box hat. By 1966 he was designing clothes and by the mid-1970s he had firmly established himself as couturier and designer to the stars. "You're only as good as the people you dress,"

he famously said and Halston dressed them all, especially the Studio 54 crowd, who elected him King of the Club to Liza Minelli's Queen.

Halston's clothes were radical in their simplicity. His silk jersey dresses, tunics, and trousers were cut so beautifully that they did not need buttons, bows, flounces, or even collars or cuffs to draw attention to themselves. This new minimalism provided a way forward in the dressed-up, stylistic chaos of the decade.

Certain quintessentially 1970s Halstons are already very collectible on today's vintage market and remain as wearable now as they were then. His long, beautifully flowing jersey evening gowns are very sought after, along with his "ultrasuede" wrap coats and day dresses. His cashmere twin-sets, with their long cardigans, are always a great find and his somewhat anomalous tie-dyed chiffons have their fans as well.

Halston and the "Beautiful People" wearing his creations.

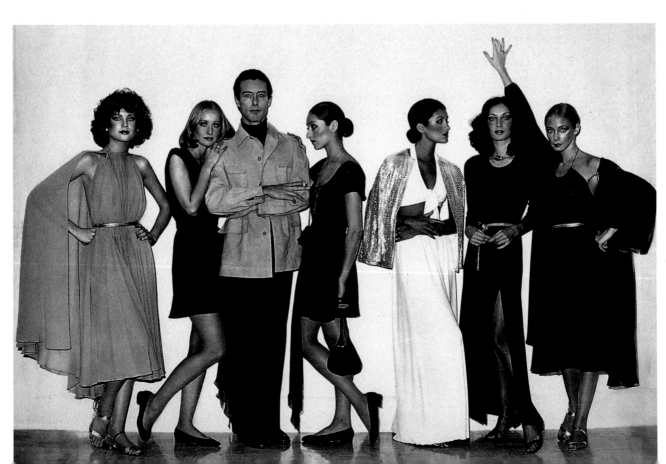

The collector, though, must always be careful, not only with Halston but with all post-war designers, as most produced a hierarchy of different lines which vary enormously in price and quality. This practice increased as the decade wore on.

Many pre-war giants like Poiret, Schiaparelli, and Fortuny have ceased production and clothes are no longer made bearing their labels, but the names of many successful post-war designers are still used by clothing companies today. These later pieces, though they share a label, have nothing to do with the pieces that are valuable on the vintage market today. For example, a piece labeled Halston III or IV is not at all collectible, while a piece simply marked "Halston" may well be.

The answer is to train your eye. Look at as much as you can in auctions, vintage stores, even old magazines, and learn to recognize key stylistic features of each particular era. A trained eye is the only way through the confusing maze of modern mass-produced "diffusion" lines and licensing agreements.

There are certain key 1970s details that can help to authenticate a piece if you are in doubt. Cowl and bow necks were popular, along with Dolman or bat sleeves. Dresses were often backless and deeply cut at the front and fell in irregular handkerchief or lettuce hems.

An American polyester disco dress with handkerchief hem

Diane von Fürstenberg

The belted wrap front was also a very important 1970s feature, appearing on dresses, coats, jackets, and cardigans, and the greatest wrapper of them all was Diane von Fürstenberg.

As the ex-wife of a German prince and the onetime girlfriend of Richard Gere and Warren Beatty, Diane's glamorous jet-set lifestyle no doubt helped to shift some of the millions of dresses she sold during the decade, but the bottom line is that these were some of the prettiest, most flattering, sexy, and, at the same time, practical creations of the post-war years.

They came in cotton, rayon, or silk jersey, in a wide variety of eye-catching prints. These beauties suited many different body shapes and sizes, and worked equally well for day and evening. From the moment they appeared, women collected Diane's dresses and they are still hotly pursued by today's vintage enthusiasts. Because such huge numbers were sold, there are still a lot of originals out there but prices are rising—don't hesitate if you find a good one. You must, however, be aware that Diane has recently relaunched the wrap dress and other clothing, first on the American Home Shopping Network and later in the shops, so don't pay a vintage premium only to end up with just a modern re-issued piece.

While hemlines fluctuate between mini, midi, and maxi, the feminist-fueled 1970s saw the mainstream acceptance of pants for women at all levels of society and variations on the pants theme proliferated. While bells and flares are perhaps the best remembered trouser shape of the decade, jodhpurs, baggies, pyjama pants, culottes, and all-in-one jumpsuits also appeared, just to confuse the issue.

As global mass marketing and advertising became more sophisticated in the 1970s, the cult of the designer grew, prefiguring the huge importance that label and logo dressing was to assume in the 1980s.

By the later decade, even jeans come to defy their earlier incarnation as the ultimate symbol of classless, unisex equality. Calvin Klein stitched his name on the seat of Brooke Shields' pants, took some beautiful pictures of her wearing them, and from that moment we had lift off. Labels migrated from the inside to the outside of garments. Just before we slipped into the designer feeding frenzy of the 1980s, however, there were snarls of dissatisfaction with the slick, over-packaged fashion and music culture that had come to dominate the later decade.

"Nothing comes between me and my Calvins"—Brooke Shields in an ad for Calvin Klein jeans

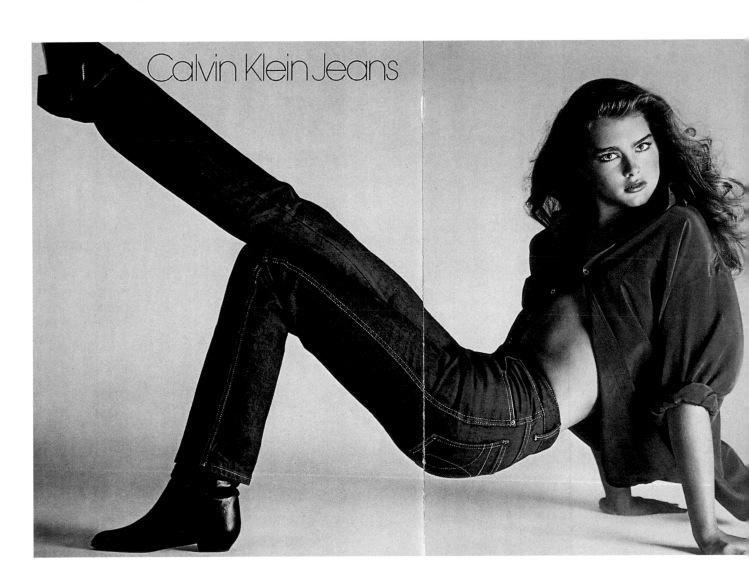

FASHION IN CRISIS: THE NEW BRUTALISM

The 1970s world wasn't, of course, one big non-stop disco party. It was frightening and insecure too. Radical political groups like the Black Panthers and Baader-Meinhof were formed and the gentler, more passive resistance of the 1960s hippie protest turned violent. Bombings, hijackings, and hostages hit the headlines while the world was thrown into deep economic recession and an energy crisis, tearing down the consumer utopia of the 1950s and 1960s.

The "Punks"—a rabidly anti-hippie subculture—came to the fore, claimed "we just want to be hated" and used the illicit iconography of kinky sex, Nazism, political anarchy, and self-mutilation to get their message across.

From bondage trousers to the now legendary "Destroy" T-shirt, from the Sex Pistols to The Clash, Punk music and fashion blew the 1970s sky high. The movement started with an informal assortment of disaffected British teenagers hanging around on the King's Road and then, with Vivienne Westwood and Malcolm McClaren at its helm, it snowballed into one of the biggest media happenings of the decade. "The Punk" became an internationally recognized British icon. Punk style still continues to have an impact on worldwide fashion today.

> The Punk look—subversive, violent, confrontational—offered an antidote to the 1960s hippie hang-over that had dogged the decade's popular culture and become not only stale, but wildly out of touch.

NEW MUSICAL EXPRESS
By the mid-1970s, the pop heroes and rebels of the previous decade were over thirty—"a gerontocracy of boring old farts" wrote the *NME* (*New Musical Express*) magazine—not only old but also by now ultra-rich. Their flashy lifestyles and slick, professionally packaged music seemed impossibly distant from the harsh realities confronting many British teenagers. The country was in deep recession, unemployment was at an all-time high, schools were ridiculously underfunded and huge, impersonal post-war tower blocks created a landscape of frightening and dehumanizing urban decay.

A new youth revolution was desperately needed, one that expressed the feelings of this unemployed, depressed, undereducated generation. So in contrast to the "Summer of Love," 1976 became the "Summer of Hate" and Punk style was born.

McCLAREN AND WESTWOOD
Vivienne Westwood started her professional life in London on a teacher training course and is remembered by a fellow student as "a star pupil... potentially the greatest primary school teacher of her generation."

Luckily for the fashion world, her interests and innate creativity led her in another direction and she is now one of Britain's greatest designers—eccentric, controversial, sometimes shocking, but always utterly original.

Her spectacular career began in partnership with pop impresario Malcolm McClaren. The pair first hit the headlines in 1974 as proprietors of "Sex," a boutique on the King's Road in Chelsea that gave a high street profile to the bondage and fetish fashion that had long been available, though only discreetly, through mail order and underground outlets.

OPPOSITE: **"They were dangerous clothes. You had to have balls to wear them. You'd get confronted in the street and you'd have to stand up for yourself."**

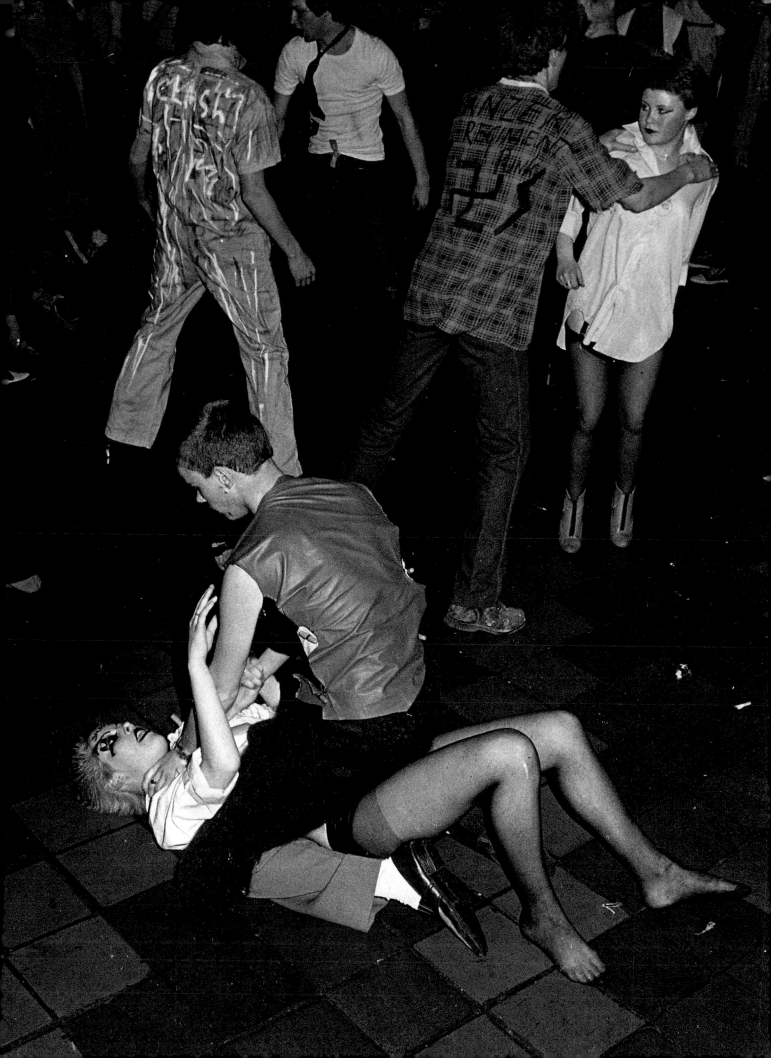

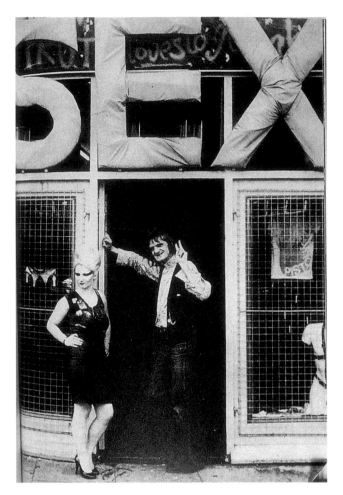

Shop assistant Alan Jones was arrested in London in 1975 for wearing "Two Naked Cowboys" in public and the police subsequently raided Sex, arresting McClaren and Westwood in a blaze of valuable publicity.

At the somewhat surreal T-shirt trial, the judge had the distance between the two naked cowboys' members carefully measured before ruling that Westwood and McClaren were indeed guilty of "exposing to public view an indecent exhibition." They were fined and banned from selling the design, which they in fact continued to sell covertly from under the shop counter.

The aim at Sex—and later, Seditionaires—was to disturb and challenge received ideas about sex, society, and tradition. Shock tactics seemed the easiest, most direct way to do this.

Punks used tampons as dangly brooches, hair went pink, spiky, and dangerous, while makeup was morbidly macabre. Anything that smacked of extreme bad taste was grist for the mill and bored, displaced teenagers found themselves shaken out of their apathy in this new, exciting world where old taboos became the stuff of fashion. "Fuck your mother and don't run away, Punk" exhorted one of McClaren and Westwood's popular slogan T-shirts. Nothing like that had ever been openly sold on the high street before.

A T-shirt dress by Vivienne Westwood for Seditionaires featuring an iconic image of Marilyn Monroe graffitied with obscenities and squiggles of faux urine

While hard-core sexual adventurers were always welcome at Sex, McClaren and Westwood aimed their often customized clothes at a more mainstream audience of clubbers, disaffected teenagers out to shock, and fashion victims who simply couldn't get excited by Halston, Calvin Klein, or the Abba-inspired disco fashions on offer.

The shop featured a stack of headless mannequins, arranged orgy style with long strips of surgical rubber on the walls, and a selection of whips, chains, nipple clamps, and eyeless masks scattered willy-nilly.

At Sex, the famous McClaren/Westwood slogan T-shirts took off, becoming increasingly provocative and offensive, exploiting themes and subjects previously thought of as unmentionable. The Cambridge Rapist, a notorious serial killer, was immortalized in cotton; Micky and Minnie mouse engaged in a sex act, and "Two Naked Cowboys" stood face to face in full cowboy gear, with penises drawn.

Customers flocked to the King's Road, the media swarmed and the police only added to the shop's street credibility by raiding the premises on a regular basis.

Westwood started out "customizing" ready-made clothes rather than designing and producing them from scratch. She might cut out arms, slash and tie areas of cloth, and sometimes turn garments inside out before she started work on them, and she decorated pieces with lavatory chains, feathers, studs, paintings, slogans, even bones. This do-it-yourself handmade look was quickly adopted by kids who felt disgusted by the slick, packaged, mass-produced 1970s world and Westwood's reputation grew among the fed-up and disaffected.

The big push though came with the Sex Pistols, the band McClaren cobbled together in 1975. It was centered around two local lads who hung around the pubs at the World's End part of the King's Road: John Lydon and John Beverly a.k.a. Johnny Rotten and Sid Vicious. Before becoming two of the Punk movement's most revered and hated icons, they became not only Malcolm McClaren's contractual property but walking, talking, outrageously behaved billboards for McClaren/Westwood clothes. The link between the music and "the look" was so strong that lyrics from Sex Pistols songs were actually printed on to the clothes, so the clothes sold the music which sold the clothes.

This ushered in a new phase and the King's Road shop was redesigned around the theme of the bombed city of Dresden complete with searchlights, faux bomb damage, and a live rat pacing in a cage. The message now turned away from the purely sexual, focusing on the band's themes of anarchy and sedition.

This new 1976 venture was renamed "Seditionaires." Clothes dating from this period are labelled "Malcolm McClaren and Vivienne Westwood, Seditionaires." They were sold under the logo "Clothes for Heroes" claiming to be intended for "soldiers, prostitutes, dykes, and punks."

Johnny Rotten, lead singer for The Sex Pistols, a band which brought punk ideology and style into the international limelight. The band was managed by Malcolm McClaren and dressed by Vivienne Westwood

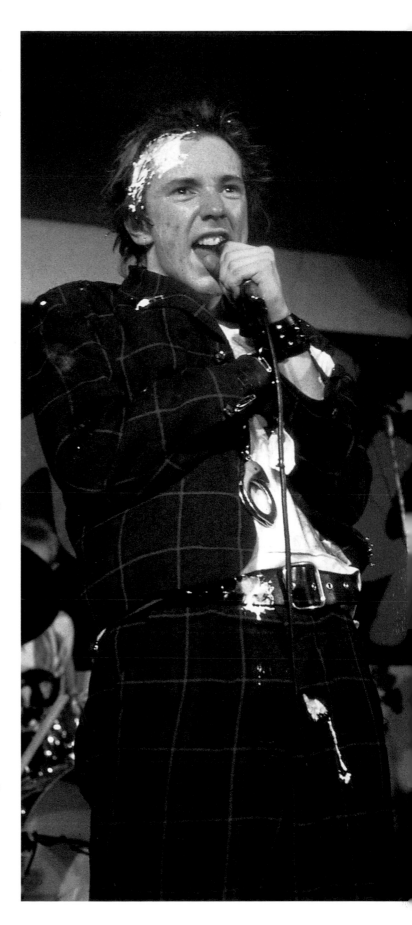

Malcolm McClaren (above): Prankster, packager of The Sex Pistols and co-owner, with Vivienne Westwood (left), of Sex and Seditionaires, world-famous shops that went against the post-hippie grain of the 1970s

A key piece from the Seditionaires, Punk era is the "bondage trouser," based on standard issue army trousers with bondage straps between the knees, along with various zippers running up and down the leg and even under the crotch. A loincloth of toweling material—called a "bum flap"—was attached at the rear. The earliest bondage trousers were made in black sateen while later ones favored tartan wool. These were often worn with a "parachute shirt" or jacket which also had a paramilitary look but sported various straps secured by a ring in the middle of the chest, making it reminiscent both of bondage gear and a hospital strait-jacket. These were usually decorated with a slogan like "Only anarchists are pretty" and often sported the "A" anarchist symbol as well. Bondage trousers could also be worn with Westwood's mis-shapen spider-webbed mohair sweaters, which are very collectible today.

Confrontational T-shirts continued to be a favorite medium for the message, although gauzy, long-sleeve muslin shirts also became canvases for Seditionaires' cult graffiti. Slogans were culled from the *Anarchist's Cookbook* (which gave recipes for, among other things, Molotov Cocktails) or else assembled from a subversive bricolage of popular culture. One of the most typical and now most valuable of the slogan clothes is the notorious "Destroy" shirt, which came both in muslin and as a cotton T-shirt. The shirt depicts Christ crucified upside down and surrounded by swastikas, an image of the Queen of England's severed head and lyrics from the Sex Pistol's hit "Anarchy in the UK."

Early McClaren/Westwood pieces from Sex and Seditionaires have a devoted cult following of vintage collectors. The most sought after pieces are the early customized shirts Westwood made by hand on her kitchen table. The "Venus" shirt with its metal studs, cut-outs, attached chains, and bike tyre shoulders, trailing wisps of real horsehair is one such Holy Grail. Another is the infamous "Perv" shirt, upon which the word is spelled out in real chicken bones that Westwood collected from a local Italian restaurant before they were drilled and applied. Alice Cooper, infamous for biting the heads off live chickens as part of his act, is reputed to have bought one of these in the 1970s.

These early hand-dyed, handprinted slogan T-shirts and muslins are now very valuable, but be warned: they were made only in the most limited quantities and as demand and prices started to rise on the vintage market of the 1990s, fakes began to appear and, as the whole point was for these clothes to look scruffy and homemade to begin with, they are easy to fake today.

Further complicating the issue is the fact that Westwood and McClaren's printing screens were sold to the London company Boy in the mid-1980s. Boy then mass-produced dozens of versions of the shirts that are nowhere near as valuable. Original authentic slogan clothes will usually appear to be in very bad shape as Westwood often distressed them before printing and the dyes were not perfectly colorfast so they often ran and faded in the wash.

While McClaren/Westwood's early designs already command huge sums at street-style auctions, many Punks made their own clothes and these turn up on the vintage market at far more affordable prices. Clothes and studded black leather jackets, with handpainted slogans, graffiti, and decoration are good souvenirs of this brief, but important era in post-modern fashion history.

Punk's roots can be traced to films like *The Rocky Horror Picture Show* (1975) and the mid-1970s music scene in America, where bands like The New York Dolls sported the torn fishnets, safety pins, and dog collars which also appear in the iconography of British Punk

A slicker version of Punk's fascination with violence and the seamier side of sexuality appears in some of the most influential fashion photography of the decade. Helmut Newton played with images of female sexual aggression, bondage, violence, and "model as prostitute" in much of his work during this period. Guy Bourdin explored the relationship between sex and death in a particularly controversial ad for Charles Jourdan, which took the scene of an apparently fatal car crash as a platform for selling expensive shoes. Some argued that this type of imagery degraded women but others claimed that it liberated them from the previously rigid division between sexless mother figure and shameless whore. This style of photography certainly sold a lot of clothes and excited a jaded 1970s palate exhausted by too much cocaine, too much sex, and too much disco.

ACCESSORIES

Accessories in the 1970s were as eclectic as the clothing styles and the various looks and styles each came with unique extras.

Ethnic jewelry reigned supreme. There was a huge craze for Native American turquoise and silver pieces to accompany the rustic landscape of fringed suede and denim that stretched to the horizon. Each tribe has its own particular style but, very roughly, Navajo work tends to feature large natural chunks of turquoise and coral, while Zunis specialized in detailed inlay work and beaded necklaces of carved animal fetishes. Although an enormous amount of this jewelry was produced, it remains inexplicably scarce on the vintage market today and prices are high, so turn out your jewelry boxes.

American disco medallion

If you're interested in the simpler side of silver, track down some of Elsa Peretti's work from the now highly collectible jewelry line that she designed for Halston.

Yves St. Laurent turned his hand to costume jewelry in the 1970s and 1980s, and the bold, showier pieces also bring good prices at auction.

There are loads of cheap and cheerful jewelry souvenirs out there too. Enormous disco medallions that once lay buried in men's bare hairy chests, "mood rings" that were claimed to change color according to the wearer's temperament, and a galaxy of zodiac jewelry that brings back (with toe curling vividness) that seminal 1970s disco pick-up line, "Hey baby, what's your sign?"

While vintage disco bags are not extremely valuable, they give an authentic twist to any 1970s outfit

American bead and sequin disco bag

As far as bags go, the shoulder strap was the big 1970s story and even the Hermès Kelly bag responded to the challenge. There was a (now very collectible) early mobile phone bag by Dallas handbags featuring a real working telephone, although in those days it had to be plugged into a telephone point. Tiny disco bags, large enough to hold only a key and a $50 bill, came on a long cord and were worn across the chest for hands-free boogying.

Suede and tooled leather shoulder bags were popular for hippy-esque daywear, while a hard, plastic, folded-over magazine clutch bag appealed to sharper dressers.

This highly collectible clutch bag takes the form of a folded magazine

The 1970s saw a return to hats and the retro mood led to a revival of 1920s cloches and 1930s turbans. Men's funky superfly hats came in leather or crushed velvet and sometimes sported feathers on decorative hatbands. While 1970s hats are not hugely valuable, they do lend authenticity to an outfit and make for some smooth-looking moves on the dance floor.

The biggest accessory story of the decade of course was the return of the platform, the perfect clunky shoe to balance those wide bell-bottomed trousers. Platforms had not been seen or heard from since the late 1930s and 1940s, so they looked quite revolutionary in their reincarnation. The use of cork soles meant that platforms could rise four, five, or even ten inches without being overly heavy. Some cork platforms were left natural while others were decorated with strips of brightly colored leather or snakeskin, then glammed up further with the glitter or patchwork that was already so popular in clothing.

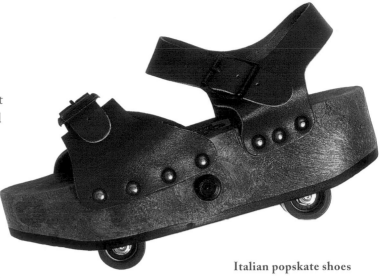

Italian popskate shoes

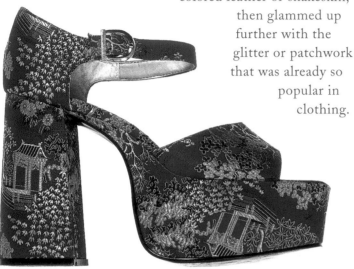

Chinoiserie platforms

Platforms were either one continuous parapet as in Salvadore Ferragamo's legendary 1930s creations, or else 1940s style with a platform at the front and a tall chunky ferrule heel and ankle strap at the back.

Hotpants cried out for boots and these got the platform treatment as well. Biba did wonderful platform shoes and boots which are highly collectible today, along with Ossie Clark's snakeskin versions which customers have been known to fight over in vintage stores.

For the true aficionado, the most sought after platforms of the 1970s were made by the Englishman Terry de Havilland, whose business card read "Cobblers to the world."

The stacked heel T-strap recently revived by Prada was another 1970s classic, along with wedge soled espadrilles and Fiorucci's famous plastic jellies.

Sneakers got the disco glitter treatment as well, complete with high heels. Examples of these by Terry de Havilland or Norma Kamali already bring high prices at street style auctions.

In the "Kitsch is King" atmosphere of the 1970s, some particularly bizarre shoes emerged. One sported a clear plastic "aquarium" platform, in which a live goldfish unhappily tried to swim. Pop skates were designed to convert from platform sandals to platform roller skates at the flick of a button. Famolare's "Amsterdam" shoes were a huge, brightly colored fiberglass version of the traditional Danish clog.

Vivienne Westwood, godmother to the Punk generation, stubbornly avoided platforms in this decade and went for perfectly flat bondage boots and, of course, the now iconic Doc Marten steel-toed, black leather lace-up. Although the aggressive paramilitary look of these boots appealed to the 1970s Punk subculture, they were originally invented in the 1950s by two Germans, Dr. Klaus Maertens and the engineer Herbert Funck, as an orthopedic shoe.

OPPOSITE:
Fiorucci platforms in wood and plastic

Doc Martens Air Wair lace-up boots

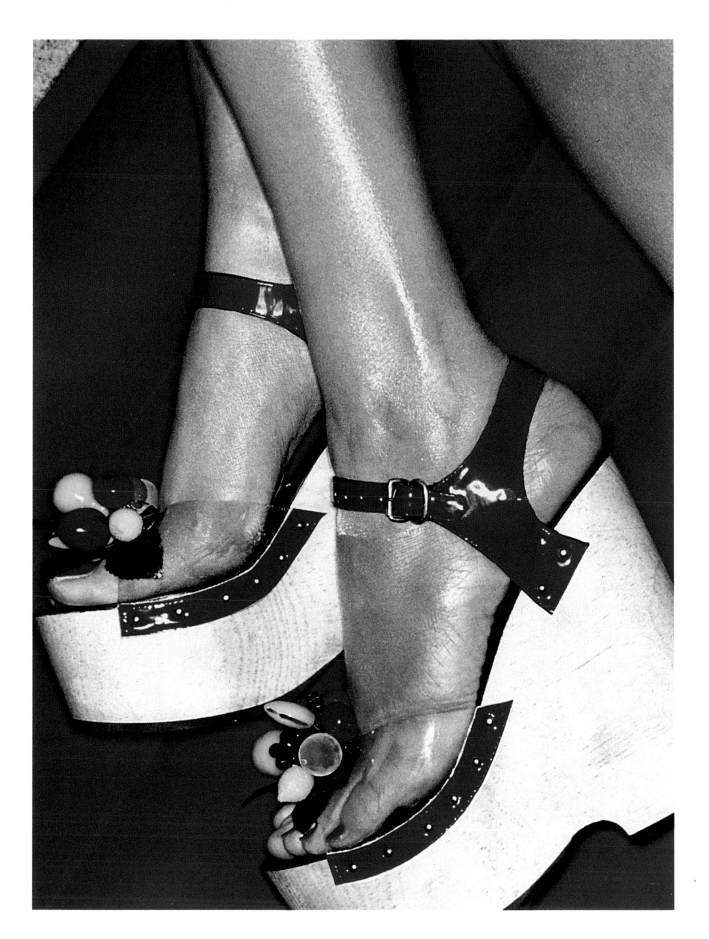

HAIR AND MAKEUP

Face painting continued and grew more outrageous under the tutelage of David Bowie and the glam rockers. Their bristly, multi-colored, stand-up "rooster" hair was taken to new heights later in the decade by the Punks with their trademark Mohican hair sculptures.

Mainstream hair was either long, lank, and center parted or long, layered, and hugely blow-dried in the style of 1970s TV icon and pin-up Farrah Fawcett.

Disco spawned a vogue for glitter nail polish, "wet look" lip-glossed lips and dramatic nighttime makeup in jeweled colors, while celebrity makeup artist Way Bandy's lighter, dewy look found its way into much of the fashion photography of the decade.

The healthy, natural, outdoor style of supermodel and 1970s icon Lauren Hutton carried on this theme and created a taste for carefully applied makeup that did not look like makeup.

LEFT: **The punk look was confrontational and tribal, meant to shock outsiders, and mark insiders as members of the tribe**

Farrah Fawcett (center) of *Charlie's Angels* **launched a generation of blow-dried, feathery hairstyles that came in small, medium, and extra large**

KEY DESIGNERS

YVES ST. LAURENT

Yves St. Laurent remained a strong force in fashion throughout the decade and explored all the various threads of 1970s style. The period's fascination with androgyny was catered to by St. Laurent's "Le Smoking" tuxedo for women, an idea he first developed in the later 1960s. These earlier YSL pantsuits are now very collectible. Radical chic came out in his simple, military-inspired khakis, while an ethnic theme underpinned his 1976 Russian collection of Cossack coats and long gypsy skirts as well as his later Chinese fantasy of golden brocades.

Pieces designed by St. Laurent in his short stint as head of Dior from 1957–60 are extremely valuable today and his A-line trapeze dresses, produced both for Dior and under his own label from 1962 and beyond, can be similarly pricey.

Again, you must be careful with St. Laurent in any decade because the seriously valuable pieces are the rare couture ones. As a great believer in ready-to-wear, St. Laurent also produced a lot of cheaper inferior pieces. For example, 1960s and 1970s St. Laurent "Rive Gauche" labels for his boutique line are collectible, but not as valuable as couture from this period.

MISSONI

Knitwear was big in the 1970s and some of the best, most collectible pieces were made in Italy by husband and wife team Tai and Rosita Missoni. The Missoni look is based on thin lines of flecked color, straight or zigzagged, arranged in various geometric patterns all on the same piece. Their classically cut dresses, pants, cardigans, blouses, and capes tend to be simple shapes so as not to detract from the beauty and interest of the fabric itself. The various pieces do not usually match exactly but because the fabric is so distinctive they coordinate.

1970s name check
Look out for Diane von Fürstenberg wrap dresses, Missoni Knits, Mary McFadden's hand-painted silks, Halston ultrasuede and liquid jersey, Bill Gibb, Ossie Clark, Thea Porter, Zandra Rhodes, McClaren/Westwood, Peter Max's Pop Art prints, Stephen Burrows, John Anthony's wrap dresses, Yves St. Laurent, Geoffrey Beene, Giorgio Sant'Angelo, and early Chloé. Late 1960s and 1970s pieces by these designers appear regularly in top auction rooms and good pieces bring good prices.

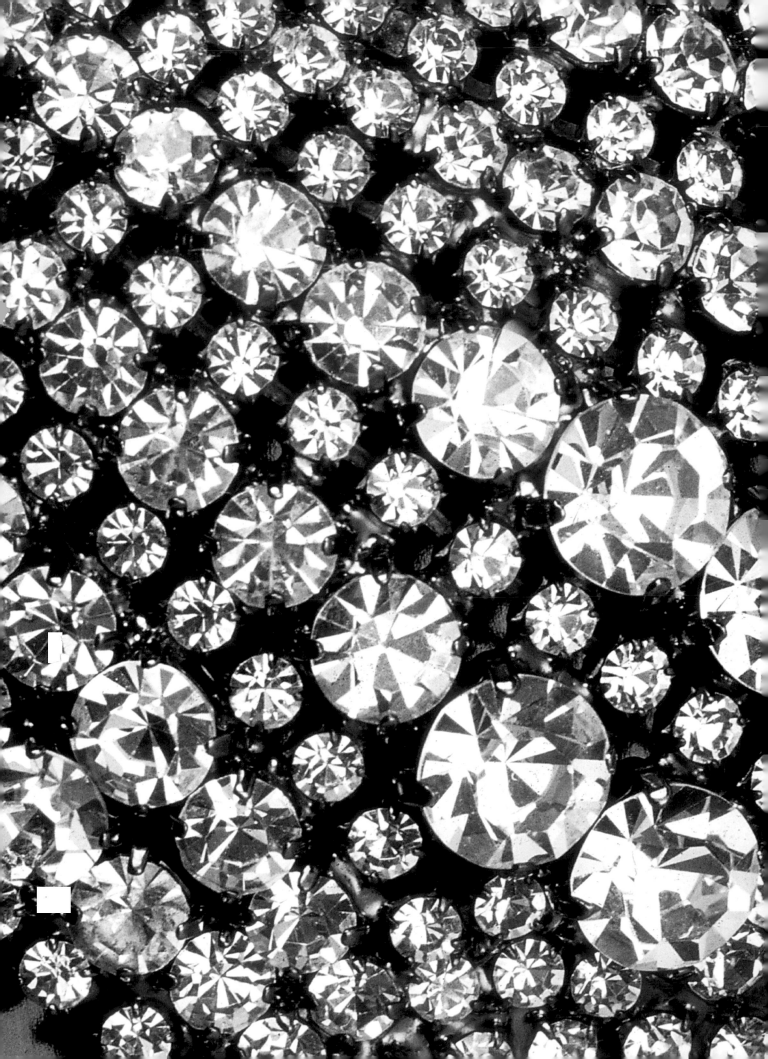

THE 1980s

How to Get Ahead in Power Dressing

In the "Gimmie Decade" of the 1980s, many played the money game and a new breed of urban capitalist emerged, proudly dedicated to the pursuit of money, power, and all the trappings of conspicuous consumption— the "Yuppie" or young, urban professional was born. As one popular motto of the day put it, "Whoever dies with the most toys, wins." *Wall Street* (1987) film character Gordon Gecko told us "Greed is Good," while the trickle-down financial policies of Ronald Reagan and Margaret Thatcher encouraged a "shop till you drop" mentality of spend, spend, spend that was portrayed as almost patriotic.

THE YUPPIES

Many Yuppies felt a need to display their wealth, so "dress for success" fashion became a form of self-advertisement and self-promotion, both for those who had made it and those who hoped someday they would. The street-style looks of the young and penniless were swept aside in favor of an opulent look and the fashion designer quickly became a superstar. Even the couture and its $30,000 dress was pronounced cool.

The fashion pack has been whispering about a 1980s revival for several years now, but for most of the 1990s, the 1980s look was just too painfully fresh in our minds so nothing really materialized. Lately though, some of the edgier, youth-oriented fashions have shown 1980s-inspired designs, along with 1980s originals. A full-scale revival is right around the corner so now is the time to start stockpiling your 1980s gear while it's still undervalued and, in some cases, dirt cheap.

From the working girl to the ladies who lunch, from Yves St. Laurent to Moschino and the spin-offs they launched, the big shouldered "power dressers" skirt suit is an archetype of the 1980s look. Mythologized in films like *Working Girl* (1988) and prime-time soaps like *Dallas* and *Dynasty*, good 1980s suits by key designers will become sought after when that inevitable revival rolls around.

While most business suits were black, beige, or navy, evening or "power lunch" versions came in a range of jewel colored wools. Jackets were either long, boxy, and hip skimming or else flared by a Dioresque peplum. The only constant was the huge pair of shoulder pads that provided that "linebacker" look, emphasizing a tiny waistline and tight, gym-honed buttocks. Long, toned legs were in as they usually are and very much on display, set off by towering heels, preferably by Manolo Blahnik.

Nearly every designer of the decade dabbled in suits, but some of the best and most collectible came from Yves St. Laurent, Karl Lagerfeld, and Thierry Mugler, who exaggerated that 1950s hourglass shape to cartoon-like proportions. Such suits are still relatively cheap on the vintage market.

Melanie Griffith in *Working Girl*

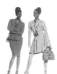

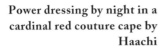
**Power dressing by night in a
cardinal red couture cape by
Haachi**

Hair and makeup
Power dressing was a high-maintenance, ultra-groomed look so makeup became heavier and more dramatic. Big, regularly coiffured hair à la *Dallas* and *Dynasty*, plus carefully manicured feet and nails, testified to the existence of lots of disposable income, more than enough to finance frequent and regular visits to top salons.

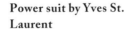
**Power suit by Yves St.
Laurent**

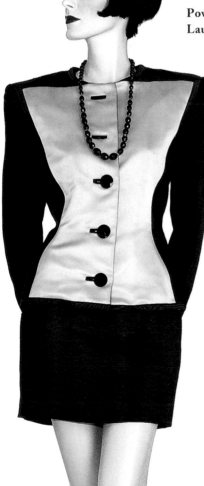

Shoulder pads found their way into dresses, jackets, coats, suits, and even casual knitwear and exercise clothing.

 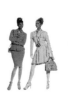

LACROIX

Although the "power suit" was a key daytime look, elaborate over-the-top cocktail dresses and gowns ruled the night. The Yuppies were forever organizing balls, and openings—thanks to their "Work hard, play hard" ethos. Here, the "If you've got it, flaunt it" mentality expressed itself in some of the most theatrical, flamboyant dressing of the twentieth century.

Enter Christian Lacroix, couturier extraordinaire to the evening extravaganza of the 1980s. Although he'd worked for Hermès and Patou earlier in the decade, Lacroix burst in on the late-1980s scene with his own truly over-the-top collections. Lacroix's best pieces were his big, showy, fitted evening gowns, flaring at the hem like a flamenco dancer's or swelling with petticoats of alarming proportions. Others were out and out puffballs (called "poufs") with tight fitting corset tops. Rustling taffetas and shimmering silks were decorated with bows, flounces, ruffles, and bustles in fuchsia, royal blue, and other colors not commonly found in nature. Deeply cut necklines left plenty of space for elaborate jewels, both real and fake. Lacroix's love of eighteenth-century France and the opulence of the Ancien Regime was well suited to the 1980s "Let them eat cake" spirit and, along with his rival Karl Lagerfeld, Lacroix led the way for the revival of "couture" fashions and designer superstars.

A Lacroix couture creation could cost upwards of $20,000, so even during this ultra-consumer decade relatively few were produced. These are definitely worth buying on the vintage market and will soon come to command serious prices. The 1980s couture pieces out there,

Drawing for a Lacroix couture evening gown

however, are still generally a bit sluggish in the show rooms today because the period is too close for us to stand back and assess it properly. It will become a big area for serious collecting in the very near future though because this decade, like the 1950s, was a real couture highpoint.

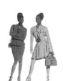

Look out for pieces by Emanuel Ungaro, Chloé, Moschino, Yves St. Laurent, Chanel, and Karl Lagerfeld.

If you find couture thin on the ground then go for prêt-à-porter pieces by these French designers or their American counterparts like Geoffrey Beene and Bill Blass. Snap up suits or anything lavish in eveningwear, preferably strapless or one-shouldered with bows, beading, ruffles, flounces, and even feathers. Leather suits with huge shoulder pads are well worth buying too, along with spectacular knitwear, especially funky animal designs by Italian manufacturers like Krizia.

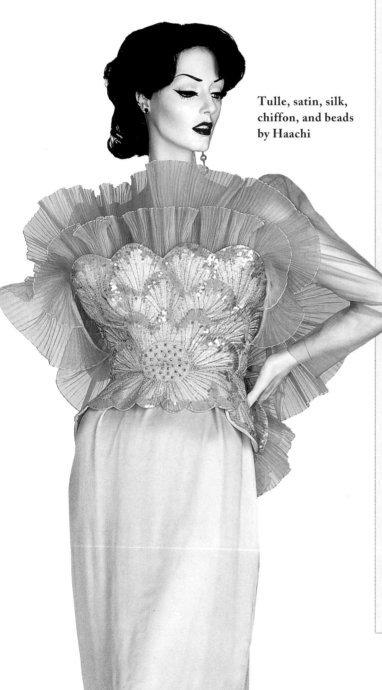

Tulle, satin, silk, chiffon, and beads by Haachi

Puffballs

Vivienne Westwood's "mini-crini" (meaning mini-crinoline) was probably the first "puffball" or "pouf" of the decade, but with Christian Lacroix, the puffball became an overnight sensation and found its way on to everything, from couture originals to chain store knockoffs. Love 'em or loathe 'em, the puffball and the big-shouldered power suit is so instantly recognizable that it has come to epitomize the decade. In response to a rash of 1980s-theme costume parties, the puffball has bloomed again on vintage racks worldwide. Prices for "no name" poufs are reasonable and even designer versions will not break the bank. But the problem is that nobody is sure if you are actually allowed to wear your puffball again after the party's over.

A quintessential American puffball, unlabeled

"I couldn't design a pouf if you put a gun to my head."

Calvin Klein

LAGERFELD AND CHANEL

The legendary Coco Chanel died in 1971 and sadly the "Chanel magic" seemed to have gone with her until German-born Karl Lagerfeld took over as design director in 1983. He took the classic—some might say now "frumpy"—Chanel signature touches and infused them with his own vision, turning the whole look on its ear. The result was instant cool and Chanel went center stage for the rest of the decade.

Lagerfeld took the traditional mid-calf length Chanel skirt, slashed the hem, and came up with a micro-mini suit. He used electric pink and lime green tartan tweeds, along with denim and leather, and he took Chanel's classic baroque pearls, traditionally made by the Maison Gripoix in Paris, and blew them up to the size of golf balls while her honey-colored old gold chains went shiny and brash.

Lagerfeld's vocabulary of in-your-face overstatement was nowhere more successful than in his use and some might say "abuse" of the "CC" logo. Coco herself had this logo placed discreetly on the buttons of some of her clothes but with Lagerfeld at the helm, the 1980s Chanel look became a logo extravaganza.

Lagerfeld's Chanel collections were wildly and proudly expensive. A made-to-measure suit cost well over $10,000, while even an off-the-peg version could run to $4,000.

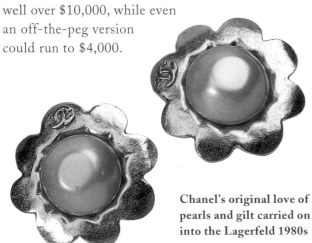

Chanel's original love of pearls and gilt carried on into the Lagerfeld 1980s

A single infamous jacket in one collection bore an eye-popping $75,000 price tag so Yuppies shelling out this money were glad that their clothing would advertise that fact. Lagerfeld's love affair with the "CC" logo fitted in perfectly with the 1980s *Zeitgeist* and proved to be a shrewd marketing tool. Sales of Chanel clothing, accessories, and perfume sky-rocketed and boutiques sprang up all over the world.

Second-hand Chanel from the 1980s and 1990s has always commanded high prices at the better dress agencies (consignment houses) because there have always been women who wanted the status and the look but could or would not pay for it. Lately though, 1980s Chanel is turning up in vintage shops where prices are buoyant. Chanel couture from this period would be a real find but even ready-to-wear is hotly pursued. Suits command the best prices while dresses, blouses and knitwear make good bargain purchases.

During the 1980s carnival of glitzy costume jewelry, the Chanel company produced a quantity of styles loosely based on Coco's earlier designs and these are well worth snapping up. Long gilt chains with pearls and colored glass beads, especially in her signature red and green, are sought after. Poured glass brooches and necklaces are great finds and because of the difficulty in manufacturing them, tended to be faked less. Beware, though—even these 1980s versions are fragile and must be worn and stored with care.

Chanel/Lagerfeld earrings

Unfortunately, during the whole 1980s logo extravaganza, fakes of the bestselling luxury goods were produced in huge numbers and survive today, confusing the vintage situation. Chanel jewelry was particularly targeted so take care when paying high prices. Genuine Chanel costume jewelry usually bears a tiny oval plate stamped "Chanel." This plate is soldered on to the back of an earring, brooch, or cuff bracelet while necklaces tend to have one dangling near the catch. This signature plate usually gives the date of manufacture in two digits —"87" or "88" for example—and specifies it was "Made in France."

Frustratingly, some fakes also bear this plate but the "Chanel" and the date stamp (if it exists) tend to be fuzzier on knock-offs, so look for good clear lettering when you are trying to assess authenticity. Weight is also a good indicator. A genuine piece will be heavier and feel more solid than a mass-produced knock-off.

Lagerfeld put Chanel's classic "2.55" quilted chain bag through its paces in the 1980s and early 1990s

Naomi Campbell epitomizes the new Chanel attitude

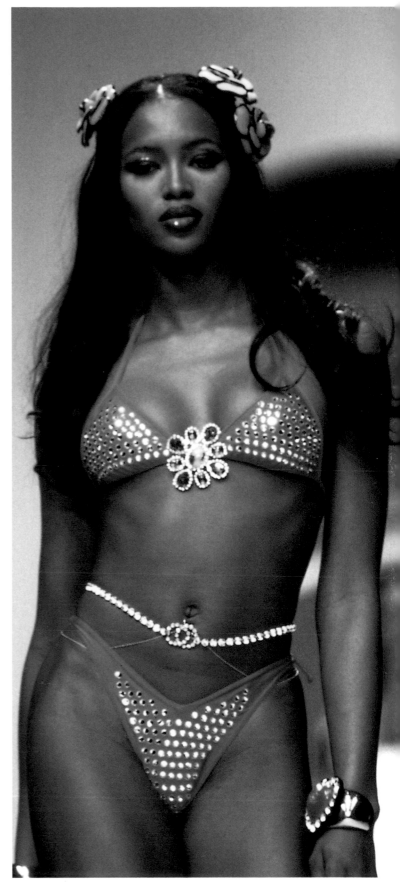

LOGOMANIA

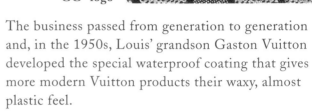

The Gucci "GG" logo

Expensive luxury goods were advertised as "investment" dressing and Yuppies, keen to identify themselves as members of the high earners tribe, jumped on the bandwagon. The 1980s became the era when designer names really went public.

Accessories, especially handbags, became a big area for the display of conspicuous consumption and many old established labels went from being discreet badges of wealth, recognized only by a tiny elite, to an internationally understood visual language of status symbols.

Louis Vuitton "logo" handbags, briefcases, and suitcases became hugely popular in the 1980s, although their origin stretches back to mid-nineteenth century France. Louis Vuitton started life as a humble trunk packer for wealthy women on the move. He soon realized that the humpbacked trunks in use at that time were less than practical so he designed flat-topped, stackable versions that were soon all the rage at the court of the Empress Eugénie. By 1875, Louis' son George was on board and designed the now famous patterned brown canvas with its repeated "LV" monogram.

The business passed from generation to generation and, in the 1950s, Louis' grandson Gaston Vuitton developed the special waterproof coating that gives more modern Vuitton products their waxy, almost plastic feel.

Period Vuitton trunks, suitcases, and vanity cases bring huge prices at auction today and you should certainly pounce if you're lucky enough to spot any of these at a yard sale or thrift store. Handbags do not bring anywhere near as much as these larger items but genuine examples are well worth buying and are very wearable today.

Gucci was another firm that basked in 1980s logomania but actually started off much earlier. Founder Guccio Gucci opened his first leather and saddlery shop in Florence in the 1920s. His original, equestrian-inspired snaffle motif has stayed with Gucci products to this day. Gucci quickly shifted away from exclusively horse-related products however and started dabbling very successfully in high fashion handbags and shoes.

In 1933, Guccio's son Aldo joined the business and introduced the iconic "GG" logo based on his father's initials. This logo, along with the distinctive red and green canvas strip, quickly came to signify wealth and the romance of European styling.

Gucci did a roaring trade in leather trimmed canvas "GG" logo bags in the "LV" style. Like Vuitton, they also did smaller items like key holders, belts, wallets, and coin purses. Fendi logo bags ("FF") were also in evidence in the 1980s, along with the Dior logo print accessories which got a particular push when Princess Diana was spotted with one of these handbags. Also look out for Dior's logo print clothing which was made in the 1950s and 1960s and is now highly collectible.

A Louis Vuitton bag

Logomaniacs ran wild in the 1980s. When New York rappers the Beastie Boys wore car logos as medallions, luxury cars like Mercedes Benz and BMW were stripped of their hood ornaments that then fetched up as do-it-yourself fashion statements.

Expensive logo bags like Gucci's and Louis Vuitton's slipped out of fashion in the repentant early 1990s but made a ferocious comeback at the end of the century. Hip young designers, like Marc Jacobs at Louis Vuitton and Tom Ford at Gucci, revamped these classics and they were suddenly trendy again. Vintage 1980s logo handbags sell instantly and for good prices, although prices for these are nowhere near as high as prices for new bags. Vintage finds are usually a real bargain, at least for as long as the logo trend holds. Beware though: these bags were illegally faked on a massive scale in the 1980s and they are still being faked today.

A vintage find might look well worn and therefore genuine, only to turn out to be an "authentic" period fake!

It is remarkably difficult to spot a good fake of a canvas logo bag because the plastic feel of the real thing was particularly easy to copy. Your best bet is to look inside. Interiors should be leather or suede. Check leather trims and straps too. Does the stitching show evidence of unraveling? The trims and straps on genuine bags are usually flat and in good condition, even on vintage pieces.

The Hermès scarf

Aside from its iconic Kelly bag, Hermès has always been known for its top quality printed head-scarves, which are avidly collected and worn today. Examples from the 1980s are bold and colorful but, as with all luxury products from the period, watch out for fakes. Both Chanel and Hermès scarves were faked in their thousands and sold on street corners and markets at bargain prices. Genuine scarves are usually rolled at the seams. Hermès also did a line of scarf-inspired tunics, blouses and jackets in the 1980s. These, along with other Hermès clothing from earlier periods, are well worth buying on the vintage market today.

Scarf-inspired tunic top by Hermès

Lesage

As couture was revived in the 1980s, its traditional supporting industries stepped into the limelight too.

Old established firms, such as the nineteenth-century Lesage embroidery house, went from well-kept couturier's secrets to brand names. Paris-based Lesage began in 1868 as embroiderers of family crests for aristocrats and royals. By the twentieth century, they had teamed up with the high fashion world and decorated clothes by Schiaparelli, Dior, Balmain, and other couturiers. The typical Lesage look is based on swirling patterns of raised threads, often interspersed with beads, faux jewels and pearls. During the 1980s, Lesage produced some now highly collectible embroidered cuffs, bracelets, and other costume jewelry pieces.

THE PREPPY LOOK

With all this new money around and previously well kept secrets like Louis Vuitton, Gucci, and Hermès well and truly out of the bag, old money aristocrats felt a need to distinguish themselves from the Yuppies, while social climbers cast around for the insider information provided by lifestyle guides like the U.K.'s "Sloane Ranger" or America's "Preppy" handbooks. This new preoccupation with class led to a revival of "The Season" in London and débutante balls in America.

The great American Preppy was born in the late 1970s but really came to power in the early 1980s. This particularly fastidious style tribe was governed by a minutia of rigid rules that applied to every aspect of dress from their grosgrain headbands right down to the tip of their usually landlocked Sperry deck shoes.

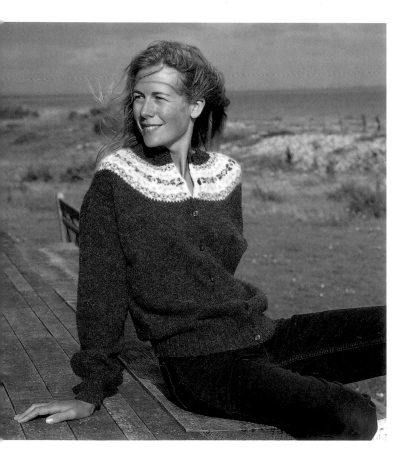

For women, one of the key Preppy principles was on no account to appear in any way sexy. The style was instead dowdy and matronly. Indeed, many Preppy mothers, daughters, and even grandmothers dressed alike. The below the knee length wraparound skirt was a favorite, either in patchwork madras or else canvas and corduroy. Skirts were often decorated with a repeating embroidered motif depicting accepted Preppy symbols like strawberries or spouting whales. Wraparound skirts were commonly worn with a turtleneck and a wool cardigan or jersey. Fair Isle 1930s-style Scottish knits were particularly popular and came in a range of bright Preppy colors. The hot pink and lime-green combination was a form of Preppy semaphore and this strange color pairing was happily worn by men and women, boys and girls.

The range of acceptable footwear was strictly circumscribed and clearly defined. L.L. Bean blucher moccasins and duckshoes, Bass Weejuns, Gucci loafers, Tretorn tennis shoes, and Sperry topsiders skipped over the gender divide and the only exclusively feminine shoes allowed were espadrilles, clogs, Chanel pumps, and the particularly pretty flat-soled Papagallo blosom ballet slipper that came in a range of jeweled colors.

"Blossoms" appear on the vintage scene today and are worn by a generation of "girly girls" with the skimpiest of slip dresses—a sexy and revealing look that no Preppy girl would have dared leave the house in!

Preppy girls didn't actually wear many dresses but when they did, a little Lilly Pulitzer number was usually the dress of choice. These simple summer shift dresses first appeared in the late 1950s. Lilly Pulitzer was a self-confessed "bored housewife" from Palm Beach, Florida, who started

The "Fair Isle" yoke sweater was a preppy staple in the 1980s

Wrongly called "Alligator" shirts by many 1980s Preps, the Chemise Lacoste polo shirt was designed in 1933 by French tennis star René Lacoste. Lacoste was nicknamed "Le Crocodile" after he won a crocodile-skin suitcase in a bet—the rest is history. While these are still manufactured today, vintage enthusiasts look for early examples

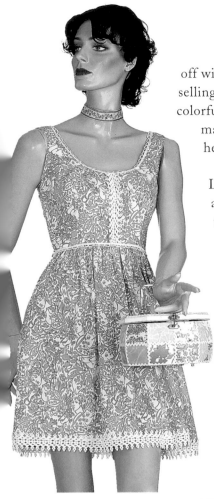

A Lilly Pulitzer dress and handbag

off with a stand on the beach selling orange juice and the colorful print dresses she made as a way of keeping herself busy.

By the late 1960s Lilly was big business and Preppy daughters in the 1980s carried on this resortwear tradition. While the Lilly dress was a standard, the company also manufactured pants, blouses, and shorts for both men and women in its distinctive signature prints. These are most commonly floral in pale, soft colors, especially pink. Like Pucci, the Lilly Pulitzer signature appears discreetly interwoven into the design of the fabric.

In the late 1990s atmosphere of overtly-feminine dress, Lilly clothes enjoyed a comeback on the vintage market and prices are modest—about the same as a new summer dress at a mall. Unusual prints, especially animal print Lilly designs, bring slightly more but Lilly is still very much purchase-to-wear rather than a serious vintage investment.

The most valuable Preppy artifact is probably the lighthouse basket bag which has been manufactured for generations as a cottage industry on Nantucket Island in Massachusetts. These have a woven straw body with a scrimshaw ivory carving mounted on a wooden plaque on the lid. The ivory carving usually depicts a nautical motif like a whale, a seashell, or a lighthouse. Many Nantucket bags are signed and dated by the maker and good early examples sometimes command five figures at top vintage outlets!

American company Papagallo made bags that came with a collection of changeable, button-on covers

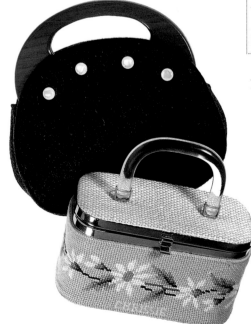

Personalized needlepoint came not only in the form of belts but as bags too

DIANA

The British had their own version of the U.S. preppy, christened the "Sloane Ranger" after London's Sloane Square in Chelsea, where these "Sloanes" supposedly hung out. Also dubbed the "Welly Brigade" after their trademark green rubber Wellington boots, the Sloane look was based on a slightly incongruous melding of town and country attire. The most famous Sloane of all time of course was Lady Diana Spencer.

Although she first appeared in the public eye as a kindergarten teacher at a London nursery, Diana became a style icon for the 1980s and 1990s. The world was mesmerized by her transformation from shy English rose to fashion superstar.

Diana's wedding dress, designed by British partners David and Elizabeth Emmanuel, was fit for a fairy-tale princess—all taffeta and ruffles with long lace cuffs trailing 18 feet of pearl encrusted train. Seven hundred and fifty million TV viewers watched Diana walk down the aisle at St. Paul's Cathedral.

As a 19-year-old Princess, Diana's early look was rather uninspired, based on the traditionalism of her upper-class upbringing. Nevertheless, the Sloaney look went global and Diana started a vogue for ruffled blouses, simple Laura Ashley-type dresses and skirts, velvet jodhpurs, and tweed vests. Her drop-waisted dresses with sailor collars were also widely imitated.

The fashion press documented every nuance of her dress and hair, often unkindly in the early days, so Diana quickly saw that more would be required in the fashion stakes. She turned to British couturiers like Bruce Oldfield and her favorite, Catherine Walker of the Chelsea Design Company, and together they created the new Diana. This new look was elegant and sophisticated but at the same time it brought a feeling of freshness and modernity to the ancient institution of British monarchy. The world was enchanted and in the process the new Diana came to exist as a force in her own right.

Through her glamorous clothes and her amazing work for various charities, Diana not only carved out her own unique image but achieved a form of independence from her husband that gave her confidence and helped her show a brave face to the world, despite the difficulties she was suffering in her unhappy marriage. By the mid-1990s though, Diana no longer needed fashion to bolster her confidence, which now came from within.

"Clothes are not as essential to my work as they used to be," she said and in 1997 she sold many of her most beautiful outfits at auction in New York, raising over three million dollars for charity.

Princess Diana in 1989

THE FITNESS CRAZE

The hard-core Preppies and Sloanes may have been perfectly content to hide their lights under layers of cotton and wool, but the fitness-crazed girls of the 1980s preferred to let it all hang out.

The health and fitness craze, which started in the late 1970s, really took off in the 1980s. Aerobics, jogging, and gym workouts created the perfect, well-toned body that was now worshipped. New, skintight fabrics, such as lycra, spandex, even stretch velvet, left nothing to the imagination. For the first time, sports clothes manufacturers started targeting women. Leggings, cycling shorts, and name-brand sneakers were now worn, both inside and outside the gym.

New York-based Norma Kamali made some of the most popular dressy clothes of the decade, but her low priced "sweats" collection epitomized this aerobic generation. They not only sold like hotcakes but inspired a frenzy of imitators worldwide. Kamali used sweatshirt fabric for coordinated leggings, rah-rah skirts (or cheerleader-style skirts), and huge shoulder padded tops, all of which probably spent far more time on the street than they ever did in the gym. These will never be extremely valuable on the vintage scene but they so typify the period that they're probably worth buying along with earlier, 1970s Kamali collectibles like her down coats, platform sneakers, and clothes made of parachute fabric.

Patrick Kelly Eiffel Tower dress, crystal and lycra

The fitness craze not only inspired a generation of gym clothes but flexed its muscles in the world of high fashion as well. Although layering and big silhouettes were a 1980s staple for some, Tunisian born designer Azzedine Alaïa was wildly body conscious and came to be known as the "King of Cling."

"The base of all beauty is the body," Alaïa said and he gave us plenty. His skintight clothes, with their distinctive bias-cut seams and darts, meant that the body interacted directly with the clothing. Buttons, collars, cuffs, and all surface decoration were banished so nothing would detract. Dull, muted colors like brown, moss green, gray, and black further minimized distraction from the message, which was simply curves, curves, and more curves!

Despite the fact that the 1980s is just getting hot as a collectible decade, vintage Alaïa pieces are already very sought after, so if you see them, buy them. Look out for hooded dresses with prominent seaming, fishtail "mermaid" dresses or skintight co-ordinating outfits of leggings, top, and jacket.

A Patrick Kelly dress with gold metallic hearts

THE ITALIANS

Somewhere between big shoulders and bare shoulders, the Italians carved out their own look, which was very strong in the 1980s. Established labels like Valentino were popular while newcomers like Gianfranco Ferre came to prominence too. Ferre's expert tailoring and clean lines owe much to his early training as an architect. Gianni Versace trod a somewhat wilder Italian path that went center stage in the 1990s on the backs of some of the world's most glamorous celebrities.

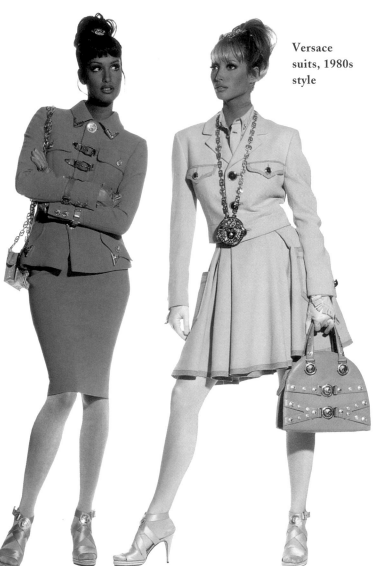

Versace suits, 1980s style

Look out for clothes labeled "Valentino couture," along with 1980s Ferre pieces in fur or leather—they are bound to increase in value. Prices for 1980s and 1990s Versace are sky high so don't hesitate. Versace's 1982 chain mail dress would be a spectacular find from the decade, along with the rubber and leather clothes that he seamed with lasers.

Although Italy was buzzing with talent in the 1980s, the most influential Italian of the period was Giorgio Armani who brought the uncluttered, more relaxed style of traditional menswear dressing into mainstream women's fashion. The cornerstone of Armani's dressed-down look was the unstructured jacket, which was hailed as the voice of reason in this glitzy decade of high maintenance dressing.

Unfortunately, because it is so "reasonable" and understated, 1980s Armani passes unnoticed on the vintage market in preference to the more high impact creations of the decade, but no 1980s collection would be complete without Armani.

Armani's belief in the classic and quietly expensive was echoed in America by Ralph Lauren and Calvin Klein, who carried their late 1970s experiments in casual minimalism very successfully into the next decade. Both had a horror of "gimmicky, overdesigned clothes" and preferred to concentrate instead on simpler lines expressed in natural materials.

Collecting the 1980s
Many of the best post-war designers carried on successfully into the 1990s and, as a consequence, dress agencies (consignment houses) are often a better source for 1980s wear than vintage stores. While some agencies ruthlessly exclude everything but the most up-to-date, many agencies, especially in smaller towns, will take anything with a designer name, not realizing that what they think is a modern Galliano or Gaultier is really a rare 1980s treasure.

CULT
DRESSING

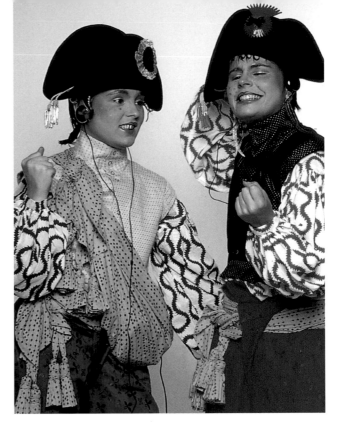

Vivienne Westwood's "Pirate" collection

While "status dressing" of both the understated and the wildly overstated variety dominated the decade, a strong vein of interesting cult dressing ran just below the mainstream. This 1980s fashion subculture is already hotly pursued by today's vintage fanatics.

"WORLD'S END"

In 1980, Vivienne Westwood and Malcolm McClaren reinvented themselves yet again, this time as "World's End." Although they parted company soon afterward and Westwood went on to become one of the most innovative and influential designers of the post-war period, that original World's End shop—looking like a little crooked house on the King's Road, with its tilting floors and thirteen-hour backward running clock—remains relatively unchanged to this day.

World's End opened as a showcase for Vivienne's new "Pirate" collection, a look that was promoted by McClaren's latest band, Adam and the Ants, later re-styled Bow Wow Wow. Adam and the Ants' 1981 hit "Stand and Deliver" made the link between the clothes and the music ever more explicit. Vivienne's "Pirate" collection included loose, multicolored shirts with one sleeve cut longer than the other, made in her distinctive dot or squiggle print fabric. These shirts were teamed with slashed Jacobean jackets and culottes or historically accurate drop seat trousers. Napoleonic bicorne hats and high boots completed the look. The look was colorful, theatrical, and androgynous, fitting in perfectly with the "New Romantic" street sensibility that was developing in some of London's cutting edge clubs and eventually went global on the back of pop stars like Duran Duran and Boy George.

"Pirates" was the first collection that Vivienne formally debuted at a catwalk show and it proved to be a turning point in her career. It heralded the beginning of a series of theme collections which became increasingly innovative and assured. Pieces from all of Vivienne's 1980s collections already bring big prices at vintage shops and auctions and are collected now in the same cultish way that they were bought and worn by their original owners.

Westwood label check

McClaren and Westwood changed labels as often as they reinvented their store, so genuine 1970s and early 1980s pieces can be identified by any of the following labels:

• Sex Original, 430 King's Road
• Malcolm McClaren, Vivienne Westwood, and Seditionaires
• World's End, McClaren, Westwood, born in England. (This tag shows an arm bearing a machete.)

Labels in this era were not always placed in the neck, so turn a possible Westwood inside out and don't forget to look on the outside as well! Later pieces are simply labeled "Vivienne Westwood, made in England" and show the distinctive orb logo which she used since 1987.

GALLIANO

Although John Galliano has become a 1990s couture superstar at the helm of Christian Dior, his early designs have roots in the street subcultures of London in the 1980s. He freely acknowledges the inspiration he took from the London club scene and its high energy emphasis on freestyle, theatrical dressing.

Galliano burst on the scene with his 1984 St. Martin's degree collection "Les Incroyables," which was featured in Brown's—London's cutting-edge fashion showcase. It sold out instantly. The collection was based on a brief period in eighteenth-century French history when the "Incroyables"— street style dandies of the Directoire—and their female counterparts the "Merveilleuses" scandalized post-revolutionary France with their extreme and extravagant style of dress.

Galliano's "Incroyables" centered on eight interchangeable outfits for both men and women. Asymmetrical ruched jackets were layered over uneven vests and voluminous sheer muslin shirts finished with a huge bow at the neck. Gathered, drop-seated pants fell in baggy folds around the middle and then cut tight from mid-thigh down challenged the very architecture of twentieth-century clothes. A small group of these designs was offered recently on the vintage scene at extremely high prices but perhaps these price tags will someday prove to have been reasonable, given their extreme rarity and interest as markers of the very beginnings of John Galliano's career.

Galliano went on to present a series of ground breaking collections in the 1980s, which started with the seminal 1985 "Ludic Game." Here, with the help of his then muse and collaborator Amanda

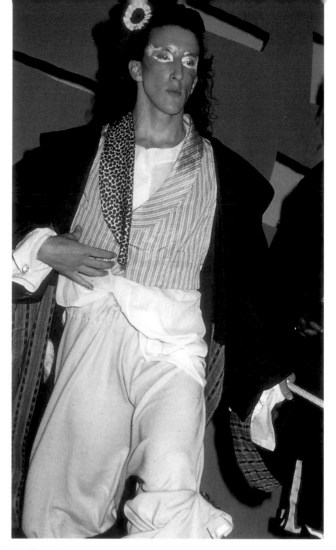

Galliano's "Les Incroyables" St. Martin's degree show, 1984

Harlech, John continued with his idea of the essentially "narrative" or "storytelling" show but layered it now with a rich mix of literary, cultural, and historical allusions. To the Bacchanalian mood of the ancient Roman Ludi—or games—Galliano grafted "Celtic and runic symbols, while the clothes were meant to be worn upside down and inside out."

"It's all a mad mix, everything is off balance—skirts have fronts rolled up, shirts are worn as skirts, waistcoats have rumpled fronts and halter necks—in colors such as dried blood. I mix shapes, mix proportions. I put long over short, short over long, and break every possible rule."

– John Galliano

A white dress in the nineteenth-century countrymaid tradition had a toga-like drape at the front and fell provocatively off one shoulder. Roman headbands, along with sticks, twigs, clocks, and stuffed birds, were used as headgear. The look was rural, gothic, Roman, and yet all infused with the spirit of Shakespeare's tragic Ophelia. This unique combination of romantic-looking clothes, brought about by precision cutting, became a defining feature of Galliano's later 1980s collections like "Fallen Angels" and "Forgotten Innocents."

Although Galliano was revered by the fashion *cognoscenti*, this did not translate into widespread commercial success and many of his early pieces were therefore made in very small quantities. They are rare on the vintage market and justifiably expensive but they do appear, especially in dress agencies (consignment houses), so keep your eyes peeled. Pieces from these early 1980s collections look set to become treasures of post-war fashion. Look out for white, gauzy empire line dresses, asymmetrical pieces with uneven hems, and ruched "ducktail" backed jackets and frock coats. Corks used as buttons could indicate a rare, early piece.

Galliano's "Ludic Game," 1985–6

Cult collectibles

A generation of young fashion designers found their feet in the clubs and subcultures of 1980s London. Key labels include Body Map, Demob, Annie Lapaz, Sue Clowes, John Flett, and Leigh Bowery, all of which are hotly pursued by cutting-edge vintage collectors in the know.

Many of these young British street stylists were showcased in America by New York boutique owner, talent scout, and fashion impresario Suzanne Bartsch. Bartsch not only sold the clothes in her own shop, but also staged regular shows of their work in New York, Los Angeles, and Japan, where it sold very well and turns up now on the vintage market today.

"Me, I like everything, everything can be beautiful or ugly."

Jean-Paul Gaultier

GAULTIER

The Gallic take on cult dressing was expressed by Jean-Paul Gaultier, a self confessed admirer of London street style. From his high fashion Paris creations to his cheaper diffusion lines, Gaultier brought taboo-breaking fashion into the mainstream.

Known in the 1980s as the *enfant terrible* of French fashion, Gaultier quickly turned his back on his establishment roots at the Couture houses of Pierre Cardin and Jean Patou, and blazed a trail of genderbending, fetish inspired dressing that made its mark on the look of the 1980s and 1990s.

"Genderbending. Huh! It's a game," he said. "Young people understand that to dress like a tart doesn't reflect one's moral stance—perhaps those 'jollies madames' in their little Chanel suits are the real tarts? I'm offering equality of sex appeal."

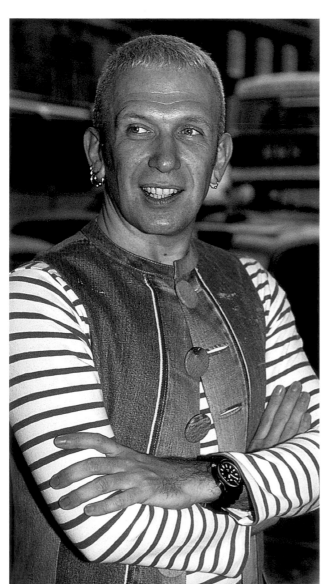

Aside from members of Scottish clans, few men took up Gaultier's challenge to parade around in skirts but the question Gaultier posed in his "God Created Man" collection of 1985 was exciting and valid.

Women had long been comfortable borrowing key elements of masculine dress but the skirts, dresses, and even tutus, which Gaultier showed in his 1980s menswear collections, confronted a taboo. In Gaultier's work, both sexes are invited to play around with their own and each other's gender stereotypes and clichés. Not behind closed doors in some seedy, overly serious, covert atmosphere but openly and with wit and humor.

Gaultier's first corset dress appeared in his groundbreaking 1983 "Le Dadaism" collection. He freely acknowledges a huge debt to Vivienne Westwood, but it was his corsets that opened the floodgates on a rash of bondage and fetish-inspired clothes that traveled straight into the 1990s.

High heels, suspender belts, bullet bras, and all that forbidden, sexy, classically secret stuff came out now in full view, beautifully cut, and brought across in luxury materials. Sly, tongue-in-cheek, surrealist details and accessories conveyed the message that "none of this is serious, ladies and gentlemen. It's a game. It's a bit of fun, so go ahead. Go wild!"

Women worldwide went wild Gaultier-style, egged on of course by the divine Madonna, whose 1990 "Blonde Ambition" tour took Gaultier's vision of "fantasy exaggerated" into the mainstream. Madonna's "Blonde Ambition" look was a perfect expression of the Gaultier aesthetic, a male/female spirit which he believed summed up the contemporary world. Madonna sported a men's tailored pinstriped suit, a power suit, but under it she wore a 1950s-style salmon pink corset complete with top stitched, bullet shaped bra and suspender belts. Her suspender belts did not hold up stockings, however, but waved freely as she danced, symbolizing Madonna's ability to use the once secret trappings of femininity to further her own ends. In other words, here was a blonde with ambition!

Jean-Paul Gaultier, as usual, in his striped T

MADONNA

Madonna was an icon of the 1980s and can serve as a fashion barometer for the eclectic cult spirit that bubbled just below the surface in this otherwise status-driven decade.

The cult method was to combine incongruous "found" elements in unexpected ways. It was about dressing up to play a role and when you grew bored with that role you moved right on to the next one.

One of Madonna's first looks was enshrined in the film *Desperately Seeking Susan* (1985). This look was based on New York flash/trash club style, where aggressive post-Punk met the girly, New Romantic sensibility.

One part lace, one part black leather, Madonna as Susan jangled along in armloads of fake jewelry, fishnets, fingerless gloves, blood red lips, messy "just rolled out of bed" hair, and a prominently displayed belly button—a hitherto passed over erogenous zone which Madonna showcased and claimed as her own. The Madonna/Susan look was an overnight sensation and legions of young girls rushed out and bought not only the albums but the clothing too. Madonna went on to re-create Marilyn Monroe in her 1986 "Material Girl" video and her new best friends were a king's ransom in diamonds from Harry Winston. She then wrapped up the decade laced into John Paul Gaultier's cyber-corset in a cross dressing, fetish-fueled extravaganza of bedroom power dressing.

From the vintage point of view, the Gaultier incarnation will make for your shrewdest Madonna-inspired buys. Gaultier will certainly be seen as one of the world's most important post-war designers. Late 1970s and 1980s Gaultier has already found pride of place in museum collections and good pieces command good prices on the vintage scene today. Go for corsets and corset dresses and anything with his signature bullet or exaggerated cone bras. Look out for surrealist touches; earrings in the shape of tea infusers, belts made out of shower hoses or his "mille-patte" (millipede) spike-soled shoes. His cheeky cut-out clothes would be fun buys even if you're not brave enough to wear them on the street, while many of his ethnic-inspired, kimono-style creations are currently undervalued and would make for good

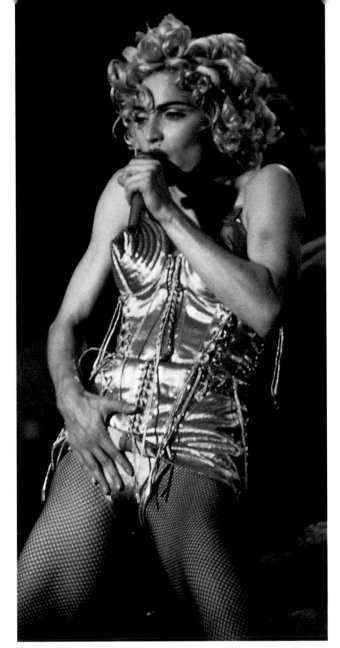

Madonna in concert wearing the famous exaggerated cone bra corset by Jean-Paul Gaultier

investments. Bear in mind that the 1988 "Junior Gaultier" and the 1994 "JPG" labels indicate a lower-priced diffusion piece that will never bring top money on the vintage scene.

"Crucifixes are sexy because there's a naked man on them."
– Madonna

SPROUSE

While cult dressing was primarily a European-led idea in the 1980s, American designer Stephen Sprouse made a huge impact among the young and avant-garde. Sprouse revived the 1960s and claimed former Warhol superstar, Edie Sedgewick, as his ghostly muse. He designed hipsters and cut-out mini-dresses which he infused with an 1980s palette of bright jeweled colors. As a protégé of Andy Warhol in the 1980s, many of Sprouse's designs are based on Pop Art themes. He in fact holds exclusive rights to reproduce Warhol's most famous images on clothing, although these pieces mainly date from 1997 when Sprouse re-launched his label after nearly a decade in the shadows.

Look out for Sprouse's skintight body suits and his T-shirts and clothes decorated with squiggles and graffiti à la Jean Michael Basquiat, all of which became instant collectibles.

THE JAPANESE

While Sprouse may have reveled in his electric palette, the post-holocaust look of Japanese designers like Rei Kawakubo of Comme des Garçons ushered in the reign of black, an anti-fashion color destined to become the big story of the early 1990s. Like Westwood in the Punk era, Kawakubo ripped and shredded clothes and then patched them together to form new clothes.

Japanese collectibles
Track down 1980s pleated pieces by Issey Miyake and Yohji Yamamoto plus spiderweb knits and punk styles by Comme des Garçons.

Rough stitching, crude and deliberately careless seams, as well as mismatched areas of fabric challenged the idea that fashion was meant to be perfect. Her loose, black, irregular silhouette and the distressed condition of her fabrics led to charges that Kawakubo was sending out a procession of "nuclear bag ladies," but her look was the perfect antidote to the sometimes frivolous, high maintenance 1980s status dresser. Comme des Garçons was quickly seized upon by intellectual, artistic, and serious-minded women worldwide.

1980s clubbers went in for face painting and high-impact hair

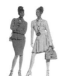

CULT CULTURE

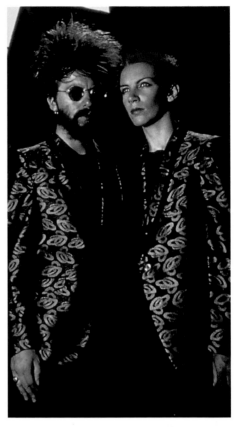

"Everybody's looking for something," sang Annie Lennox in her cross-dressing menswear clothes

The 1980s saw the dawn of MTV music videos, an instantly successful and voracious medium powered by a steady stream of diverse new bands. Before MTV, music programs had been a once or twice a week affair but now there were hours of dead airtime for MTV to fill every day.

In fashion terms MTV gave a tremendous push to the New Romantic look favored by bands like Duran Duran, Soft Cell, and the Human League. The look was based on a glamorous, eclectic, fancy dress sensibility which had its roots in Bowie's glam rock style. Gender bending was a related MTV-popularized trend that appeared on the stage as often as it appeared on the catwalk—boys like Boy George of Culture Club dressed like a geisha girl and sang like a soul man, while girls like Annie Lennox shaved their heads and dressed in pinstriped suits that would not have looked out of place on a Wall Street banker.

The London club scene gave rise to a subculture of flamboyant, sexually fluid characters who stamped their style on the decade. Boy George was perhaps the most famous of the London clubbers, but Francis Bacon model and Taboo Club co-founder Leigh Bowery was influential, along with the cross-dressing chanteuse simply styled "Marilyn" after his idol Marilyn Monroe.

The gay community enjoyed a place in the sun during the early 1980s. Gay culture defined the cutting edge in music and fashion while gays in general found greater acceptance. Tragically, the specter of AIDS also rose in the 1980s. While governments sat on early AIDS reports, trying to decide what to do with them, an entire generation was cut down. The arts, media, entertainment, and fashion fields lost many of their best and brightest stars while the straight world recoiled in a renewed climate of fear and suspicion. Princess Diana and the actress Elizabeth Taylor worked to raise awareness and dispel the stigma first associated with AIDS.

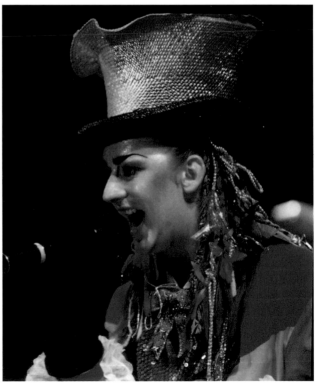

Boy George and Culture Club's genderbending addiction to ragamuffin glamor popularized a subculture of cult dressing that ran against the 1980s grain of big, high-status money-guzzling clothes

ACCESSORIES

COSTUME JEWELRY

While the 1970s relegated diamanté to the junkyard of passé fashion, it soon returned with a vengeance and became the key accessory of the 1980s. In the 1980s climate of designer mania, costume jewelry by Chanel, Yves St. Laurent, and Christian Lacroix sold like hotcakes and good pieces bring good prices on the vintage scene today.

If you cannot find or afford these couture names, look for pieces from lower priced costume jewelry specialists like Trifari, Attwood and Sawyer, Fior, and, best of all, anything by the crowned heads of 1980s glitz, Butler and Wilson.

Nicky Butler and Simon Wilson began modestly in the 1960s with an antique jewelry stall in a London street market. Demand for their handpicked vintage selections quickly outstripped supply so they decided to manufacture new pieces based on the best of their period finds. By the 1980s, Butler and Wilson's designs went global, riding in on the lapels of a new, dressed-up glamor in fashion that positively cried out for showy, decorative jewelry. Track down Butler and Wilson's 1980s classics like their massive jeweled bibs and outsized diamanté brooches. Whimsical figures like bubbly champagne glasses, huge Georgian style bows, hands, and three dimensional spiders are all good flea market finds, along with that iconic slithery diamanté lizard that Princess Diana launched during her much-photographed official tour of Canada. Remember though, Butler and Wilson pieces can be signed with the initials B&W.

A diamanté dragonfly measuring six inches from top to tail

Judith Leiber

Hungarian-born Judith Leiber had enjoyed a long and distinguished career as a handbag designer before she went center stage in the 1980s. Her jeweled "minaudière" as evening bag was introduced by Van Cleef and Arpels in the 1930s as a small, usually strapless metal case divided inside into separate compartments for evening necessities. Leiber's iconic 1980s "minaudières" broke with tradition and went figural. They came as three dimensional, quasi-sculptures of cats, teddy bears, and even Fabergé eggs, each decorated all over with a continuous carpet of 10,000 individually handset rhinestones sourced from the famed Swarovski Crystal company in Austria. These glittering confections, more like jewelry than handbags at all, were and still are outrageously expensive, so vintage bargains are truly serendipitous.

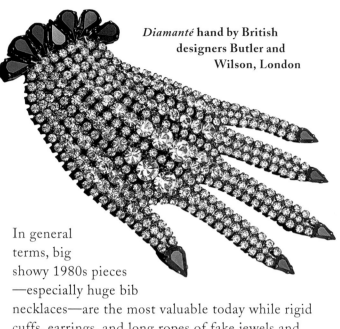

Diamanté hand by British designers Butler and Wilson, London

In general terms, big showy 1980s pieces —especially huge bib necklaces—are the most valuable today while rigid cuffs, earrings, and long ropes of fake jewels and pearls are cheaper, so well worth snapping up. The most popular piece by far in the 1980s was the big decorative brooch which made its presence felt on the stiff lapels of power dressing suits worldwide. With the 1990s love for more feminine, delicate fabrics like chiffon and devoré velvet, the big heavy brooch of the 1980s slipped out of fashion and many fine examples from the 1930s, 1940s, and 1950s, along with their 1980s updates, lie covered in dust on the bottom shelf of vintage showcases. This is clearly the time to pounce.

Look out for the truly monumental brooches of Iradje Moini (signed "Iradje"). These paste stunners, often the size of side plates, usually come in figural designs. Everything from gigantic parrots, lobsters, elephants, and motorcycles to the creepiest, crawliest insects emerged from Moini's imagination in a mosaic of glitzy faux jewels. Prices for these painstakingly handset originals are justifiably high. While many pieces date from the 1990s, they are infused with the 1980s belief that glitz is good and bigger is necessarily better.

Butler and Wilson's iconic lizard brooch

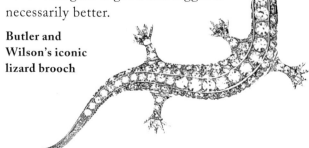

Blahnik

Had hard-core Preppies known about "Manolos" they would have instantly banned them from their strict canon of acceptable footwear on the grounds that they were far too beautiful and sexy to be allowed, but for the rest of the power dressing world Manolo Blahnik was the only port of call for seriously fashionable feet. The icons of the 1980s, from Princess Diana to Madonna, flocked to his small shop in London's Chelsea.

Unlike many 1980s designers who found it difficult to translate their ideas into the 1990s, "Manolos" are still swooned and fought over by today's most famous and fashionable women, who claim his shoes are not only beautiful and flattering but have a weightlessness that makes the wearer feel that they are floating blithely above them. Keep your eyes peeled for 1980s classics with strappy straps and towering spike heels.

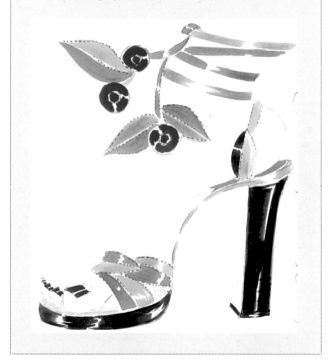

Look out for articulated metal belts and leather belts jazzed up with beads, faux jewels, and even feathers. These will never be worth a fortune on the vintage scene but they do help to re-create the authentic 1980s look.

 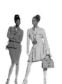

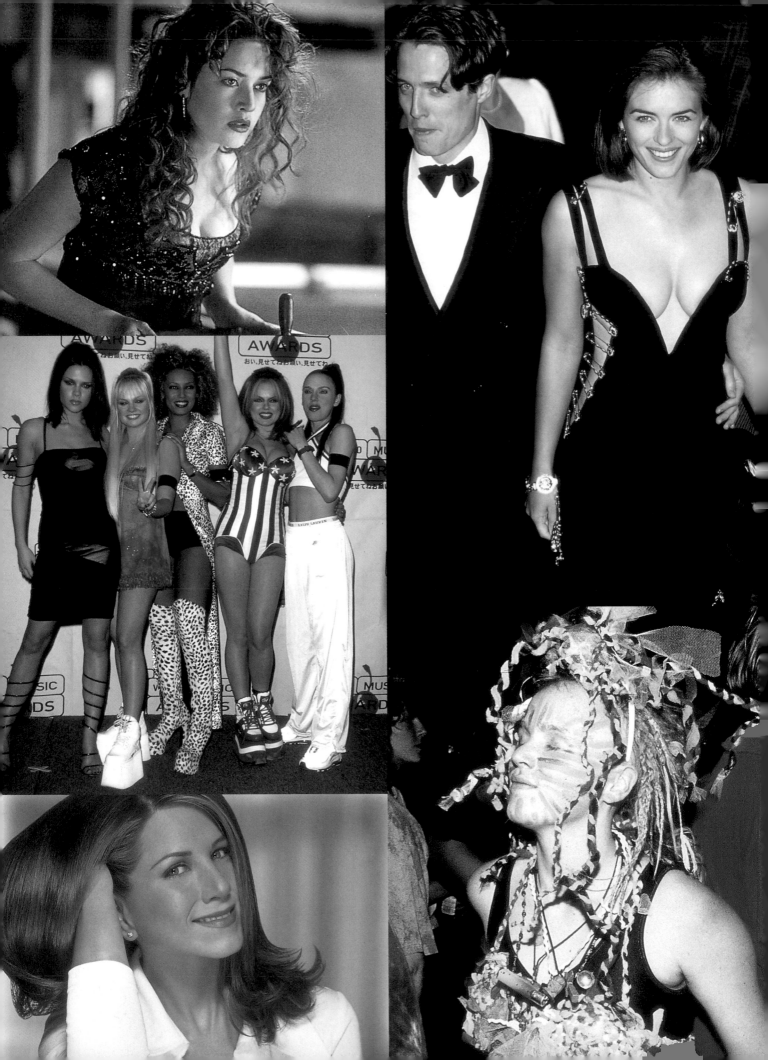

THE 1990s

Grunge and Retromania —

Fashion at the Fin de Siècle

The 1987 stock market crash, Black Monday, not only wiped billions off the value of publicly quoted companies but it wiped the smiles off a generation of yuppie faces as well. The 1990s then kicked in with a lot of soul searching and an understandable backlash against the roller coaster extravagance of the 1980s. The triumphant fuchsias and electric blues were thrown out now for a reign of black: black jeans, black dresses, and thin black cords that we tied around our necks to show off a tiny piece of drilled pebble or a lump of dented silver. Donna Karan introduced a simplified working wardrobe, much of it in black, and when we all started to get fidgety, the magazines sold brown and grey as "the new blacks."

"BRICOLAGE"

Grunge and anti-glitz was born in the street in a desperate attempt to cast off the 1980s super-rich look with a hodge-podge of cast-off clothes. Glamorized by bands like Nirvana, Hole, and Pearl Jam, Grunge was briefly co-opted by high fashion designers like Anna Sui, Marc Jacobs, and even Prada, who sent models out on the catwalk dressed as truckstop waitresses and domestic cleaners.

By the middle of the decade everyone was tired of looking tired and for the rest of the 1990s women decided to dress up again and flaunt their feminine charms, albeit in a more subtle way than they did in the 1980s. The 1990s are still so fresh in our minds that it is difficult to summarize but the illusion at least of individual eclectic dressing was certainly a key theme by the middle of the decade and pretty clothes came back with a vengeance.

In the spirit of post-modern art, mid- and later 1990s fashion concerned itself with "bricolage"—a term which means the juxtaposition of incongruous images, objects, and materials. Suddenly it was okay to wear your cowboy boots with a flimsy 1950s slip dress and a Victorian jet choker because it was all about pulling it together with "attitude." Retro styling is the ultimate bricolage tool and top designers like Galliano, Dolce and Gabbana, Westwood, and Prada all re-invented and re-combined a variety of earlier eras while a popular *fin de siècle* passion for vintage swept through the mainstream. The authentically old blended easily with 1990s updates and vintage gave an outfit that slightly eccentric personal twist. Thanks to an aesthetic shift that happened in the 1990s, thrift stores, flea markets, and vintage shops have now thrown off their secondhand, grungy stigma and

Dolce and Gabbana pulled together a variety of 1990s themes

entered the canon of totally acceptable fashion sources for shoppers of all ages and budgets.

Our fashion history was exhaustively explored in the 1990s as 1930s screen goddesses, Geisha girls, Titanic-inspired Edwardian ladies, and disco divas were all sent out on the catwalk, although not necessarily in chronological order.

Dresses replaced the ubiquitous 1980s suit and both long and short versions came in 1920s-inspired devoré velvet, shimmering bias-cut 1930s satin, heavy tweed or slinky 1970s polyester.

The wildly popular "girlie" look was based on a 1950s nylon full or half slip, worn with a pretty, lightweight cardigan, kitten heels and a teeny tiny handbag, preferably by Lulu Guinness. This "underwear as outerwear" trend continued with a vogue for basques, bustiers, bra tops, Victorian bodices, and petticoats. With all these unmentionables proudly on display now, underwear itself had to get saucier in the 1990s to have any effect so a range of specialist lingerie shops appeared like the infamous Agent Provocateur in London or Victoria's Secret in the USA.

"I'm obsessed. I could spend days picking through things in antique markets looking for the right piece of lace, for a trim, or a brilliant button for a jacket."

– Stella McCartney

ITALIAN STYLE

While the appeal of the girlie girl was somewhat coy and innocent, grown-up sex kittens turned their attentions to Italy where Gianni Versace and his kiss-and-tell eye-popping dresses gave the 1980s cult of body worship a whole new meaning. One of the differences was in the detail. Skintight dresses and bodysuits were beaded or boned then jazzed up further with feathers, faux jewels, chains, and large cut-away areas that revealed more than enough of the body beneath. "I like to dress egos," Versace said, and he certainly did as the rich and famous adored both him and his clothes. But Versace not only dressed stars, he made them—especially Elizabeth Hurley, whose career as an actress and model really took off after she was photographed in that now legendary Versace safety pin number.

Although Versace tended to buck the retro trend, fellow Italians Dolce and Gabbana had a love affair with our fashion past and their dramatic, sensual, retro-inspired clothes were some of the best of the decade. Diaphanous, see-through fabrics, leopard prints, sumptuous embroideries, and corsetry were the favorite themes and the D & G label soon became one of the real must-haves of the 1990s. Miucca Prada made a huge impact too, although she joined

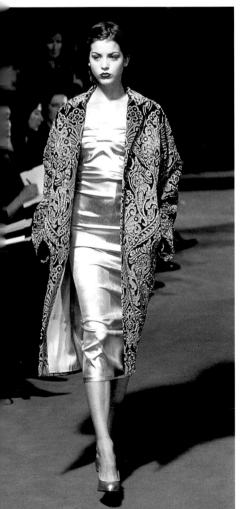

As masters of the retro trend, Dolce and Gabbana became a 1990s "must have" label

the 1990s scene humbly with a simple black nylon backpack that has now become one of the true fashion icons of the decade. Like many designers, she played with images of the past, re-combining and re-inventing them in surprising new ways.

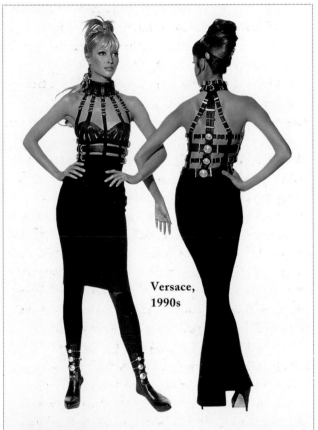

Versace, 1990s

Fetish style
The 1990s were not all floaty chiffon and feelgood devoré velvet. Instead, many were dressed to kill in the fetish-inspired fashion that went increasingly mainstream during the decade. Belly buttons, lips, noses, even tongues were pierced, sometimes repeatedly, while tattoos were all the rage, even for girlie girls who showed them off with skimpy slip dresses. For the squeamish, there was always the tattoo decal or the elaborate henna graffiti that Madonna popularized, not only for hands but for faces too.

COOL BRITANNIA

While the Italians were undoubtedly a major force in the 1990s and continue to be strong today, the 1990s was also the decade of "Cool Britannia" and London relived its swinging Sixties role as a global trendsetter. Suddenly, London Fashion Week was on the map again and young, exciting, innovative designers like John Galliano, Alexander McQueen, and Stella McCartney made such an impact that they all now head up old line French couture houses in an unprecedented British invasion on Paris. (McCartney at Chloé, McQueen at Givenchy, and Galliano at the House of Dior.)

Stella McCartney went to Chloé in 1997 at the tender age of 25. Though some of the fashion press characterized her appointment as a cynical attempt to trade on her famous name, McCartney has breathed a young spirit into the label which has put Chloé at the cutting edge. "It's about my friends," McCartney said, describing her Chloé début collection, "and what I get up to when I'm in London."

Fellow Brit Alexander McQueen graduated from Central St. Martins College of Art and Design in 1992 with his "Jack the Ripper Stalking his Victims" show and quickly became the bad boy of British fashion. Collections like his 1995–6 "Highland Rape" have made McQueen famous as fashion's dangerous master of the macabre and while this reputation has grabbed him a lot of headlines it obscures the fact that McQueen is actually an enormously talented designer who makes plenty of wearable clothes. We can't blame the press though for focusing on the drama of his shows, where models wade through water, dodge burning cars, endure bouts of automated spray painting or else prance with faux cauls on their eyeballs or prosthetic horns roped to their heads. Carrying on from Gaultier, McQueen's preoccupation with the strange and forbidden has made fashion more fantastic, more thought provoking than ever before and it fits in perfectly with our uncertain steps into the new millennium.

Some of the most beautiful magical clothes of the 1990s were designed by John Galliano who finally, with the help of *Vogue*'s Anna Wintour, got the business backing that he'd always needed to get his vision across to a wider audience.

Appointed head of Givenchy in 1995, Galliano singlehandedly revived this all but moribund label. He went on to the House of Dior in the following year, where the impact of his collections not only rivaled that of founder Christian Dior but revived the couture industry, dragging it sometimes kicking and screaming into the twenty-first century.

Galliano's is a wide ranging, historical, multi-layered vision, which is far too complex and personal to be called "retro." He takes a romantic, narrative approach to both the clothes and the way they are shown. His now legendary 1990s themed shows were spectacular flights of creative fantasy, carefully orchestrated right down to the now highly collectible invitations which came attached to rusty keys or as ballet slippers, love letters, or charm bracelets hidden in Russian dolls.

Women look beautiful in Galliano. The clothes are interesting in their own right and this balance—clothes that are exquisite but that don't overpower the wearer—has made Galliano one of the most sought-after names of the decade. "Ultimately I see myself as an accomplice to women," Galliano said. Women "who enjoy dressing up and celebrating their own femininity."

> *"I'm a romantic at heart and I hope this can be felt in my clothes. Fashion is like music to me, in that it's about feeling. I want people to be moved by my clothes in the same way they would be moved by music."*
>
> – John Galliano

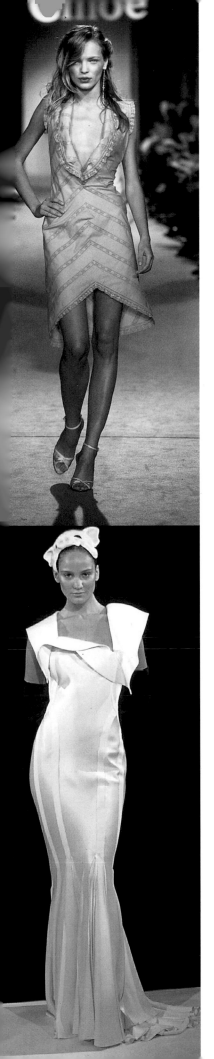

Voyage

1990s celebrities and cult shoppers flocked to London's Voyage, where designer/owners Louise and Titziano Mazilli offer a bazaar of retro-inspired, "nouveau-bohemian" clothing that captured another mood of the later decade. The 1990s Voyage look was based on bias-cut skirts, delicate slip dresses, and the velvet trimmed cardigans which became a Voyage signature. Available in a wide range of feminine colors, some garments were pre-washed to give them that slightly rumpled feel of late 1990s hippie chic. As Voyage's profile grew, the Mazillis introduced their controversial door policy which meant that regular customers were issued with "identification cards." This was certainly a novel approach to retailing and the press was scandalized but the Mazillis claimed that this was merely a means of guarding their newest ideas from swarms of larcenous fellow designers. Judging from the speed and extent that the Voyage look

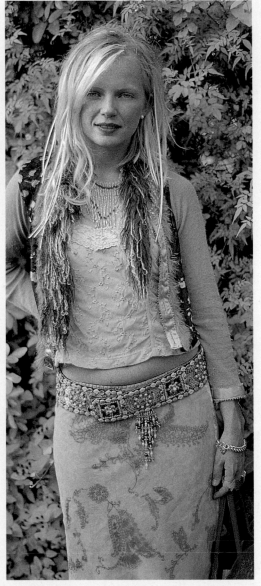

Artist Hannah Sandling decked out in Voyage, personalized with her own take on bohemian style

was copied from the highest catwalks right down to the humblest streets, the Mazillis had a valid point. Imitation may be, as Chanel believed, the sincerest form of flattery but one cannot blame these two directional designers for trying to protect their ideas at least until they emerged into the limelight on the backs of the Voyage celebrity pack.

TOP: **Stella McCartney brought Chloé to the 1990s cutting edge, while fellow "rock daughter" Jade Jagger brought accessories into a new dimension**

BOTTOM: **Galliano's love affair with the bias-cut brought romance to the 1990s**

Like the 1950s, the 1990s was a handbag decade and the average woman bought dozens in a range of styles. Luxury bags like the "Fendi baguette" were touted in the press and by the middle of the decade it was another logo extravaganza, helped along by hip young designers like Marc Jacobs at Louis Vuitton, Martin Margiela at Hermès, and Tom Ford at Gucci. Pretty, little-girl bags were also popular and cultishly collected by the slip dress brigade. Ponyskin was big too, along with 1970s tooled leather and fringed ethnic styles.

Lulu Guinness's iconic box bag (U.K.)

Costume jewelry spent the early 1990s in disgrace but it came back strongly by the middle of the decade. The chunky "CC" hardware and the glitzy heavy brooches of the 1980s gave way now to short delicate *diamanté* necklaces, Victorian inspired beaded chokers, and pretty jeweled hairclips.

The Gucci label was revamped by America's Tom Ford whose retro influences alternated from the pared-down body conscious chic of 1970s Halston to the more-is-more mentality of the 1960s hippie. His watches and handbags, emblazoned with a stylized silver "G," were highly coveted by late-1990s trendies.

With all these ultra-feminine girlie girls running around, it is not surprising that a backlash came in the shape of the Tank Girl, an urban warrior with attitude, cropped hair, and a pair of paramilitary cargo pants, a trouser shape that went on to take over the later 1990s, along with the tight-fitting capri pants that girlie girls wore with their kitten heels.

The Gap went global during the decade and sold another brand of uniform. Down-to-earth, simple, inexpensive styles were touted as "real clothes for real people" in a series of monochrome advertisements where a room full of young men and women sang and danced and veritably reveled in the fact that they all looked alike.

Diamanté chokers decorated necklines (U.S)

Models

While the 1980s elevated designers, the 1990s celebrated supermodels and Naomi, Kate, Claudia, Elle, and Cindy became household names. The early 1990s look was androgynous, waif-like, and illicitly underage. Charges of heroin chic and anorexia dogged this grunge style, which gave way by the middle of the decade to a more refined grown-up look, and even Kate Moss went from waif to woman in the 1990s.

Following John Paul Gaultier's 1980s lead, we also saw larger, older, more unconventional models on the catwalk. Alexander McQueen, of course, took this all a bit further and used severely handicapped women, who were captured in a hauntingly beautiful series of photographs by cutting-edge photographer Nick Knight.

Shawls were big news and the plain cashmere pashmina, reportedly discovered by *Vogue*'s Hamish Bowles, was so truly covetable that it ended up getting over-exposed. It was supplemented though by swathes of retro-looking embroidered piano shawls, angora "shruggies," and chunky crochet knits just like grandmother used to make.

Galliano's millennium ideas took in chunky, handmade knits

Sneakers

Name-brand sneakers like Nike and Adidas went global in the 1990s and a vibrant market for vintage versions sprang up in their wake. A rare 1980s prototype pair of Nike Air Jordans sold for a staggering $22,500 in 1999 and even styles that were only three or four years old have brought many times their original price on the vintage market. Pop stars like Noel Gallagher of Oasis have popularized this retro trend and a young generation of collectors now scour not only the vintage shops but the internet too. Unworn boxed sneakers tend to bring the highest prices but even smelly old, well-used shoes can be valuable so before you clear out your sports locker, do check out one of the specialist publications or internet sites to make sure you're not sitting on a slightly odiferous gold mine.

1990s Nike sneaker

1990s Dolce and Gabbana

Collecting the 1990s

It is always difficult to predict tomorrow's collectible but there are some surefire bets that emerge from the decade. 1980s and 1990s Galliano already attracts serious money on the vintage scene today and though his work was produced in greater quantity as his fame grew, Galliano will always be a good investment. If you are lucky enough to run into any of his early Dior couture, guard it carefully as these pieces look certain to become the holy grails of vintage collecting in the twenty-first century. A private collection of 1990s Versace brought four figure sums at Sotheby's in London in 1998 so his work is certainly worth hanging on to, along with 1990s McQueen, Gucci, Dolce and Gabbana, Prada, and McCartney's Chloé. Pieces by Belgian deconstructionists Ann Demeulemeester and Martin Margiela will surely be future collectibles, along with pieces by Irish designer Lainey Keogh, whose gossamer rivers of delicate knitting are truly unique. Phillip Treacey's innovative hats, like millinery sculptures, are well worth preserving, along with the elaborate beaded crystals of British costume jewelers Erickson Beaman.

CONCLUSION

In the 1990s many designers were accused of merely ripping off the past to compensate for a dearth of their own original ideas. While this is partially true, particularly at the lower end of the fashion pyramid, it is a ridiculous charge to level at the truly talented designers because it misinterprets the whole spirit of the 1990s postmodern aesthetic. This image of a dress by John Galliano for Dior below, styled by him and photographed by Nick Knight, illustrates the point. Consider its learned references alongside its startling beauty and quintessentially late-1990s feeling. The dress is inspired by embroidered shawls of the 1890s and so evokes a previous millennium. The stillness, the *fin de siècle* repose suggests closure, putting the century to sleep, while the dynamism, the excitement of the pose, with its red shoe pointing towards the

future, suggests waking up in a new century, without forgetting the rich, multicultural fashion past that we bring with us. The Art Deco, the chinoiserie, the slightly kitschy "Vargas girl" coloring, marry with the sophistication and elegance that marked our post-war beginnings, that moment when Dior burst on the scene with his spectacular New Look—it's all here now, embedded in Galliano's complex, edgy, mysterious, and above all romantic vision of what makes a woman beautiful.

Poets, novelists, and painters have long looked to their predecessors for inspiration, and now that the art of the best fashion designers is taken more seriously, it is hardly surprising that they too should study their history and use it in their efforts to push their art forward.

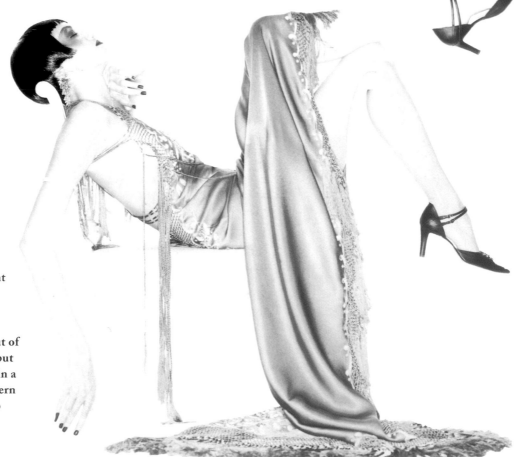

Galliano brought back the immensely flattering and wearable bias-cut of 1930s Vionnet, but reinterpreted it in a thoroughly modern way that came to define the later 1990s

SOURCE LIST

What follows is a list of shops and other sources that stock vintage clothing, around the world. With such an extensive source list, there should be no problem tracking down that elusive piece of couture. An asterisk (*) denotes that visits must be made by appointment.

CANADA

Acme Rag Company, 36 Kensington Ave., Toronto, Ontario M5T 2J9. 416-599-4220

Ashton-Blakey Antiques & Collectibles 6021 Yonge St., Toronto, Ontario M2M 3W2. 905-886-5122

Asylum, 42 Kensington Ave., Toronto, Ontario M5T 2J9. 416-595-7199

Bernard's Antiques, 699 Mt. Pleasant Rd., Toronto, Ontario, M4S 2NY. 416-483-6471

Brava Vintage Clothing, 483 Queen St. W., Toronto, Ontario, M5T 2L9. 416-504-8742

Bug Me, 279 Augusta Ave., Toronto, Ontario, M5T 2J9. 416-599-4141

Courage My Love, 14 Kensington Ave., Toronto, Ontario, M5T 2J9. 416-979-1992

Divine Decadance, Manulife Centre, Main Floor 55 Bloor St. West, Toronto, ONT M4W 1A5. 416-324-9759

Exile 489 Queen St. W., Toronto, Ontario, M5T 2L9

Granny's Boot Antiques, 3389 Kings St., Vineland, Ontario, L0R 2C0. 905-562-7055

Hyperlight Enterprises, 3845 Rupert St., Vancouver, BC V5R 2G7. 604-454-0695

Jardin Antiques, 5225 Highway 97, Okanagan Falls, British Columbia,

V0H 1R0. 888-615-5553

L.J. Antiques, 4 Main St., St George, Ontario, N0E 1N0. 519-442-4465

Regina Antique Mall, 1175 Rose St., Regina, Saskatchewan, S4R 1Z5. 306-525-9688

Ruthie's On The River, 40 William St., Paris, Ontario, N3L 1L1. 519-442-4465

Shirley You Jest, 280 Augusta Ave., Toronto, Ontario, M5T 2L9. 416-975-9712

Yank Azman, The Harbourfront Antiques Market, 340 Queen's Quay West, Toronto, ONT M5V 3A6. 1-877-260-5662

USA

ARIZONA

As If, 6925 E. 5th Ave., Scottsdale, AZ 85251. 480-429-3724

Buffalo Exchange, 2001 E. Speedway Blvd., Tucson, AZ 85719. 520-795-0508

Buffalo Exchange, 227 W. University Dr., Tempe, AZ 85281. 480-968-2557

Desert Vintage & Costume, 636 N. 4th Ave., Tucson, AZ 85705. 520-620-1570

Full Circle Vintage, 519 N. 4th Ave., Tucson, AZ 85705. 520-884-4789

How Sweet It Was, 419 N. 4th Ave., Tucson, AZ 85705. 520-623-9854

Incahoots, 9 E. Aspen Ave., Flagstaff, AZ 86001. 520-773-9447

Loose Change, 417 N. 4th Ave., Tucson, AZ 85705. 520-622-5579

Plush Living, 706 S. Forest, Tempe, AZ 85281. 480-967-9200

Travel Thru Time, 5115 N. 7 St., Phoenix, AZ 85014. 602-274-0666

Wardrobe, 920 N. Broad St., Globe,

AZ 85501. 520-425-7974

Wonderland, 266 E. Congress, Tucson, AZ 85701. 520-792-4222

Yesterday's Wearables, 2413 E. Osborn Rd., Phoenix, AZ 85016. 602-957-3944

ARKANSAS

Lady I's Specialty Shoppe, 7706 Cantrell Rd., Little Rock, AR 72227. 501-228-4860

Melinda's Memories, 40 King's Highway, Eureka Springs, AR 72632. 501-253-7023

CALIFORNIA

4 Nancy Collection, 7613½ Melrose Ave., Los Angeles, CA 900460. 323-782-8535

560 Hayes Vintage Boutique, 560 Hayes St., San Francisco, CA 94102. 415-861-7993

Age of Innocence, 11054 Magnolia Blvd., North Hollywood, CA 91601. 818-980-0462

Ages Ahead, 524 Bryant St., Palo Alto, CA 94301. 650-327-4480

Alice & Annie, 11056 Magnolia Blvd., North Hollywood, CA 91601. 818-761-6085

All American Hero, 314 Santa Monica Blvd., Santa Monica, CA 90401. 310-395-4452

American Rag Compagnie, 1305 Van Ness Ave., San Francisco, CA 94109. 415-441-0537

American Vintage Clothing, 201 Main St. #C, Huntington Beach, CA 92648. 714-969-9670

Animal House, 66 Windward Ave., Venice, CA 90291. 310-392-5411

As Time Goes By, 616 18th St., Bakersfield, CA 93301. 661-325-5222

B-Bop Costumes, 1931 L St., Sacramento, CA 95814.

916-443-2234

Becky's Jeans, 11649 Riverside Dr., North Hollywood, CA 91602. 818-508-7181

Big Mamma's Soul Kitchen, 1306½ 19th St., Sacramento, CA 95814. 916-447-7685

Blue Parrot, 238 Vernon St., Roseville, CA 95678. 916-773-2583

Blues, The 114 E. State St., Redlands, CA 92373. 909-798-8055

Buffalo Exchange, (4 locations) 1007 Garnet Ave., San Diego, CA 92109. 619-273-6227
1555 Haight St., San Francisco, CA 94117. 415-431-7737
2585 Telegraph Ave., Berkeley, CA 94704. 510-644-9202
3862 5th Ave., San Diego, CA 92103. 619-298-4411

Captain Jack's, 866 Valencia St., San Francisco, CA 94110. 415-648-1065

Channel 1, 763 The Alameda, San Jose, CA 95126. 408-280-1001

Cheap Thrills Costumes & Party, 1217 21st St., Sacramento, CA 95814. 916-446-1366

City Limit, 2588 Newport Blvd., #C, Costa Mesa, CA 92627. 949-722-6750

City Rags, 10967 Weyburn Ave., Los Angeles, CA 90024. 310-209-0889

Classic Recycled Clothing, 5101 N. Lankershim Blvd., North Hollywood, CA 91601. 818-763-1109

Clothes Contact, 473 Valencia St., San Francisco, CA 94103. 415-621-3212

Club 501, 7547 Melrose Ave., Los Angeles, CA 90046. 323-653-3335

Come To Mama, 4019 W. Sunset Blvd., Los Angeles, CA 90029. 323-953-1275

Country Cousins, 2889 Adams Ave., San Diego, CA 92116. 619-284-3039

The Cranberry House, 12318 Ventura Blvd., Studio City, CA 91604. 818-506-8945

Crossroads Trading Co. (8 locations) 2231 Market St., San Francisco, CA 94114. 415-626-3162;

1901 Fillmore St., San Francisco, CA 94115. 415-775-3282
1959 West San Carlos, San Jose, CA 95128. 408-292-6622
2935 Arden Way, Sacramento, CA 95825. 916-972-0357
7409 Melrose Ave., Los Angeles, CA 90046. 323-782-8152
5636 College Ave., Oakland, CA 94114. 415-626-3162
7831 Greenback Lane, Citrus Heights, CA 95610. 916-722-8199
1519 Haight St., San Francisco, CA 94117. 415-355-0554

Daddyo's, 5128 Vineland Ave., N. Hollywood, CA 91601. 818-769-8869

Debbie Lyn's Costumes, 954 W. El Camino Real, Sunnyvale, CA 94087. 408-245-8720

Decades, (2 locations) 785 Higuera St., San Louis Obispo, CA 93401. 805-546-0901
8214 Melrose Ave., Los Angeles, CA 90046. 323-655-0223

Deja Nu, 1224 4th St., San Rafael, CA 94901. 415-258-0200

Denim Bank, 10115 Hole Ave., Riverside, CA 92505. 909-352-5868

Denim Exchange, 3095 El Cajon Blvd., San Diego, CA 92104. 619-521-1015

Departures From The Past, 2028 Fillmore St., San Francisco, CA 94115. 415-885-3377

Drama Vintage Clothing, 621 State St., Santa Barbara, CA 93101. 805-963-1217

East of Eden, 103 S. Main St., Sebastopol, CA 95472. 707-829-1968

Edith's Daughter, 12 N. Fir St., Ventura, CA 93001. 805-643-9343

Flashback Fashion, 414 15th St., Oakland, CA 94643. 510-839-1157

Flashbacks, 463 N. Tustin St., Orange, CA 92867. 714-771-4912

Flashbacks Recycled Fashions, 3847 Fifth Ave., San Diego, CA 92103, 619-291-4200

Four Sis, 1854 W. 169th St., Gardena, CA 90247. 310-532-5070

Four Your Eyes, 12452 Venice Blvd., Los Angeles, CA 90066. 310-306-5400.

From The Heart, 6876 Katella Ave., Cypress, CA 90630. 714-903-1491

Front St. Thrift, 428 Front St., Santa Cruz, CA 95060. 831-469-3673

Gasoline Alley, 3744 E. Chapman Ave., Suite D, Orange, CA 92869. 714-639-6550

Geez Louise Vintage Clothing, 111 E. Commonwealth Ave., Fullerton, CA 92832. 714-871-4375

Gift Garden Antiques, 15266 Antioch St., Pacific Palisades, CA 90272 310-459-4114

Glory Days, 13758 Arnold Dr., Glen Ellen, CA 95442. 707-935-3305

Golyester Antiques, 136 S. La Brea Ave., Los Angeles, CA 90036. 323-931-1339

Gurnsey, Beth Santa Monica Antique Market, 1607 Lincoln Blvd., Santa Monica, CA 90404. 310-314-4899

Hollyvogue Vintage, 2588 Newport Blvd #A, Costa Mesa, CA 92627. 949-646-4223

Hot Couture, 101 3rd St., Santa Rosa, CA 95401. 707-528-7247

Hubba Hubba, 3220 W. Magnolia Blvd., Burbank, CA 91505. 818-845-0636

Iguana Vintage Clothing, 14422 Ventura Blvd., Sherman Oaks, CA 91403. 818-907-6716

Indigo Way, 437 Market St., San Diego, CA 92101. 619-338-0173

Jabot Vintage Clothing, 527 3rd St., Eureka, CA 95501. 707-445-8220

Jeans In Motion, 11061 Weddington St., North Hollywood, CA 91601. 818-761-1999

Jet Rag, 825 N. La Brea, Los Angeles, CA 90046. 323-939-0528

Julian's Vintage Clothing, 8366 W. 3rd St., Los Angeles, CA 90048. 323-655-3011

Junk for Joy, 3314 W. Magnolia Blvd., Burbank, CA 91505. 818-569-4903

La Bomba, 2222 E. 4th St., Long

Beach, CA 90814. 562-433-9112

La Rosa Vintage, 1711 Haight St., San Francisco, CA 94117. 415-668-3744

Leopard Lounge, 414 Walnut St., Huntington Beach, CA 92648. 714-960-1984

Life's Little Pleasures, 4219 Park Blvd., San Diego, CA 92103. 619-296-6222

Lindy's Shoppe, 401 San Gabriel Dr., Vallejo, CA. 707-552-4445

Lisa's NY Style Resale, 13541 Ventura Blvd., Sherman Oaks, CA 91423. 818-788-2142

Look Fashion & Finery, 6761 Sebastopol Ave., #400, Sebastopol, CA 95472. 707-823-6288

Lottie Ballou Classic Clothing, 130 W. E St., Benicia, CA 94510. 707-747-9433

Lundberg Haberdashery, 396 Colusa Ave., Kensington, CA 94707. 510-524-3003

Madame Butterfly, 5474 College Ave., Oakland, CA 94618. 510-653-1525

Mad Scientist, 32395 Clinton Keith Rd., Ste 102, Wildomar, CA 92595. 909-678-7813

Maggie's Vintage Clothing, 1121 High St., Auburn, CA 95603. 530-888-0988

Mars Mercantile, 2398 Telegraph Ave., Berkeley, CA 94704. 510-843-6711

Martini Merchantile, 1736 Haight St., San Francisco, CA 94117. 415-831-1942

Material World Recycled Clothing, 122 4th St., Santa Rosa, CA 95401. 707-523-4038

Melrose Vintage, 6718 Greenleaf Ave., Whittier, CA 90601. 562-907-5518

Meow, 2210 E. 4th St., Long Beach, CA 90814. 562-438-8990

Mixed Pickles Antiques, 1746 Shattuck Ave., Berkeley, CA 94709. 510-649-1353

Mood Swingz, 1145 W. 17th St.,

Santa Ana, CA 92706. 714-550-9105

Moon Zoom, 1630 W. San Carlos St., San Jose, CA 95128. 408-287-5876

Moon Zoom Endangered Clothing, 813 Pacific Ave., Santa Cruz, CA 95060. 831-423-8500

Morning Star Vintage Clothing, 9522 Spring Hill School Rd., Sebastopol, CA 95472. 707-823-4032

Needful Things, 118 N. School St., Ukiah, CA 95482. 707-468-1199

Old Hat Vintage Clothing, 56 S. Oak St., Ventura, CA 93001. 805-653-7220

Once Around Lightly, 871 41st Ave., Santa Cruz, CA 95062. 831-462-3796

Option, 320 French St., Santa Ana, CA 92701. 714-667-0410

Out-A-Site, 5126 Vineland Ave., North Hollywood, CA 91601. 818-623-9570

Paper Bag Princess, 8700 Santa Monica Blvd., W. Hollywood, CA 90069. 310-358-1985

Park Place Vintage Clothing, 1318 Lincoln Ave., San Jose, CA 95125. 408-294-9893

Pia's Faded Blues, 711 4th Ave., San Diego, CA 92101. 619-238-4583

Planet Caravan, 763 The Alameda, San Jose, CA 95126. 408-295-0126

Playclothes, 11422 Moorpark St., Studio City, CA 91602. 818-755-9559

Pull My Daisy, 3908 W. Sunset Blvd., Los Angeles, CA 90029. 323-663-0608

Ragsaver, 819 N. La Brea Ave., Los Angeles, CA 90038. 323-965-1782

Ragtime Vintage & Denim, 8044 W. 3rd St., Los Angeles, CA 90048. 323-852-0171

Raspberry Beret, 168 N. Main St., Sebastopol, CA 95472. 707-829-4788

Razzamatazz, 8235 1/2 W. 3rd St., Los Angeles, CA 90048. 323-852-6921

Rebecca's Dream, 16 S. Fair Oaks Ave., Pasadena, CA 91105. 626-796-1200

Repeat Performance, 318 N. La Brea

Ave., Los Angeles, CA 90036. 323-938-0609

Retro Fit Vintage, 910 Valencia St., San Francisco, CA 94110. 415-550-1530

Retro Rag 733 E. Olive Ave., Fresno, CA 93728. 559-497-0717

Roadkill Enterprises, 124 W. Wilshire Blvd., #B, Fullerton, CA 92832. 714-773-1156

Sandy's Place, 8318½ W. 3rd St., Los Angeles, CA 90048. 323-655-6138

Satellite Vintage, 1364 Haight St., San Francisco, CA 94117. 415-626-1364

School Bell Antiques, 3555 Gravestein Highway, S. Sebastopol, CA 95472. 707-823-2878

Second Hand Rose, 2418 Artesia Blvd., Redondo Beach, CA 90278. 310-372-6216

Second Time Around, 577 Marsh St., San Luis Obispo, CA 93401. 805-543-0997

Seek & Find, 31629 Outer Highway 10, Redlands, CA 92373. 909-794-1785

Shake Rag Inc., 440 F St., San Diego, CA 92101. 619-237-4955

Shangri La, 4352 Sunset Dr., Los Angeles, CA 90027. 323-913-3949

Shards & Remnants, 130 S. Main St. #103, Sebastopol, CA 95472. 707-823-1366

She Wore Blue Velvet, 207 N. Main St., Sebastopol, CA 95472. 707-823-6015

Slow Clothing, 7474 Melrose Ave., Los Angeles, CA 90048. 323-655-3725

Sophia's Treasures, 4922 Vineland Ave., N. Hollywood, CA 91601. 818-752-4881

Speedboat, 803 Pacific Ave., Santa Cruz, CA 95060. 831-457-9262

Squaresville, 1800 N. Vermont Ave., Los Angeles, CA 90027. 323-669-8464

Stage Stop, 4330 Clayton Rd., Suite C, Concord, CA 94521. 925-685-4440

Stateside Vintage, (2 locations) 2930 Bristol St., Costa Mesa, CA 92626. 714-549-1854
7207 Melrose Ave., Los Angeles, CA 90048. 323-933-3857
Stop The Clock, 2110 Addison St., Berkeley, CA 94704. 510-841-2142
Stray Cat Vintage & Costume, 108 N. Harbor Blvd., Fullerton, CA 92832. 714-738-5680
Studio Wardrobe Dept., 7145 Vineland Ave., N. Hollywood, CA 91605. 818-503-1490
Swankys, 11825 Firestone Blvd., Norwalk, CA 90650. 562-868-2882
Swellegant Vintage, 3409 Newport Blvd., Newport Beach, CA 92663. 949-673-3604
Swing Set, 846 Divisadero St., San Francisco, CA 94117. 415-923-1996
Swoozy's Fashion Exchange, 1857 Bacon St., San Diego, CA 92107. 619-523-5801
Tata Lane, 525 Evans Place, San Diego, CA 92116. 619-563-9778
Those Were The Days, 1586 Lincoln Way, Auburn, CA 95603. 530-823-2519
Time After Time, 8311½ W. 3rd St., Los Angeles, CA 90048. 323-653-8463
Tippecanoe's, 648 S. Coast Highway, Laguna Beach, CA 92651. 949-494-1200
Trappings of Time, 470 Hamilton Ave., Palo Alto, CA 94301. 650-323-3061
Trixie's Vintage Boutique, 1724 Fillmore St., San Francisco, CA 94115. 415-447-4230
Truly Victorian, 18925 John F. Kennedy Blvd., Riverside, CA 92508. 909-780-3112
Tumblin' Dice Vintage Clothing, 3108 W. Magnolia Blvd., Burbank, CA 91505. 818-557-1411
Underground Clothing, 515 S. Bascom Ave., San Jose, CA 95128. 408-280-5548
Ver Unica, 148 Noe St., San Francisco, CA 94114. 415-431-0688

Vintage Buzz, 6551 Topanga Canyon Blvd., Canoga Park, CA 91303. 818-992-5177
Vintage Collection, 853 41st Ave., Santa Cruz, CA 95062. 831-477-1497
Vintage Silhouettes, 1301 Pomona Ave., Crockett, CA 94525. 800-636-1410
Wasteland, The, (2 locations) 1660 Haight St., San Francisco, CA 94117. 415-863-3150
428 Melrose Ave., Los Angeles, CA 90046. 213-653-3028
Wear It Again Sam, 3922 Park Blvd., San Diego, CA 92103. 619-299-0185
We-Cycled Wonders, 117 W. Main St. Suite 4, Turlock, CA 95380. 209-668-2586
Worn Out West, 645 N. Martel Ave., Los Angeles, CA 90036. 323-653-5645

COLORADO

5 & Dime, (3 locations) 2037 East 13th Ave., Denver, CO 80206. 303-399-3735.
606 East 13th Ave., Denver, CO 80206. 303-861-4979
604A Parker St., Ft. Collins, CO 80525. 970-224-3391
American Aces Vintage Clothing, 78 S. Broadway, Denver, CO 80209. 303-733-2237
American Vogue Vintage Clothing, 10 S. Broadway, Denver, CO 80209. 303-733-4140
Bloomingdeals, 1301 Marion St., Denver, CO 80218. 303-831-9505
Boss Unlimited, 8 Broadway, Denver, CO 80203. 303-871-0373
Candy's Vintage Clothing, 4483 N. Broadway, Boulder, CO 80304. 303-442-6186
Carlotta's Cottage, 520 13th St., Greeley, CO 80631. 970-353-5122
Clothes Lion, 119 Main St., Sterling, CO 80751. 970-521-0828
Counter Evolution, 1622 Pearl St., Boulder, CO 80302. 303-444-1799
Flossy McGrew's, 1959 S. Broadway, Denver, CO 80210. 303-778-0853

Heritage Liquidation Market, 2749 S. Broadway, Englewood, CO 80110. 303-806-0222
Indigo Rose, 218 Linden St., Fort Collins, CO 80524. 970-482-3449
My Groovy Closet, 170 N. College Ave., Fort Collins, CO 80524. 970-482-1778
Nohe Antiques, Rebecca, 315 E. Pikes Peak Ave., Colorado Springs, CO 80903. 719-635-1171
Repeat Boutique, 239 Linden St., Fort Collins, CO 80524. 970-493-1039
Repeat Performance, 829 N. Union Blvd., Colorado Springs, CO 80909. 719-633-1325
Rev 2, 403 N. Tejon St., Colorado Springs, CO 80903. 719-635-4944
Ritz, 959 Walnut St., Boulder, CO 80302. 303-443-2850
Stellar, 1203 13th St., Boulder, CO 80302. 303-443-5190
Wear It Again Sam, 140 S. College Ave., Fort Collins, CO 80524. 970-484-0170

CONNECTICUT

Doll Factory, 2551 Berlin Turnpike, Newington, CT 06111. 860-666-6162
Retro, 266 Kent Rd., New Milford, CT 06776. 860-355-1975
Retro Active, 30 Broad St., Milford, CT 06460. 203-877-6050
Schneider, Suzanne, Torrington, CT 860-496-7355 *
Troncale, Mary, Branford, CT 203-481-3302 *
Yesterday's Threads, Branford, CT 203-481-6452 *

FLORIDA

Bonnie's Vintage Emporium, 1937 Suwanee Ave., Ft. Myers, FL 33901. 941-936-4888
Donovan & Gray, 3623 S. Dixie Highway, West Palm Beach, FL 33405. 561-838-4442
La France, 1612 E. 7th Ave., Tampa, FL 33605. 813-248-1381
Sherry's Yesterdaze, 1908 S. Mac Dill

Ave., Tampa, FL 33629.
813-258-2388
Squaresville, 508 S. Howard Ave.,
Tampa, FL 33606. 813-259-9944

GEORGIA
Powell, Cornelia, 271 E. Paces Ferry
Road, Atlanta, GA 30305.
404-365-8511

HAWAII
Consignors' Emporium, 725
Kapiolani Blvd., #C111, Honolulu, HI
96813. 808-597-9177
Linda's Vintage Isle, 2909 Waialae
Ave. #105, Honolulu, HI 96826.
808-734-6163
Linda's Vintage Isle Waikiki, 2139
Huhio Ave. #105, Honolulu, HI
96815. 808-921-0430

IDAHO
Acquired Again Antiques, 1306
Alturas St., Boise, ID 83702.
208-338-5929
Chester's Vintage Clothing Shop,
1747 Broadway Ave., Boise, ID
83706. 208-368-0862
Déjà Vu, 191 N. Main St., Ketchum,
ID 83340. 208-726-1908
Flying Deuce Auction & Antique,
1224 Yellowstone Ave., Pocatello, ID
83201. 208-237-2002
Picture Show-Retro & Vintage, 225
N. 5th St., Boise, ID 83702.
208-344-7278
Vintage Vanities, 921 S. Fir St.,
Jerome, ID 83338. 208-324-3067

ILLINOIS
Back Seat Betty's, 1530 N. Milwaukee
Ave., Chicago, IL 60622.
877-222-5732
Mr. Modern, 807 Madison St., Oak
Park, IL 60302. 800-775-5078. *
Silver Moon, 3337 N. Halsted,
Chicago, IL 60657. 773-883-0222
Una Mae's Freak Boutique, 1422 N.
Milwaukee, Chicago, IL 60622.
773-276-7002

INDIANA
Red Rose Vintage Clothing, 834 E.
64th St., Indianapolis, IN 46220
317-257-5016
Vintage Clothing Co. The, 161 W.
Banta St., Franklin, IN 46131.
317-738-9115

IOWA
Amazon Dry Goods, 411 Brady St.,
Davenport, IA 52801. 800-798-7979
Handled With Care, 419 Jefferson St.,
Burlington, IA 52601. 319-754-1121
Mohair Pear, 2225 College St., Cedar
Falls, IA 50613. 319-266-6077
Trash Can Annie's, 421 Brady St.,
Davenport, IA 52801. 319-322-5893
Zalkin Vintage Clothing, 1101 S.
20th St., Council Bluffs, IA 51501.
712-325-1115

KANSAS
Orange Crate Gallery, 3125 SW
Huntoon St., Topeka, KS 66604.
785-296-9207
Sugartown Traders, 918
Massachusetts St., Lawrence,
KS 66044. 785-331-2791

KENTUCKY
Elizabeth's Timeless Attire, 2050
Frankfort Ave., Louisville, KY 40206.
502-895-5911
Just Faboo, P.O. Box 3913, East Main
St., Midway, KY 40347.
606-846-5666
Past Perfect Vintage Clothing, 1520
S. 2nd St., Louisville, KY 40208.
502-636-5152
Zebra Lounge Vintage, 430 West
Maxwell St., Lexington, KY 40508.
606-252-5865

LOUISIANA
Antiques on Consignment, 315 N.
Columbia, Covington, LA 70434.
504-898-0955
Smiley Vintage Clothing, 2001
Magazine St., New Orleans, LA
70130. 504-528-9449
Trashy Diva, 829 Chartres St.,

New Orleans, LA 90116.
888-818-DIVA

MAINE
1840 House of Maine, 356 Main St.,
Yarmouth, ME 04096. 207-846-9719
Barbara Sale, 52 Dean St., Ellsworth,
ME 207-667-4033

MARYLAND
Old Hat Vintage Clothing, 111 S.
Carroll St., Frederick, MD 21701.
301-695-9304

MASSACHUSETTS
Better Yet, 15 Market St.,
Northampton, MA 01060.
413-584-3948
Davenport & Co, 146 Bowdoin St.,
Springfield, MA 01109.
413-781-1505
Linda White, 2 Maple Ave., Upton,
MA 02568. 508-529-4439
Phyllis Mount, 83 Massasoit St.,
Northampton, MA 01060.
413-585-5753
Reflections in Vintage Clothing,
7 City Hall Ave., Gardner, MA
01440. 978-630-3710
Sparkle Plenty, 1 Lincoln St., Newton
Highlands, MA 617-332-2408
Vintage Jewelry, 40 Main St.,
Edgartown, MA 02539.
508-627-5409
Yours, Mine & Ours, 140 South St.,
Pittsfield, MA 01201. 413-443-5260

MICHIGAN
Rage of the Age, Ann Arbor, MI
434-662-0777 *

MINNESOTA
The Corner Store, 900 W. Lake St.,
Minneapolis, MN 55408,
612-823-1270
Gabriela's, 1404 W. Lake St.,
Minneapolis, MN 55408.
612-822-1512
Grand Remnants, 1136 Grand Ave.,
St. Paul, MN 55105. 651-222-0221
Lula, 1587 Selby Ave., St. Paul, MN

55104. 651-644-4110
Repeat Performance, 3404 Lyndale Ave. S., Minneapolis, MN 55408. 612-824-3035
Rummage In The Park, 1418 13th Ave. E., Hibbing, MN 55746. 218-262-5322
Tatters Alternative Clothing, 2928 Lyndale Ave. S., Minneapolis, MN 55408. 612-823-5285
Via's Vintage Wear, 2405 Hennepin Ave. S., Minneapolis, MN 55405. 612-374-3649

MISSOURI
Alice's Vintage Clothes, 4703 McPherson Ave., St. Louis, MO 63108. 314-361-4006
Atomic, 6254 Delmar Blvd., St. Louis, MO 63130. 314-725-8188
Boomerang, 1415 W. 39th St., Kansas City, MO 64111. 816-531-6111
Class Act Antiques, 224 E. Commercial St., Springfield, MO 65803. 417-862-1370
Creverling's, 1125 Charles St., St. Joseph, MO 64501. 816-232-9298
Dottie Mae's, 7927 Wornall Rd., Kansas City, MO 64114. 816-361-1505
Enokiworld, 16 Princeton Ave., St. Louis, MO 63130. 314-725-0735. *
Flair Vintage Clothing, 1908 Cherokee St., St. Louis, MO 63118. 314-664-7950
General Waste Trading Co., 1920 N. Broadway, St. Louis, MO 63102. 314-231-7966
GVC, 2820 N. 9th St., St. Louis, MO 63147. 314-621-4704
Gypsy's Junique, 825 N. 2nd St., St. Charles, MO 63301. 636-947-0801
James Country Mercantile, 111 N. Main St., Liberty, MO 64068. 816-781-9473
Mamie Maple's Emporium, 825 N. Second St., St. Charles, MO 63301. 636-947-0801
Matinee Retro Goods, 4 Westport Rd., Kansas City, MO 64111. 816-561-9941

Nellie Dunn's, 211 E. Commercial St., Springfield, MO 65803. 417-864-6822
Regeneration, 3196 S. Grand Blvd., St. Louis, MO 63118. 314-664-5533
Remember Me, 1021 Russell Blvd., St. Louis, MO 63104. 314-773-1930
Re-Runs, 4126 Pennsylvania Ave., Kansas City, MO 64111. 816-561-4425
Re-Runs Warehouse, 1408 W. 12th St., Kansas City, MO 64101. 816-221-9002. *
Revue Inc, 1415 W. 39th St., Kansas City, MO 64111. 816-561-6059
Ruth's Vintage Clothing, 5233 Jeffco Blvd., Imperial, MO 63052. 636-467-1065
Vintage Haberdashery, 3143 S. Grand Blvd., St. Louis, MO 63118. 314-772-1927
Voisin's Vintage Clothing, 12³⁄₄ South Euclid, St. Louis, MO 63108. 314-361-6777

MONTANA
Anna Herman's Antiques & Clothes Store, 216 N. Higgins Ave., Missoula, MT 59802. 406-728-4408
Daddy-O's Vintage Attire, 2509 Montana Ave., Billings, MT 59101. 888-376-0542
Karma's Vintage Clothing, 1205 E. Broadway St., Helena, MT 59601. 406-442-1159
Montana Vintage Clothing, 2509 Montana Ave., Billings, MT 59101. 406-248-7650
Red Willow Dry Goods, 111 Main, Victor, MT 59875. 406-642-3130
Rediscoveries Vintage Clothing & Costume 55 W. Park, Butte, MT 59701. 406-723-2176

NEBRASKA
Shock, 1212 Howard St., Omaha, NE 68102. 402-346-8166
Weird Wild Stuff, 4965 Dodge St., Omaha, NE 68132. 402-551-7893

NEVADA
Katie Magoo's, 912 S. Virginia St., Reno, NV 775-329-8553

NEW HAMPSHIRE
Antique Apparel, Acworth, NH. 603-835-2295 *

NEW JERSEY
G. Montlack, 88 Harwood Rd., Jamesburg, NJ 08831. 609-860-8408 *
Goldfarb Inc., West Orange, NJ. 973-678-4550 *
Incogneeto, 25 W. Main St., Somerville, NJ 08876. 908-231-1887
Lizzie Tish Vintage Clothing, 36 Sky Manor Rd., Pittstown, NJ 08867. 908-996-1000
Pahaka, Upper Saddle River, NJ. 201-327-1464 *
Revival Vintage, 186 Center Ave., Westood, NJ 07675. 201-722-9005
Uniquities, 973-763-1778 *Shows only*
Victoria Vintage Clothing, Bogota, NJ. 201-488-2824*

NEW MEXICO
A Few Of My Favorite Things, 111¹⁄₂ Amherst, Albuquerque, NM 87106. 505-254-9600
Act 2, 839 Paseo de Peralta #A, Santa Fe, NM 87501. 505-983-8585
Antique & Unique, County Rd., 89B, Santa Fe, NM 87501. 505-455-7651
Costume Studio, 5005 4 N.W., Ste. 202, Albuquerque, NM 87107. 505-344-7315
Double Take, 320 Aztec St., Santa Fe, NM 87501. 505-989-8886
Faerie Queen Treasure Boutique, The 316 Garfield, Santa Fe, NM 87501. 505-983-4908
Forest Floor, Santa Fe, NM 505-424-6904 *
La Vieja, 2230 Avenida De Mesilla, Las Cruces, NM 88005. 505-526-7875
Marino Dry Goods Emporium, 5206 Constitution Ave. N.E., Albuquerque, NM 87110. 505-265-8560
Off-Broadway Vintage Clothing &

Jewelry, 3110 Central Ave. S.E.,
Albuquerque, NM 87106.
505-268-1489
Sonrisa's Glad Rags, 309 Paseo De
Onate, Espanola, NM 505-753-1829
The Gen!, 1201 W. Picacho Ave., Las
Cruces, NM 88005. 505-541-5474
Velvet Crush, 110 Amherst Dr. N.E.,
Albuquerque, NM 87106.
505-266-0337

NEW YORK

Academy Clothes, Inc. 888 8th
Avenue, New York, NY 10019.
212-957-0605
Alice's Underground, 481 Broadway,
New York, NY 10002. 212-431-9067
Allan & Suzi, 416 Amsterdam Ave.,
New York, NY 10024. 212-724-7445
Almost New Vintage Clothing, 68 St.
Marks Ave., Brooklyn, NY 11217.
718-398-8048
Andy's Chee-pee's, 691 Broadway,
New York, NY 212-420-5980
Antique Boutique, 712 Broadway,
New York, NY 10012. 212-460-8830
Atomic Passion, 430 East 9th St.,
New York, NY 10009. 212-533-0718
Auntie Macassar, 15 Main St.,
Tarrytown, New York, NY 10591.
914-332-4504
Chazanof, Ilene, New York, NY
212-254-5564 *
Cheap Jack's Vintage Clothing,
841 Broadway, New York, NY 10003.
212-777-9564
Cherry, 185 Orchard St., New York,
NY 10002. 212-358-7131
Cobblestones, 314 East 9th St., New
York, NY 10003. 212-673-5372
Darrow, 7 West 19th St., New York,
NY 10011. 212-255-1550
Daybreak, 22 Central Ave., Albany,
NY 12210. 518-434-4312
Ellen Christine Millinery, 255 W.
18th St., New York, NY 10011.
212-242-2457
Family Jewels, 832 6th Ave., New
York, NY 10001. 212-679-5023
Foley & Corinna, 108 Stanton St.,
New York, NY 10002. 212-358-8634

Gordon, Leah, Manhattan Art &
Antiques Center, 1050 Second Ave.
Gallery 50-C, New York, NY 10022.
212-872-1422
Hollywood & Vine Co., 32
Westchester Ave., Pound Ridge, New
York, NY 10576. 203-852-0649
Illisa, 212-721-7039 *
La Vie En Rose, 7376 S. Broadway,
Red Hook, NY 12571. 914-758-4211
Legacy, 109 Thompson St., New
York, NY 10012. 212-966-4827
Lest We Forget, 1020 Cornell Ave.,
Albany, NY 94706
Live Shop Die, 151 Avenue A, New
York, NY 10003. 212-674-7265
Lorraine Wohl Collection,
860 Lexington Ave., New York, NY
10021. 212-472-0191
Love Saves The Day, 119 Second
Ave., New York, NY 10003.
212-228-3802
Lucille's Antique Emporium,
127 W. 26th St., New York, NY
10011.
Map, 127 Fulton St., Penthouse, New
York, NY 212-571-6644
Mara The Cat, 406 East 9th St., New
York, NY 10009. 212-614-0331
Mary Efron, 68 Thompson St., New
York, NY 10012. 212-219-3099
Metropolis Antiques, 55 Mohawk St.,
Cohoes, NY 12047.
518-233-1195
Mullen & Stacy, 17 East 16th St.,
New York, NY 10003. 212-647-9882
New Scotland Antiques, 240
Washington Ave., Albany, NY 12210.
518-463-1323
Oldies, Goodies & Moldies, Ltd.
1609 Second Ave., New York, NY
10028. 212-737-3935
Oly's, 210 East 21st St., New York,
NY 10010. 212-673-2800
Patricia Pastor, Ltd. 212-734-4673. *.
Vintage couture
Pepper, Brooklyn, NY.
718-499-1853 *
Phase Vintage, 29-A Ave. B., New
York, NY 10009. 212-375-8051
Piacente, 38 Main St., Tarrytown, NY

10591. 914-631-4231
Reminiscence, 50 West 23rd St., New
York, NY 10010. 212-243-2292
Replay Country Store, 109 Prince St.,
New York, NY 212-673-6300
Resurrection, (2 locations) 217 Mott
St., New York, NY 212-625-1374;
123 East 7th St., New York, NY
212-228-0063
Ricky's Place, 274 Goodman St. N.,
Rochester, NY 14607. 716-442-0042
Right to the Moon Alice, 240 Cooks
Falls Rd., Cooks Fall, NY 12776.
607-498-5750 *
Rose Is Vintage, 96 East 7th St., New
York, NY 10003. 212-533-8550
Rue St. Denis Clothier, 174 Avenue
B, New York, NY 212-260-3388
Schneider, Suzanne, Bayside, NY
718-631-1865. *
Screaming Mimi's, 382 Lafayette,
New York, NY 10003. 212-677-6464
Selima Optique, 59 Wooster St., New
York, NY 10012. 212-343-9490
Sheila Steinberg, P.O. Box 973 Lenox
Hill Station, New York, NY 10021 *
Snappy Gabs, New York, NY
212–677-9318,
snappygabs@aol.com. *
Spooly D's, 51 Bleeker St., New York,
NY 10003. 212-598-4415
Star Struck, 47 Greenwich Ave., New
York, NY 10014. 212-691-5357
Starr, Jana, 236 E. 80th St., New
York, NY 10021. 212-861-8256
Stella Dallas, 218 Thompson St., New
York, NY 10012. 212-647-0447
Tender Buttons, 143 East 62nd St.,
New York, NY 10021. 212-758-7004
The Fan Club, 22 West 19th St., New
York, NY 10011. 212-929-3349
Trouville Francaise, 212-737-6015 *
Valenti, Keni, 247 West 30th St., 5th
Floor, New York, NY 10001.
212-967-7147 *
Vintage by Stacey Lee, 305 Central
Ave., White Plains, New York, NY
10606. 914-328-0788
Vintage Loft, 117 W. 26th St. #3W,
New York, NY 10001.
212-352-0275*

What Comes Around Goes Around,
351 West Broadway, New York, NY
10013. 212-343-9303
Whiskey Dust, 526 Hudson St., New
York, NY 10014. 212-691-5576

NORTH CAROLINA
Showboat, 229 N.E. Broad St.,
Southern Pines, NC 28387.
910-692-5648

NORTH DAKOTA
Make Believe Room, 2500 Demers
Ave., Grand Forks, ND 58201.
701-772-1922. *Rentals only*

OHIO
Cleveland Shop, The 11606 Detroit
Ave., Cleveland, OH 44102.
216-228-9725
Legacy Antiques & Vintage, 12502
Larchmere Blvd., Cleveland, OH
44120. 216-229-0578
Nostalgia Vintage Clothing, 1200 N.
High St., Columbus, OH 43201.
614-469-9025
Suite Lorain, 7105 Lorain Ave.,
Cleveland, OH 44102. 216-281-1959

OKLAHOMA
Collectibles Etc., 1516 NW 23rd St.,
Oklahoma City, OK 73106.
405-524-1700
Ivy Cottage & Rose Garden, 622 SW
D. Ave., Lawton, OK 73501.
580-248-8768
Sparkle Plenty Vintage Clothing 918
N. Britton Rd., Oklahoma City, OK
405-842-0905
Vintage Plus, 727 NW 23rd St.,
Oklahoma City, OK 73103.
405-524-0086
Vintage Vibe, 311 W. Main St.,
Norman, OK 73069. 405-447-4777

OREGON
All American Vintage Co., 1400 E.
Burnside, Portland, OR 97214.
503-236-2261
Antrican, 304 E 13th Ave., Eugene,
OR 97401. 541-484-5750

Avalon Antiques, 203 SW 9th Ave.,
Portland, OR 97205.
503-224-7156
Buffalo Exchange Ltd., 1420 SE 37th,
Portland, OR 97214. 503-234-1302
Cheap Frills Quality Resale, 817 SW
Hurbert St., Newport, OR 97365.
541-265-9588
Cheap Thrills, 575 Highway 101 #B,
Florence, OR 97439. 541-902-0187
Decades Vintage Co., 328 SW Stark,
Portland, OR 97204. 503-223-1177
Deja Blues, 933 Pearl St., Eugene,
OR 97401. 541-485-4885
Donkey Salvage/Banana Warehouse,
500 Olive St., Eugene, OR 97401.
541-302-8226
Egads Vintage Clothing, 1435 SE
37th, Portland, OR 503-234-3921
Eugene Jeans, 132 E. 13th Ave.,
Eugene, OR 97401. 541-338-4395
Hattie's Vintage, 2721 SE 26th,
Portland, OR 97202. 503-235-5305
Keep 'Em Flying, 510 NW 21st Ave.,
Portland, OR 97209. 503-221-0601
Kitty Princess Boutique, 3356 SE
Belmont, Portland, OR 97214.
503-233-2567
Lavender's Green Historic Clothing,
Level 5, 520 SW 9th, Portland, OR
97205. 503-295-2633
Level 5, 520 SW 9th Ave., Portland,
OR 97205. 503-295-2633
Lil' Gypsy, 1387 Broadway St., NE,
Salem, OR 97303. 503-375-3060
Magpie, 324 SW 9th, Portland, OR
94205. 503-295-2633
Nan's Glad Rags, 21325 SW Tualatin
Vly Hwy., Aloha, OR 97006.
503-642-9207
Perry & Della's Vintage Clothing,
10613 SE Main, Milwaukie, OR
97222. 503-786-8743
Persona Vintage Clothing, 100 10th
St., Astoria, OR 97103. 503-325-3837
Puttin' On The Ritz, 350 E. 11th
Ave., Eugene, OR 97401.
541-686-9240
Ray's Ragtime, 1021 SW Morrison,
Portland, OR 97205. 503-226-2616
Reflections In Time, 1114 NW 21st,

Portland, OR 97209. 503-223-7880
**Retread Threads Quality Clothing
Exchange,** 2700 SE 26th, Portland,
OR 97202. 503-230-8042
Shine Design House & Vintage, 516
NW 21st Ave., Portland, OR 97209.
503-916-8054
Torso Boutique, 64 SW 2nd Ave.,
Portland, OR 97204. 503-294-1493
Torso Vintages, 2432 NE Broadway,
Portland, OR 97232. 503-281-7230
Vintage Revu, 232 SW Ankeny,
Portland, OR 97204. 503-241-1876
Vintage Vogue, 122 NW Couch,
Portland, OR 94209. 503-248-0098
Westside Vintage, 960 W 7th Ave.,
Eugene, OR 97402. 541-343-9225
What Goes Around?, 3206 SE
Hawthorne Blvd., Portland, OR
97214. 503-232-1637

PENNSYLVANIA
Auerbach & Maffia, P.O. Box 178,
Fountainville, PA 18923.
215-345-6793. *
Cat's Pajamas, 335 Maynard St.,
Williamsport, PA 17701.
570-322-5580
Checkered Past, 316 4th St., New
Cumberland, PA 17070.
717-774-7180
Decades Vintage, 4369 Cresson St.,
Manayunk, PA 19128. 215-487-1970
Hinesight, Lancaster, PA
717-396-9527 *
Kennedy, Barbara Q, 464 Kenny
Drive, Sinking Spring, PA 19608.
610-796-7303. *
Liao Collection, 609 Bainbridge St.,
Philadelphia, PA 19147.
215-925-1809
125 W. Lawn Ave., West Lawn, PA
19609. 610-678-5781*
Walker's Collectables, Pittsburgh, PA
412-922-0862 *
Yoko Trading, 22 Bick Rd.,
Fleetwood, PA 19522.
610-987-9720 *
Zap & Co. 315 N. Queen St.,
Lancaster, PA 17603. 717-397-7405

SOUTH DAKOTA

Wear It Again Sam, Inc., 402 E. Fairmont Blvd., Rapid City, SD 57701. 605-342-8283

TENNESSEE

Zelda, 5133 Harding Rd., Nashville, TN 37205. 615-356-2430

TEXAS

Ahab Bowen, 2416 Boll St., Dallas, TX 75204. 214-720-1874

Amelia's Retro-Vogue & Relics, 2024 S. Lamar Blvd., Austin, TX 78704. 512-442-4446

Antique Clothing by Old Time, 1126½ W. 6th St., Austin, TX 78703. 512-442-8610

Attic Apparel, 2617 Golder Ave., Odessa, TX 79761. 915-332-4225

Baraka Clothing Exchange, 913 N. Lamar Blvd., Austin, TX 78703. 512-478-0913

Big Bertha's Bargain Basement, 1050 S. Lamar Blvd. #E, Austin, TX 78704. 512-444-5908

Blackmail, 2040 S. Lamar Blvd., Austin, TX 78704. 512-326-7670

Blast From The Past, 1801 Fort Ave., Waco, TX 76707. 254-714-1183

Blue Velvet, 3203 Red River St., Austin, TX 78705. 512-474-5147

Bon Ton Vintage Clothes, 124 S. Highway 77, Forreston, TX 76041. 972-483-6222

Caralee's Fashions of Yesteryear, 11424 Northview Dr., Aledo, TX 76008. 817-560-4372

Champagne Clotheshorse/Kimono, 1030 S. Lamar Blvd., #D, Austin, TX 78704. 512-441-9955

Color Explosion Fashion, 2607 Blodgett St., Houston, TX 77004. 713-526-0310

Déjà Vu, 3302 Quaker Ave., Lubbock, TX 79410. 806-799-6845

Denim Edge, 17776 Tomball Pkwy. #21, Houston, TX 77064. 281-469-8604

Electric Ladyland, 1506 S. Congress Ave., Austin, TX 78704.

512-444-2002

Fashions of Yesteryear, 11424 Northview Dr., Aledo, TX 76008. 817-560-4372

Flashback, 2047 S. Lamar Blvd., Austin, TX 78704. 512-445-6906

Flipnotics Clothespad, 1601 Barton Springs Rd., Austin, TX 78704. 512-322-9011

Gratitude, 3714 Fairmont St., Dallas, TX 75219. 214-522-2921

Laverty's, 600 N. 18th St., Waco, TX 76707. 524-754-3238

Limbo, 5015 Duval St., Austin, TX 78751. 512-302-4446

Nelda's Vintage Clothing, 1621 N. Main Ave. #3, San Antonio, TX 78212. 210-271-7111

New Bohemia Retro Resale, 1714 S. Congress Ave., Austin, TX 78704. 512-326-1238

Past Perfect Quality Vintage, 3130 W. 7th, Fort Worth, TX 76107. 817-870-1088

Pin Pin Vintage Clothing, 2538 Times Blvd., Houston, TX 77005. 713-520-9156

Rose Costumes, 521 N. Elm St., Denton, TX 76201. 940-566-1917

SNK Trading, 6701 Harwin Dr. #120-B, Houston, TX. 713-266-1226

UTAH

Grunts & Postures, 779 E. 300 South, Salt Lake City, UT 84102. 2256 801-521-3202

VERMONT

White Trillium, 141 Lincoln Ave., Rutland, VT 05701. 802-773-2260

VIRGINIA

Halcyon Vintage Clothing, 117 N. Robinson St., Richmond, VA 23220.

Suzi's Antiques, 235 N. Main St., Farmville, VA 23901. 804-392-4655

WASHINGTON

Amazing Grace Fashionable Clothing, 1930 2nd St., Seattle, WA 98101. 206-443-1444

Americana Paul's, 119 Summit Ave. E., Seattle, WA 98102. 206-328-7055

Atlas Clothing Co., 1515 Broadway, Seattle, WA 98122. 206-323-0960

Buffalo Exchange, (2 locations) 216 Broadway Ave. E., Seattle, WA 98102. 206-860-4133
4546 University Way N.E., Seattle, WA 98105. 4511 206-545-0175

Crossroads Trading Co., 325 Broadway E., Seattle, WA 98102. 206-328-5847

Diamond Lil, 4001 198th S.W., Lynnwood, WA 98036. 425-771-3667

Doubletake Vintage & Consignment, 1175 NW Gilman Blvd., Ste. B6, Issaquah, WA 98027. 425-392-4908

Freemont Antique Mall, 3419 Fremont Pl. N., Seattle, WA 98103. 206-548-9140

Fritzi Ritz Vintage Clothing, 3425 Fremont Pl. N., Seattle, WA 98103. 206-633-0929

Heller's Café, Inc., 1654 E. Olive Way, Seattle, WA 98102. 206-322-7130

Hello Gorgeous, 1530 Post Alley #5, Seattle, WA 98101. 206-621-0702

Isadora's Antique Clothing, 1915 1st, Seattle, WA 98101. 206-441-7711

Le Frock, 317 E. Pine, Seattle, WA 98122. 206-623-5339

Madame & Co. 1901 10th Ave. W., Seattle, WA 98119. 206-281-7908

Old Duffers Stuff, 1519 1st, Seattle, WA 98101. 206-621-1141

Once Upon A Time, 223 SW 152nd, Burien, WA 98166. 206-248-5655

Private Screening, 3504 Fremont Place N., Seattle, WA 98103. 206-548-0751

Red Light Clothing Exchange, 4560 University Way NE, Seattle, WA 98105. 206-545-4044

Retroviva, (5 locations) 1511 1st, Seattle, WA 98101. 206-624-2529;
4515 University Way N.E., Seattle, WA 98105. 206-632-8666;
2115 4th Ave. N., Seattle, WA 98109. 206-283-5629;

169 Bellevue Square, Bellevue, WA 98004. 425-452-9697;
215 Broadway E., Seattle, WA 98102. 206-328-7451
Rhinestone Rosie, 606 W. Crockett, Seattle, WA 98119. 206-447-9710
Roosevelt Antiques & Collectables, 905 NE 65th St., Seattle, WA 98115-5541. 206-527-0206
Rudy's Vintage Clothing & Watches, 1424 1st Ave., Seattle, WA 98101. 206-682-6586
Time Tunnel, 1914 2nd Ave., Seattle, WA 98101. 206-448-1030
Vintage Clothier & More, 827 N. Central, Kent, WA 98032. 253-859-1339
Vintage Voola, 705 E. Pike, Seattle, WA 98122. 206-324-2808
Wild West Trading Co., 19714 Highway 99, Lynnwood, WA 98036. 425-778-4620

WISCONSIN

Glad Rags, 109 E. College Ave., Appleton, WI 54911. 920-738-0032
Ju Ju & Moxie, 458 W. Gilman St., Madison, WI 53703. 608-255-4002
P S Collection, 1386 W. Hopkins St., Milwaukee, WI 53206. 414-374-3444
Timeless Treasures, 110-112 N. 8th St., Manitowoc, WI 54220. 920-682-6566
Touch of Class, 249 N. Water St., Milwaukee, WI 53202. 414-272-2470
Yellow Jacket, 2225 N. Humboldt Ave., Milwaukee, WI 53212. 414-372-4744

AUCTION HOUSES

Christie's, 20 Rockefeller Plaza, New York, NY 10020 212-636-2000
Wescheler's, 909 E St N.W., Washington, D.C. 20004. 202-628-1281
William Doyle Galleries, 175 East 87th St., New York, NY 212-427-2730
Sotheby's, 1334 York Ave., New York, NY 212-606-7000

VINTAGE SHOW COMPANIES

Caskey Lees, P.O. Box 1409, Topanga, CA 90290. 310-455-2886. Holds one clothing and textile show each year.
Cat's Pajamas, 125 W. Main St., W. Dundee, IL 60118. 847-428-8368. Holds two vintage clothing shows in the midwest each year.
Deco to 50's, 1217 Waterview Dr., Mill Valley, CA 94941. 415-383-3008. Holds deco shows twice a year in San Francisco.
JR Promotions, 509-375-5273. Runs vintage shows in Seattle.
Love, Eileen 914-988-9609 Runs shows and sells material.
Maven Company, 914-248-4646. Holds vintage clothing & jewelry shows each year in the northeast U.S.
Metropolitan Art & Antiques, 125 W. 18th St., New York, NY 10011. 212-463-0200. ext. 236 Holds four vintage clothing & textile shows each year
Oldies But Goodies, Hankins, NY 914-887-5272. Vanity items, *shows only*.
Show Associates, P.O. Box 729, Cape Neddick, ME 03902. 207-439-2334. Holds vintage clothing and textile shows in Sturbridge, MA.
Stella Show Management, 147 West 24th St., New York, NY 10011. 212-255-0020. Holds general antique shows with many vintage dealers in the east coast.
The Williamsburg Vintage Fashion & Accessories Show, held the last week of February in Williamsburg, VA. 215-862-5828
Vintage Expo, 707-793-0773. Holds vintage shows in San Francisco and Santa Monica.

PERIODICALS

Bustle, P.O. Box 361, Midtown Station, New York, NY 10018. 212-228-6137. Quarterly of the Ladies' Tea & Rhetoric Society.

Vintage!, Publication of the Federation of Vintage Fashion. 707-793-0773 for subscriptions.
Vintage Gazette, The published by Molly Turner, 194 Amity St., Amherst, MA 01002. 413-549-6446

EUROPE

BELGIUM

Coco, 45 rue St Jean, 1000. 512 53 77
Galontique, Venelle Aux Quatre Noeuds 2, 1150 Bruxelles. 02 770 1241
Idiz Bogam, 162 rue Blaes, 1000. 502 83 37 and 76 rue Antoine Dansaert, 1000. 512 10 32
Les Enfants d'Edouard, 175–77 avenue Louise, 1050. 640 42 45
Peau d'Ane, 37 rue des Eperonniers, 1000. 513 84 37
R&V, 19 rue des Teinturiers, 1000. 511 05 10

ENGLAND

LONDON
Angela Hale, 5 The Royal Arcade, 28 Old Bond St., London W1. 020 7493 6203
Annie's Vintage Costume & Textile, 10 Camden Passage, Islington, London N1. 020 7359 0796
Asahi, 110 Goldborne Rd., London W10. 020 8960 7299
Beauty & the Beast, Q9 Antiquarius Antique Centre, 131–141 King's Rd., Chelsea, London SW3. 020 7351 5353
Bertie Wooster, 284 Fulham Rd., Fulham, London SW10. 020 7352 5662
Blackout II, 51 Endell St., WC2. 020 7240 5006
Butler & Wilson, 189 Fulham Rd., Chelsea, London SW3. 020 7352 8255
Cenci, 31 Monmouth St., Covent Garden, London WC2.

020 7836 1400

Cloud Cuckoo Land, 6 Charlton Place, Camden Passage, Islington, London N1. 020 7354 3141

Cornucopia, 12 Upper Tachbrook St., Pimlico SW1. 020 7828 5752

Crazy Clothes Connection, 134 Lancaster Rd., London W11. 020 7221 3989

Cristobal, G125, 127 Alfie's Antiques Market, 13–25 Church St., Marylebone, London NW8. 020 7724 7789

Delta of Venus, 151 Drummond St., Camden, London NW1. 020 7387 3070

Dolly Diamond, 51 Pembridge Rd., Notting Hill, London W11. 020 7792 2479

Flashback, 50 Essex Rd., Islington, London N1. 020 7354 9656

Gallery of Antique Costume and Textiles, 2 Church St., London NW8. 020 7723 9981

Hang Ups, 366 Fulham Rd., Fulham, London SW10. 020 7351 0047

Henry & Daughter, 17–18 Camden Lock Place, Camden, London NW1. 020 7284 3302

Linda Bee, Gray's Mews Antiques Market, 1–7 Davies Mews, London W1. 020 7408 1252

Lunn Antiques, Thomas Neal's Centre, Shorts Gardens, London WC2. 020 7379 1974

Modern Age Vintage Clothing, 65 Chalk Farm Rd., Chalk Farm, London NW1. 020 7482 3787

Oguri, 64 Ledbury Rd., London W11. 020 7792 3847

Orsini Gallery, 76 Earl's Court Rd., London W8. 020 7937 2903

Past Caring, 76 Essex Rd., Islington, London N1. No telephone.

Pop Boutique, 6 Monmouth St., London WC2. 020 7497 5262

Radio Days, 87 Lower Marsh, Waterloo, London SE1. 020 7928 0800

Retro, 34 Pembridge Rd., Notting

Hill, London W11. 020 7792 1715

Ritzy, York Arcade, Camden Passage, Islington, London N1.

Rokit, 225 Camden High St., Camden, London NW1. 020 7267 3046

Spatz, 48 Monmouth St., Covent Garden, London WC2. 020 7379 0703

Steinberg & Tolkien, 193 King's Rd., Chelsea, London SW3. 020 7376 3660

Stitch Up, 45 Parkway, Camden, London NW1. 020 7482 4404

The Emporium, 330 Creek Rd., Greenwich, London SE10. 020 8305 1670

The Observatory, 20 Greenwich Church St., London SE10. 020 8305 1998

Vent, 59 Ledbury Rd., London W11.

Virginia, 98 Portland Rd., London W11. 020 7727 9908

What's New Pussycat?, The Hayloft, Stables Market, Camden, London NW1. 020 7255 3036

William Wain, Antiquarius Antique Centre, 131–141 King's Rd., Chelsea, London SW3. 020 7351 4905

Yesterday's Bread, 29 Foubert's Place, London W1. 020 7287 1929

LONDON ANTIQUE CENTRES

Alfie's Antiques Market, 13–25 Church St., Marylebone, London NW8. 020 7723 6066

Antiquarius Antique Centre, 131–141 King's Rd., Chelsea, London SW3. 020 7351 5353

LONDON AUCTIONS

Christie's South Kensington, 85 Old Brompton Rd., London SW7. 020 7581 7611

Phillips, 101 New Bond St., London W1. 020 7629 6602

Sotheby's, 34–35 New Bond St., London W1. 020 7293 5000

LONDON CHARITY/THRIFT SHOPS

Humana, 128 Uxbridge Rd., London W12. 020 8740 0140

Oxfam Originals, 26 Ganton St., London W1. 020 7437 7338

Salvation Army Charity Shop/Cloud 9, 9 Princes St., London W1. 020 7495 3958

LONDON MARKETS

Bermondsey Market, Borough, London Bridge, London SE1.

Camden Market, Camden High St., London NW1.

Camden Passage, Islington, London N1.

Greenwich Market, London SE10.

Portobello Market, Portobello Rd., (Ladbroke Grove End), London W10 and W11.

OUTSIDE LONDON

Back in Fashion, 38 High St., Tutbury, Burton on Trent, Staffordshire DE13 9LS. 01283 814 964

Beau Monde, The By George Antique Centre, 23 George St., St Albans, Herts. AL3 4ES. 01727 853 032

Bell Antiques, 43 Overdale, Swinton, Manchester M27 5PH. 0161 728 4911

Butterfield 8, Tarrystonehouse, Hoarwithy, Herefordshire HR6 QQ. 01432 840416

Casa Blanca Costumes, Park End Antiques & Interiors, 10 Park End St., Oxford OX1 1HH. 01865 200091

Collectible Costumes, Fountain Antique Centre, 3 Fountain Buildings, Lansdowne Rd., Bath BA1 5DU. 01225 428 731

Decades, 230 Brandy House Brow, Blackburn, Lancs. BB2 3EY. 01254 693320

Echoes, 650a Halifax Rd., Todmorden, Lancs. 0L14 6DW. 01706 817505

Fountain Antiques, 3 Fountain Building, Lansdown Rd.,

Bath, Avon BA1 5DU.
01225 428731
Happy Days, Cutcrew, Sawmill, Tideford, Cornwall PL12 5JS.
01752 851402
Harriet Appleby, 30 Clothorn Rd., Didsbury, Manchester M20 6BP.
0161 438 0998
Jackson, Mandy, Old Cottage, Main Rd., Milford, Stafford ST17 0UL.
01785 665888
Mulberry's, 30–32 St Owen Street, Hereford HR1 2PR. 01432 269925
Page, Katie, 4 Belvedere, Bath, Avon.
01225 315987
Pop Boutique, 34 Oldham St., Manchester M1. 0161 236 5797
Priestly's Period Clothing, 11 Grape Lane, York YO1 7HU. 01904 623 114
Real McCoy, 21 The Fore St. Centre, Fore St., Exeter, Devon EX4 4AN.
01392 410481
Replay Period Clothing, 7 Well Walk, Cheltenham, Glos. GL50 3JX.
01242 238864
Revisions, 3 Pool Valley, Brighton, East Sussex BN1 1NJ. 01273 207728
Rowberry, Patricia, 65 Steephill, Lincoln LN1 1YN. 01522 545916
20th Century Originals, 13 Wood St., East Ardley, Wakefield, West Yorkshire WF3 2BY. 0113 243277
Treasures in Textiles, 53 Russian Drive, Liverpool L13 7BS.
0151 281 602
Vintage Clothing Company, Quiggens Centre, School Lane, Liverpool. 0151 707 0051
Walton, Mrs, Tytherleigh House, Bishops Hull, Taunton, Somerset TA1 5AB. 01823288633

OUTSIDE LONDON:
ANTIQUES CENTRES
Affleck's Palace, 52 Church St., Manchester M4 1PW. 0161 834 2039
Snape Antique & Collector's Centre, Snape Maltings, Saxmundham, Suffolk IP17 1SR. 01728 688038

FRANCE

Anouschka, 6 avenue coq, Paris.
01 48 74 37 00 *
Didier Ludot, Jardins du Palais Royal, 24 Galeries Montpensier, 75001 Paris.
01 42 960656
Killiwatch, 64 rue Tiquetonne, Paris.
L'Entrepot, 14 rue de Charonne, Paris. 01 48 06 57 04
Le Shop, 3 rue d'Argout, Paris.
01 40 28 95 94
Marche Aux Pucs De Montreuil, Avenue de La Porte de Montreuil, 20th arrondissement, Paris.
Ragtime, 23 rue du Roule, 75001 Paris. 01 42 36893
Terrain Vogue, 13 rue Keller, 11th arrondissement, La Bastille, Paris.
TGV, 60 rue Greneta, Paris.

FRENCH AUCTIONS
Drouot Richelieu, 15 Avenue Montaigne, 75008 Paris.
01 48 002080

GERMANY

Calypso – High Heels For Ever, Neue Schönhauser Stra§e 19, Mitte, 10178.
281 6165
Checkpoint, Mehringdamm 57, Kreuzberg, 10961. 694 4344
Colours, 1st courtyard, Bergmannstra§e 102, Kreuzberg, 10961. 694 3348
Garage, Ahornstra§e 2, Tiergarten, 10787. 211 2760
Humana, Karl-Liebnecht-Stra§e 30, Mitte, 10178. 242 3000
U2, U5, U8, S3, S5, S7, S9 Alexanderplatz. Open 10am-6.30pm Mon-Wed, Fri;
Made in Berlin, Potsdamer Stra§e 106, Tiergarten, 10785. 262 2431
Sterling Gold, Paul-Lincke-Ufer 44, Kreuzberg, 10999. 611
Waahnsinn, Neue Promenade 3, Ecke Hackescher Markt, Mitte, 10178.
282 0029

HOLLAND

Bebop Shop, Nieuwendijk 164, Amsterdam. 638 1306
Lady Day, Hartenstraat 9, Amsterdam. 623 5850
Laura Dols, Wolvenstraat 7, Amsterdam. 624 9066
Wini, Haarlemmerstraat 29, Amsterdam. 427 9393

HUNGARY

Egyedi Ruha Galéria, IX Baross utca 4, Budapest. 118 2056
Tweed, VI Dalszínház utca 10, Budapest. 332 9294

IRELAND

Flip/Helter Skelter, 4–5 Fownes St. Upper, Dublin. 671 4299
Jenny Vander, 20 Market Arcade, Dublin 2. 770 406

ITALY

Bianco e Nero, Via Marrucini, 34, San Lorenzo, Rome. 44 50 286
Echo, Via Oriuolo 37. 23 81
Rags Utd, Piazza Campo de' Fiori, 11/12, Rome. 68 79 344

SCOTLAND

15 The Grassmarket, 15 Grassmarket, Edinburgh EH1. 0131 226 3087
Flip of Hollywood, 59–61 South Bridge, Edinburgh EH1. 0131 556 4966 and 70–72 Queen St., Glasgow G1. 0141 221 2041
Herman Brown, 151 West Port, Edinburgh EH1. 0131 228 2589
Nicol's Originals, 8 Chancellor St., Glasgow G11. 0141 337 6994
Saratoga Trunk, Top Floor, 93 West Regent St., Glasgow G2 2BA. 0141 331 2707
Starry Starry Night Vintage Clothes, 19 Dowanside Lane, Glasgow G12.
0141 337 1837
W. M Armstrong & Son, 83 Grassmarket, Edinburgh EH1. 0131 220 5557 and 313 Cowgate, Edinburgh EH1 1NA. 0131 556 5977

VINTAGE WEBSITES

Alternative Chic
www.subar.com
Vintage clothing, lingerie, hatpins, scent bottles, and accessories from the nineteenth century to the 1970s.

Andrew Wurst General Merchandise
www.awgm.com/vintage
Featuring vintage clothing from the 1950s–1970s.

Antique and Vintage Dress Gallery
www.antiquedress.com
Features clothing from the 1800s to today.

Ballyhoo Antique
www.ballyhoovintage.com
Apparel from the 1930s–1970s. Specializing in premium, designer, and never-worn clothing.

Bar-Or
www.cogent.net/~camread/Bar-Or
Distributes wholesale used & vintage clothing and Levis worldwide.

Beverley Birks
www.camrax.com/pages/birks
Collection of haute couture from the last 100 years. Large private collection; photographs and some pieces for sale.

Bittersweet Boutique
www.bittersweetboutique.com
Vintage clothing from the 1800s–1970s.

Carrie's
www.advancenet.net/~carries
Vintage clothing, costume jewelry, accessories, and collectibles.

Continental Textile Co.
www.continentaltextile.com
Processor of used and vintage clothing.

Cookies Closet Vintage
www.cookiescloset.com
Clothing and accessories including designer items.

Davenport and Company Online
www.davenportandco.com
Catalog of vintage clothing and accessories dating from 1840–1980s.

Domsey International Sales Corp
www.domsey.com
Sells vintage, export, used, secondhand clothing, and textiles.

Dumont Export
www.libertynet.org/dumont
Processor of secondhand and vintage clothing and textiles.

Enokiworld
www.enokiworld.com
Mid-century clothing and accessories.

Farley Enterprises
www.farley.com
Specializing in the Japanese market.

Fifi's Fashion Lounge
www.fifis.com
Vintage clothing and accessories for men and women, knick-knacks, and home furnishings.

5 and Dime Vintage
www.510vintage.com
Offers vintage clothing from the 1940s–1970s, specializes in retro fashions.

Glad Rags
www.vintagegladrags.com
Vintage and Victorian clothing and related accessories. Inventory includes items from the 1880s–1970s.

It's In The Past Vintage Clothing
www.itsinthepast.com
Clothing and accessories from the 1930s–1970s for men and women.

Jabot's Vintage Authentic
www.geocities.com/Eureka/Park/5956
Vintage fashions from the Victorian era through the 1970s for men and women, including hats, jewelry, shoes, and accessories.

Loma Vista Trading
www.cali-vista.com
Bulk exporter of used clothing, including vintage, speciality, and industrial rags.

Meredith Vintage Collection
www.meredith.com.au/vintage
Designer imported garments from the late 1960s and 1970s.

Midnight Sparkle
www.tias.com/stores/midnightsparkle
Vintage clothing from the 1930s–1970s, as well as shoes, purses, and accessories.

Millicent's, Another Place In Time
www.ramonamall.com/vintage_clothes
Women's clothing from the nineteenth century to the 1970s.

NIH Enterprises Inc
www.canada-products.com/vintage
Wholesaler of vintage clothing.

Old Custom
www.oldcustom.com
Wholesalers of vintage, used, and recycled Levis, 501's, and other denim products.

Ragqueen Used Clothing
www.execpc.com/~ragqueen
Sells used and vintage clothing by the piece and by the pound.

Red Rose Vintage Clothing
www.rrnspace.com
Men's and women's clothing from the 1890s–1970s.

Resource Rags International
www.resourcerags.com
Suppliers for wholesale and retail used
and vintage clothing.

**Rizzo's Reproduction Vintage
Clothing**
www.costumegallery.com/rizzos/repros
Reproduction vintage clothing for all
ages.

Row Clothing Enterprises
www.rowclothing.com
Exporters of rags and vintage clothing.

Rusty Zipper
www.rustyzipper.com
1940s–1970s men's and women's
vintage clothing.

Stitches in Time
www.stitchesintime.com
Retail and wholesale merchants of
antique and vintage clothing and
accessories.

Sunny and Mr Starr
www.tox.ndirect.co.uk
Offers vintage British fashions and
accessories.

The Old Lace and Linen Shop
www.antiquelinen.com
Specializes in antique lace and authentic
vintage clothing, christening gowns
from the nineteenth century, table, and
bed linens.

The Paper Bag Princess
www.paperbagp.com
Designer, resale, and vintage couture.

The Wasteland
www.thewasteland.com
Vintage clothing, new and
contemporary gear, vintage denim, used
501s, and more.

Trans-America Trading Co.
www.tranclo.com
Large processor of secondhand
clothing, vintage/fashion clothing,
fiber, and textiles.

Trashy Diva
www.trashy-diva.net
Men's and women's clothing and
accessories from Victorian to 1960s.

Ver Unica
www.ver-unica.com/html/ver_unica
Boutique specializing in vintage and
designer clothing and accessories for
men and women.

Vintage and Lace
www.vintageandlace.com
Original clothing and textiles from the
1920s to the 1970s.

Vintage Couture
www.vintagecouture.com
Resale site for designer clothing and
accessories, recent and vintage.

Vintage Valuations
www.vintagevaluations.com
Appraisals of vintage clothing,
handbags, and jewelry.

Vintage Visions
vintagevisions.com
Vintage clothing and accessories.

Vintage Vixen Clothing Co.
www.vintagevixen.com
Mostly women's clothing, from
Victorian to 1970s.

Wear It Again Sam
www.wearitagainsam.com
Men's and women's vintage clothing.

What Comes Around Goes Around
www.nyvintage.com
Retail and wholesale vintage clothing.

PICTURE CREDITS

All efforts have been made to trace the copyright holders of the photographs featured in this book. The publisher apologises for any possible omissions and is happy to rectify this in any future editions.

Cover: Nick Knight –Christian Dior Advertising Campaign –Autumn/Winter 97/98
Half Title Page: Woman in check skirt–Courtesy of Mary Quant
Title Page: Lizard Brooch–Courtesy of Butler and Wilson
Page 4: Champagne Glass Brooch–Courtesy of Butler and Wilson
Page 6: Market–N'Diaye/Imapress/Camera Press
Page 12: Gucci–Courtesy of Gucci
Page 13: Fabric Detail–Shaun Peacock
Page 15: Shop–John Cox
Page 16: Woman applying lipstick–IWM/Camera Press
Page 18: Bomb Shelter–IWM/Camera Press
Page 19: Reja silver brooch–Shaun Peacock
Page 23: Audrey Hepburn–Kobal Collection
Page 25: Coco Chanel–Cecil Beaton/Camera Press
Page 27: Woman in kitchen–Camera Press
Page 36: James Dean–Kobal Collection
Page 38: Liz Taylor–Kobal Collection
Page 37: Beatnik Girl–Hulton Getty
Page 39: Marilyn Monroe–Kobal Collection
Page 44: Grace Kelly–Edward Quinn/Camera Press
Page 46: Marilyn Monroe and Jane Russell–Kobal Collection
Page 47: Necklace–Courtesy of Cobra and Bellamy
Page 48: Necklace and earrings–Courtesy of Cobra and Bellamy
Page 50: Marilyn Monroe–Kobal Collection
Page 51: Jean Marsh–Hulton Getty
Page 52: Woman with umbrella–Hulton Getty
Page 54 Peter Max T-Shirt–Shaun Peacock
Page 56: Mary Quant shop–Courtesy of Mary Quant
Page 56: Mary Quant ad–Courtesy of Mary Quant
Page 56: Twiggy–John Clarke/Camera Press
Page 58: Carnaby Street–John Drysdale/Camera Press
Page 59: King's Road–Hulton Getty
Page 60: Biba ad–The Advertising Archive
Page 61: Biba boutique–Dirk Buwalda/Camera Press
Page 62: Paper dress–Camera Press
Page 64: Both pictures of Cheetah Club–Ray Hamilton/Camera Press
Page 65: 2 girls in mini-dresses–Courtesy of Pierre Cardin
Page 67: Warhol and others–Corbis/Bettmann/UPI
Page 68 & 69: Pierre Cardin outfits–Courtesy of Pierre Cardin
Page 70: Paco Rabanne chain Mail–Leon Herschritt/Camera Press
Page 71: Yves St. Laurent Dress–courtesy of Yves St. Laurent
Page 74: Jackie Kennedy –Corbis/Bettmann/UPI
Page 76: Hippie girls–Corbis/Henry Diltz
Page 78: Girl smoking joint–Ron Reid/Camera Press
Page 79: Woodstock–Corbis/Bettmann/Rothschild
Page 80: Face painting–Ray Hamilton/Camera Press
Page 81: Apple boutique–Peter Mitchell/Camera Press
Page 82: Mary Quant–Courtesy of Mary Quant
Page 82: Hippie couple–Ron Reid/Camera Press
Page 83: Vidal Sassoon–Courtesy of Vidal Sassoon
Page 91: Charlotte Rampling–Barry McKinley/Camera Press
Page 92: Marsha Hunt–Justine de Villeneuve/Camera Press
Page 94: David Bowie–Heilemann/Camera Press
Page 97: John Travolta–Jerry Watson/Camera Press
Page 98: Abba–Heilemann/Camera Press
Page 99: Jagger and Minnelli –Corbis/Bettmann
Page 101: Halston–Michael Annaud/Condé Nast Publications Ltd
Page 103: Brooke Shields–The Advertising Archive
Page 105: Punks–Alex Levac/Camera Press
Page 106: Sex shop–Courtesy of Vivienne Westwood
Page 107: Johnny Rotten–Redferns
Page 108: Malcolm McClaren–Katz
Page 108: Vivienne Westwood–Rafael Fuchs/Outline/Katz
Page 109: Rocky Horror Show–Kobal Collection
Page 112: Doc Marten Boot–Courtesy of Airwair
Page 113: Platforms–Courtesy of Fiorucci

INDEX